IDLEWILD

IDLEWILD

★ ★ ★ ★ ★ ★ ★ ★ ★ ★ ★ ★ ★ ★

History and Memories of Pennsylvania's
Oldest Amusement Park

JENNIFER SOPKO

THE
History
PRESS

Published by The History Press
Charleston, SC
www.historypress.net

Front cover image of the Old Woman Who Lived in a Shoe and back cover color image of Kiddie Land courtesy of Idlewild and SoakZone Archives.

First published 2018

Manufactured in the United States

ISBN 9781467119542

Library of Congress Control Number: 2017960348

A sincere thank you to Idlewild and SoakZone, whose invaluable assistance and cooperation made this book possible.

In memory of Richard Zane ("Dick") Macdonald (1922–2018).

CONTENTS

Contents

CONTENTS

ACKNOWLEDGEMENTS

Without the advice, knowledge, support and patience of many people, this book would not be possible. First, I would like to thank Palace Entertainment for granting me access to the Idlewild and SoakZone archives, which yielded insightful park records and beautiful photographs.

The management and staff at Idlewild—including Brandon Leonatti, Ed Ostroski, Matt Palko, Grant Rozich, Kathy Sichula, Jimmy Singer and Ricky Spicuzza—cheered me on and answered my many research questions. Special thanks to Jeff Croushore for spending much time analyzing photographs, fact-checking and discussing Idlewild's mysteries.

I am indebted to the folks at the Ligonier Valley Rail Road Association (LVRRA)—especially Jim Aldridge, Bill Potthoff and Bob Stutzman—for their research help and in-depth analyses of Idlewild's railroad era, as well as Len Daugherty and Bill McCullough. The LVRRA possesses two volumes of correspondence from Superintendent George Senft that gave me a brief yet invaluable glimpse into Idlewild's earliest days.

I had the privilege of speaking with three families and ownership groups that once owned Idlewild. Although the railroad days of the park have long passed, the Mellon family's imprint on Idlewild endures. Thank you to Sandy Springer Mellon, Seward Prosser Mellon and James Mellon for their insights. Dick and Ann Macdonald graciously welcomed me into their home and shared stories from the park's most sentimentalized time, and for that I am truly grateful. Harry Henninger, Keith Hood and Jerome Gibas also shared their anecdotes and laughs from the Kennywood era, when two competing parks became siblings.

While other members of the Idlewild family are no longer with us, their relatives brought back their memories. Thank you to Art Jennings Jr. for relating his father's creative life at Story Book Forest; to Sandy Luther Smetanka, John Smetanka and Bill Luther for photographs and stories of longtime superintendent Bill Luther; and to Stephanie Tomasic for sharing memories of her father Steve Tomasic, the "Old Timer."

Thank you to the Philadelphia Toboggan Coasters Inc. team—Tom Rebbie, Janine Rebbie Matscherz, Torry Jenkins and Alex Nagle—for access to PTC archives and photographs so that I could chase the history of two special rides: Carousel no. 83 and Rollo Coaster.

Thank you to Shirley McQuillis Iscrupe, my dear friend and steward of Ligonier Valley history, for generously opening up the Ligonier Valley Library's Pennsylvania Room archives of photographs and digitized issues of the *Ligonier Echo*, as well as contributing her expertise on Pennsylvania land records and Arthur St. Clair, not to mention moral support.

Adams Memorial Library's *Latrobe Bulletin* microfilm archives and the University of Pittsburgh Special Collection's Darlington Family Papers helped me uncover much of the park's history. Thank you to the staff at Adams who patiently waited for me to look through "just one more paper" as they turned off the lights. I respect the passion of Mary Carson O'Hara Darlington and William McCullough Darlington for local history and their foresight to preserve their property records; I am also grateful to their daughters for donating their library and manuscripts and to Pitt for making the collection available to the public.

Many unique photographs of Idlewild—more than could be included in this book—were found at the Latrobe Area Historical Society, at the Ligonier Valley Historical Society, in Ligonier legend Ray Kinsey's collection and behind the camera lens of Harry Frye. Thank you to Pam Johnston Ferrero, Mary Lou Townsend, Bob Senger and the LAHS; Malori Stevenson, Theresa Gay Rowell and the LVHS; Ray Kinsey; and Harry Frye for all of their contributions to this book.

I am also indebted to the knowledge and expertise of amusement park historians who contributed research, gave advice and fact-checked this manifesto. Many thanks to historian and Kennywood author Brian Butko, Laff in the Dark creative director William Luca, National Amusement Park Historical Association (NAPHA) historian Jim Futrell, NAPHA editor Joshua Litvik, American Coaster Enthusiasts (ACE) historian Dave Hahner, the Amusement Parkives creator Harry Michaelson and NAPHA/ACE member Greg Marcopoulos.

ACKNOWLEDGEMENTS

Thank you to the many other individuals, organizations and Facebook group friends who also contributed to this project in myriad ways, including loaning photographs, granting me research access or leads, proofreading my drafts and sharing their memories of Idlewild Park: Jim and Julia Ambrose, Kathleen Ashbaugh, Atlantic City Public Library (Jacqueline Morillo), Ron Baker, Donna Benson, Matt Berkebile, Corrine Butler Bollinger, Chestnut Ridge Historical Society (Betty Heide), Christopher Churilla, Eleanor Clark, Joseph Comm, Debbie Crouch, Charles Darr, Donna Muchmore Dastrup, Connie Deemer, Robert Domenick, Julie Donovan, Nancy Douglas, Eberly Family Special Collections Library at Penn State University (Alexandra Arginteanu and Rachael Dreyer), EDR (Mike Gandolfo), Fayette County Historical Society (Chris Buckelew), Pam Ferrero, Alan Fisher, Fred Rogers Center for Early Learning and Children's Media (Emily Uhrin), Paul Fry, Betty Giesey, Jim Giesey, Greensburg Hempfield Area Library, Rita Horrell, Edith Jagger, Wayne and Karen Johnson, Library of Congress, Ligonier Township municipal office (Terry Carcella), Lincoln Highway Heritage Corridor (Kristen Poerschke), Bill Linkenheimer, Randy Litzinger, Sarah Jane Bitner Lowe, Mike Mesich, Howard Mincone, Mary Lou Mitchell, Helen Grace Moffat, Hillorie Monsour, National Archives and Records Administration (Thomas McAnear and David Pfeiffer), Patrick Nese, Ron Newcomer, Carol Oravetz, Rosemary Overly, Stella Parton, Pennsylvania State Archives (Kurt Bell, Aaron McWilliams, Richard Saylor, Jonathan Strayer, Michael Sherbon and Megan Rentschler), Ramada Inn Ligonier (Deborah Fox and Marissa Roberts), Peter Petz, Jim Ramsey, Janice Reynolds, Dave Robb, San Antonio Public Library (Andrew Crews), Senator John Heinz History Center (Carly Lough), Kelly Shaffer, Tom Shafron, Corey Shaulis, David Shirey, Ina Mae Smithley, Pete Snodgrass, "Coach Mike" Sopko, Jean Gordon Sylvester, Toni Tesauro, Westmoreland County Courthouse, Westmoreland County Historical Society (Anita Zanke), Richard Wonderly, Susan Yealy and Ralph Zitterbart.

Thank you to my former History Press editor, Hannah Cassilly, for encouraging me to develop my second book and to my succeeding editor, Banks Smither, for pushing me to complete it.

Thank you to my family for standing by me while I devoted myself to this project: my mom and dad, Carol and Michael Sopko; my sister, Michele; my grandfather, Tom Piotrowski; and my love, David Zajdel.

Idlewild's story does not end with this book. I hope to answer more questions, uncover more photographs and hear more memories about this historic amusement park. Please share your stories and photos by contacting me through my website (www.jennifersopko.com).

INTRODUCTION

Post–Civil War Pittsburgh was a city filled with the promise of industry and innovation. The region's thriving coal, coke and steel production drove Western Pennsylvania—and America—forward during the late nineteenth century. Although the financial landscape seemed bright for Pittsburgh, the belching smokestacks and roaring furnaces of its mills created a depressing, toxic environment for city dwellers. After living day-to-day within the confines of this smoky city, businessmen and blue collars alike craved clean air and pleasant views.

The iron horse took many people east into the Allegheny Mountains for a respite in the country. Rail travel accelerated the fifty-mile trek from Pittsburgh to the Laurel Highlands, compared to earlier days when wagons and stagecoaches rolled along dirt roads and crushed stone turnpikes. Leaving the factories behind, city folk watched the landscape gradually change before their eyes from the open windows of a Pennsylvania Railroad passenger car. Instead of steel mills and soot, they gazed upon farms and clear blue skies. After transferring to a smaller line at Latrobe for the last leg of the journey, the locomotive wound through a narrow gorge, carved by the Loyalhanna Creek. A tall tree canopy framed the railroad line, providing shade as the train chugged along. A mere three miles from the town of Ligonier, the train stopped at Western Pennsylvania's famous picnic grounds: Idlewild. Men, women and children debarked the trains, headed to covered shelters and dove into the picnic baskets they carried in hand.

INTRODUCTION

Known today as Idlewild and SoakZone, the mountain park located in Ligonier Township, Westmoreland County, fills a fascinating chapter in the history of Pennsylvania amusement parks. This award-winning family attraction is considered the oldest operating amusement park in the commonwealth and the third oldest in the United States. The following pages will trace the story of Idlewild, from its relationship with the Ligonier Valley Rail Road and the historic land on which it was developed to the innovators who modernized the park, its rides and attractions and the cherished memories of people who grew up here and now return with their children and grandchildren.

Transportation was a catalyst for early parks in Western Pennsylvania, and Idlewild was no exception. The park's origins were similar to that of trolley parks of the late nineteenth century, as Idlewild was established in 1878 as a beautiful picnic grove designed to attract passenger business to the short line Ligonier Valley Rail Road that Judge Thomas Mellon and his family owned and operated for seventy-five years. The railroad moved millions of tons of freight out of the Ligonier Valley during its lifetime, but it also transported more than 9 million people, thousands of whom sought country pleasures at Idlewild Park.

Idlewild went commercial in 1931 with the introduction of electricity and rides, transitioning from a simple picnic area to a full-fledged amusement park with the Macdonald family at its helm. Guests continue to flock to some of the beloved attractions from this era, including the Philadelphia Toboggan Company carousel and Rollo Coaster. Although the Ligonier Valley Rail Road made its last run in 1952 and no longer brought patrons to the park, Idlewild flourished as a Lincoln Highway roadside attraction, expanding with additional themed areas, including Kiddie Land and Story Book Forest, the latter considered one of the last surviving nursery rhyme attractions popular during the 1950s.

After more than a half century managing Idlewild Park, the Macdonalds passed the torch to the Kennywood Park Corporation, which continued to promote group picnics and develop the park's various themed areas, notably partnering with Fred Rogers to create Mister Rogers' Neighborhood of Make-Believe, the only commercial application of his unique television show at an amusement park. Since the mid-1980s, Idlewild has gradually added slides and other aquatic attractions to its complex, cultivating a reputation as a premier water park and creating a new brand: Idlewild and SoakZone.

Now part of the Palace Entertainment family, Idlewild and SoakZone celebrates its 140th anniversary in 2018.[1] The park attracts several hundred

thousands of children and adults annually to its all-inclusive rides, wholesome entertainment and beautiful forest scenery that have continually defined it throughout three centuries. Many people who grew up at the park continue to bring their families—and picnic baskets—to Idlewild, a repeat winner of *Amusement Today*'s Golden Ticket Award for Best Children's Park.

ORIGINS OF A RAILROAD PARK

Then if a beautiful park you'd seek,
To spend the sunny hours
Among the hills and valleys deep,
Amid the fairest flowers;
Behold it where the sun ne'er shines
Beneath the branches wide,
But where the stars in silence deep
Guard it on every side!
Behold it in a lovely place
Where oaks for years have stood,
And where no artist's pen can trace
The grandeur of those woods;
Where the Ridge's sloping sides
Bend down to meet the valley,
Where the Loyalhanna glides
And 'round the woods doth rally.
Then if a beautiful park you'd seek
Among hills and valleys wild,
Behold it in the lovely place
Of picturesque Idlewild.

—*Alfred B. Henry,* Ligonier Echo, *June 12, 1889*

When Thomas Mellon's eyes first glimpsed the forested ridges of the Ligonier Valley two hundred years ago, did he have a vision of the possibilities that Western Pennsylvania's future "mountain playground" had for settlers, visitors and entrepreneurs? Ligonier left an indelible impression on the young Scotch-Irish boy, who in 1818 immigrated with his parents to America from Ireland, settling in Westmoreland County, Pennsylvania. After traveling along the main thoroughfare in the region—at that time the stone-laid Stoystown and Greensburg Turnpike[2]—the future judge and businessman arrived in the bucolic valley nestled between Chestnut Ridge and Laurel Mountain.

The Mellon family entered the farming business. Although he appreciated working the land, Thomas Mellon had more ambitious plans. He studied law, sat on a judge's bench and established the first national banking system in the region, T.A. Mellon and Sons in Pittsburgh. Mellon also wisely invested in various real estate and business ventures throughout his career, along with his sons and their progeny, and his family would eventually become one of the most wealthy and influential in Pittsburgh. Idlewild Park grew out of one of those early opportunities.

The Ligonier Valley Rail Road

The post–Civil War Reconstruction period spurred an industrial and transportation boom in the United States, Western Pennsylvania included. Pittsburgh's steel mills churned out tons of material that built America, fed by native ore from the surrounding region. The railroad industry exploded with the building and expansion of lines throughout the North and the South. Yet by the 1870s, no efficient way existed to transport native products—coal, coke, stone and timber—out of the fertile Ligonier Valley, located about fifty miles southeast of Pittsburgh.

Civic and business leaders tried for twenty-five years to establish a short line railroad between Ligonier and the city of Latrobe, about ten miles west, seeking to connect the isolated rural town to the Pennsylvania Railroad, which bypassed it in 1852. The Latrobe and Ligonier Rail Road Company was first chartered on April 15, 1853. Over the next several decades, its incorporators pursued the needed rights-of-way, repeatedly renewed the charter and graded a majority of the route but never completed the line. The company went bankrupt in the Panic of 1873, which again forced the railroad project to a halt.

Still, the town pressed for a local railroad. In early 1877, stockholders of the renamed Ligonier Valley Rail Road Company approached Thomas Mellon with the idea of investing in and completing the line. The judge initially hesitated, unsure of the line's profitability. His nine-year-old grandson, William Larimer Mellon, conducted a traffic study of the existing stone turnpike that indicated few people or native products were currently traveling in and out of the valley. However, Judge Mellon's sons convinced the banking magnate that a railroad to Ligonier would be a solid investment. He accepted an offer of four-fifths of the capital stock of $100,000 plus the mortgage and set out to complete the economical narrow-gauge railroad to Ligonier. Mellon believed this would be a good experience for sons Thomas, James, Andrew and Richard, each of whom dedicated himself to a different role in this new family business.[3]

Decent wages and cold kegs of beer spurred the Mellons' workers to finish laying the railroad track; they completed the entire project, from initial grading to final equipment purchases, within two months, way ahead of the six-month deadline.[4] The Ligonier Valley Rail Road went into service by the end of 1877, with its official opening held on December 15. This new transportation boosted industry throughout the Ligonier Valley. Trains hauled products such as stone, timber, lumber, paper, brick, ice, produce and livestock through the Loyalhanna Gap along the original 10.6-mile line that met the Pennsylvania Railroad junction at Latrobe. Coal mines, coke ovens, brickworks and other factories sprung up along the route. A six-mile branch into the coal fields north of Ligonier was later added, out of which came high-quality coal from the famed Pittsburgh seam that fed numerous beehive coke ovens in the valley. Next came people.

The Right and Privilege

Although the Ligonier Valley Rail Road never made huge profits during its lifetime, it did generate a respectable freight business, hauling native and manufactured products out of the Ligonier Valley and into wider commerce via the Pennsylvania Railroad. However, an opportunity also existed for passenger business not only from local residents traveling to and from Latrobe but also from city folk looking to escape the pollution of Pittsburgh into the clean air of the country—into the same valley that impressed Judge Mellon when he arrived in America as a five-year-old boy.

Within the first six months of the railroad's life, the Mellon family conceived a way to boost passenger business along the line: a picnic grove advertised to attract visitors and tourists to the beautiful scenery of the Ligonier Valley. It would also serve as a retreat for the Mellons' friends and family visiting from Pittsburgh. Perhaps induced by son Richard, Judge Mellon pursued the acquisition of land for this endeavor.[5]

The perfect picnic spot was a tenanted farm that lay along the railroad right-of-way about three miles west of Ligonier and seven miles east of Latrobe. The fan-shaped tract of land[6] was secluded among forested mountains and had a freshwater source: the Loyalhanna Creek, fed by nearby Four Mile Run. The property was covered by stately oak and chestnut trees. It was also located along the contemporary main routes through the Ligonier Valley: the Stoystown and Greensburg Turnpike[7] and, of course, the Ligonier Valley Rail Road, both of which sliced through the property.

The owner of the Muchmore farm was Mary Carson O'Hara Darlington, granddaughter of General James O'Hara, a notable quartermaster in the Revolutionary War, the first burgess of Pittsburgh and a successful businessman and landowner in Western Pennsylvania. Mary's husband was prominent Pittsburgh attorney William McCullough Darlington, and the two were equally avid historians.[8] The previous directors of the Ligonier Valley Rail Road negotiated a forty-foot right-of-way for the line through the Darlingtons' estate on September 21, 1872, so the two entities had a previous business relationship.[9] In early 1878, Thomas Mellon appealed to William Darlington for permission to use part of the couple's land for scenic picnic grounds. Darlington first balked at the judge's initial proposal, writing to Mellon from his Pittsburgh home, Guyasuta, on April 27, 1878:

> *Before I went to Ohio, over two weeks ago I called at your Bank more than once to see you with the same results you have met with in looking for me. I would suggest a writ of "mutual attachment" to bring the parties together. However, on Monday or Tuesday I will make an earnest endeavor to see you although I must say from the tenor of your "Form" of agreement and length of time mentioned in your note I fear we cannot come to an agreement. I had no idea you desired such a length of time—five years—or that you wanted any ground over the creek where I have twenty to thirty acres. I am inclined to be liberal toward your company but to tie myself for five years without recompense is entirely inadvisable.*

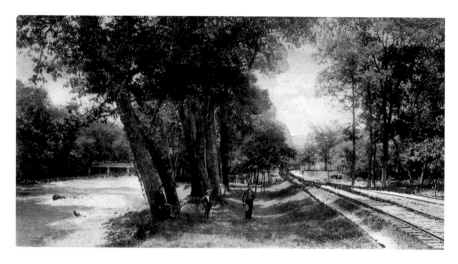

This postcard shows the original footprint of Idlewild Park between the Ligonier Valley Rail Road tracks and the Loyalhanna Creek. *Courtesy of the Latrobe Area Historical Society.*

Somehow Thomas Mellon convinced William Darlington to acquiesce to a lease—one with no initial rent, to boot—and the two men came to an agreement.[10] Darlington wrote the following letter to Mellon on May 1, 1878, settling the terms for use of the land and officially establishing Idlewild:

Dear Sir:

In compliance with your request, I will and do hereby agree to grant to the Ligonier Valley Railway Company the right and privilege to occupy for picnic purposes or pleasure grounds that portion of my land in Ligonier Township, Westmoreland County as follows—the strip or piece of ground lying between the railway and the creek and extending from the old cornfield to Byards run[11]—also two or three acres on the opposite or South Side of the creek adjoining or near the same. Without compensation in the shape of rent for three years from the first of April 1878 provided no timber or other trees are to be cut or injured—the under brush you may clear out if you wish to do so.[12]

Yours respectfully,
Wm. M. Darlington

The outlined area encompassed a roughly four-acre spread on the north side of the creek measuring about four hundred feet wide and a half mile

long,[13] plus the acreage across the Loyalhanna Creek. The agreement between Darlington and the Ligonier Valley Rail Road laid out stipulations that the Mellons and later owners of the park would generally follow while developing Idlewild throughout the nineteenth and twentieth centuries, namely restrictions on cutting trees on the property. "Build around the trees" was the maxim.

History of the Land

An epistolary handshake between the two men sanctioned the park, but Mary Darlington also played an important role as heiress of the future Idlewild property. Although her husband's name appeared on 1854 and 1879 surveys, it was Mary who legally owned the Ligonier Township estate. She inherited three tracts of land in Westmoreland County[14] that were part of twenty shares of unappropriated residual estate her grandfather, James O'Hara, bequeathed to his wife when he died in 1819. When Mary Carson O'Hara passed away in 1834, her will divided the twenty shares equally between her daughter Elizabeth O'Hara Denny and her grandchildren through son Richard Butler O'Hara: James, Elizabeth and Mary.[15] A series of deeds and transfer agreements divided this inheritance among the three grandchildren only; by 1850, Mary Darlington had received the rights to all of her grandfather's Westmoreland County property.[16]

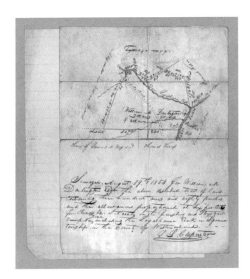

Left: This August 29, 1854 survey of the Darlington estate shows the future Idlewild Park located along the Stoystown and Greensburg Turnpike. Later, the Ligonier Valley Rail Road and Lincoln Highway also cut through the land. *From the Darlington Family Papers, 1753–1921, DAR.1925.01, Darlington Collection, courtesy of the Special Collections Department, University of Pittsburgh.*

Opposite: The first person to claim the land that would become Idlewild Park was "Shedrick Muchmore," according to the earliest survey of the property dated November 5, 1770. *From the Darlington Autograph Files, 1610–1914, DAR.1925.07, Darlington Collection, courtesy of the Special Collections Department, University of Pittsburgh.*

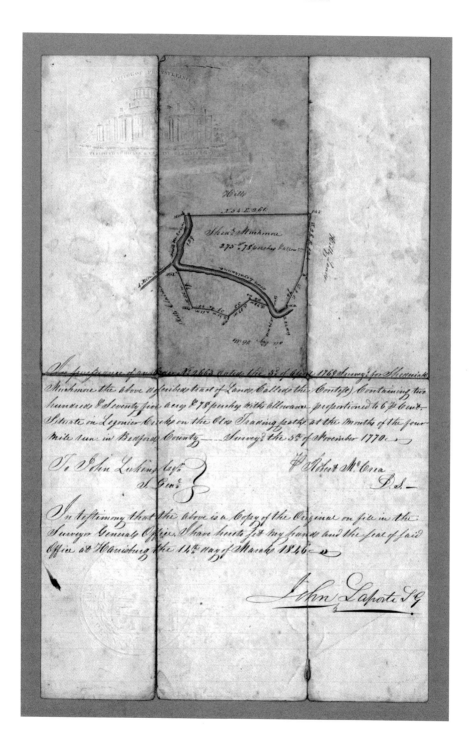

Land surveys and William Darlington's surviving diaries indicate that of the three parcels of land Mary Darlington owned, the one known as the Muchmore farm became the keystone of Idlewild Park. The issued patent, which Mary purchased in 1866, described the tract as follows:[17]

A certain tract of land, situate in Ligonier Township, Westmoreland County: Beginning at a hickory; thence by Hills, North fifty-four degrees, East two hundred and sixty-one perches to a Chestnut; thence by hilly lands, South twenty-six degrees, East one hundred and twenty-four perches to a white oak; South nine degrees, East seventy-four perches to a white oak; South twenty-four degrees, West nineteen perches to a walnut; North seventy-four degrees, West ten perches; South seventy-three degrees, West fifty-four perches to a white oak: South seventeen degrees, West fifty-five perches to a white oak; South seventy-five degrees, West thirty-nine perches to a white oak; South sixteen degrees, West forty perches to a post; thence by Kitts claim, North fifty-six degrees, West seventy-nine perches; thence down the creek, the several courses thereof to the place of beginning; Containing two hundred and seventy-five acres, seventy-eight perches, and allowance.

Land records for this property trace back to Pennsylvania's New Purchase.[18] A tract of land containing 275 acres and 78 perches named "The Contest" located "on Legonier Creeke on the old Trading path at the mouth of the four mile run in Bedford County"[19] was surveyed in the name of "Shedrick Muchmore" on November 5, 1770, after this man applied for a survey when the Pennsylvania Land Office opened on April 3, 1769.[20]

Who was this man? Family histories indicate that Shadrach Stephen Sharpen Muchmore[21] was born in Connecticut and lived in New Jersey and Carlisle, Pennsylvania, before relocating along the Ohio River in West Virginia about forty-five miles from Pittsburgh. Muchmore was a victim of Native American and colonial hostilities while sailing the Ohio River with three other men in 1775. A group of Native Americans ambushed their canoe, causing them to wreck. The collision threw Muchmore from the vessel; he hit his head on a rock, fracturing his skull. He was brought to Fort Pitt after the accident but died from his injury.

Muchmore's connection to the Ligonier Valley is obscure. Although it is certain he did not receive land in return for service during the French and Indian War, it remains unclear whether he served in that conflict. If he did, perhaps he had the chance to see the Ligonier Valley and decided to claim some land there afterward. He may have become interested in the land while

passing through when his family journeyed from Cumberland County to settle their land in West Virginia.

Although Muchmore first claimed the future Idlewild land, he lost his legal right to it to Major General Arthur St. Clair, an American Revolutionary War commander originally from Scotland who held prominent positions as civilian caretaker of Fort Ligonier, president of the Confederation Congress[22] and governor of the Northwest Territory.[23] St. Clair was also a land speculator who amassed—and lost—an enormous amount of property in Western Pennsylvania, particularly in the Ligonier Valley, where, bankrupt, he retired to in his later years before his death in 1818.

In April 1774, St. Clair brought an ejectment suit against the tenant in possession of the Muchmore property, Nathan Young. The Westmoreland County Court of Common Pleas continued the case several times, finally ruling in October 1779 in favor of St. Clair.[24] The Pennsylvania Board of Property returned Muchmore's survey to St. Clair on April 30, 1788, based on a separate application by neighboring property owner William Moore, the rights to which St. Clair purchased, as well as the county's verdict in the ejectment case. Although General St. Clair never advanced his application to receive full title by purchasing the patent, the commonwealth's decision at minimum gave him legal claim to Muchmore's land.

The Muchmore tract was a casualty of St. Clair's financial ruin toward the end of his life, despite his prestigious military and political careers and vast landholdings. The property was one of seven parcels of land that St. Clair was forced to put up for sheriff's sale in 1809 and 1810,[25] as he owed a debt to James O'Hara. During the Revolutionary War, St. Clair paid out of his own pocket to feed and clothe his men in the Second Pennsylvania, beyond what the U.S. Congress had appropriated for those troops. In need of more funds, St. Clair approached O'Hara for a loan to cover his expenses, fully expecting Congress to reimburse him, which it never did. Unfortunately, St. Clair was not able to pay off his debt with cash, so some of his landholdings went to sheriff's sale, only for O'Hara to purchase them. The Muchmore tract sold to O'Hara for $750 on December 29, 1809,[26] and passed after his death to his family, who continued to lease the farm to various tenants.

A later legal dispute over the property could have changed everything. In 1846, Arthur St. Clair's heirs filed an ejectment suit against the farm's current tenant, John Shale,[27] in the Westmoreland County Court of Common Pleas, believing that their family still owned the now 328-acre property. They argued that a separate tract of land called the Forge Tract, which had a similar description to the Muchmore farm, was actually sold twice in the

sheriff's sales, meaning that the Muchmore tract never sold. The plaintiffs were also heirs-in-law of Captain James Bayard and his wife—brother and sister-in-law of St. Clair's wife, Phoebe Bayard—who resided on the property at one time. The heirs further alleged that the land title became vested in Mrs. Bayard through a statute of limitations, as she allegedly lived there for at least twenty-one years. However, the jury sided with the defendant, holding up the premise that the Muchmore tract was sold to James O'Hara. The matter escalated to the state Supreme Court, which in December 1852 affirmed the prior county court ruling.[28] The property remained in the O'Hara family and passed to Mary Darlington.

George Washington Skirmished Here?

Idlewild Park can boast multiple military ties. In addition to claims by prominent military officers from Western Pennsylvania—James O'Hara and Arthur St. Clair—the park lies within a region significant during the French and Indian War (1754–63). Western Pennsylvania was a key battleground in this conflict, the North American part of a global struggle for dominance between Great Britain and France known as the Seven Years' War (1756–63).

The Ligonier Valley played an integral part in Great Britain's success in controlling the Ohio River waterway, which was the main travel and trade corridor to the West in the eighteenth century. General John Forbes's 1758 campaign to capture the French-held Fort Duquesne located at present-day Pittsburgh involved moving British and colonial troops along a strategic military road across the Pennsylvania wilderness. Fort Ligonier was the final supply post on that road, built only about three miles east of what would become Idlewild Park more than a century later.

Idlewild is reputed to be the setting for the famous friendly-fire incident that occurred on November 12, 1758, when a young Colonel George Washington nearly lost his life by jumping between two companies of the Virginia militia that collided at dusk near Fort Ligonier. The two contingents led by Washington and Lieutenant Colonel George Mercer fired on each other, mistaking their comrades for enemy French and Native Americans trying to ambush the fort. At great personal risk, Washington stepped within the rain of bullets when he realized the peril, batting his men's muskets away and calling for a cease-fire. The melee left nearly forty soldiers and officers missing or killed, but Washington escaped the same fate. The unfortunate

incident provided valuable intelligence from prisoners about the weakness of Fort Duquesne that led General Forbes to press on and the British and colonial troops to reclaim the abandoned fort from the French.

According to Washington's own writings,[29] the harrowing incident happened about two miles from the post at Loyalhanna (Fort Ligonier), probably near the Forbes Road junction with Four Mile Run,[30] although the exact location remains undiscovered at the time of this publication. Idlewild Park is about three miles from Ligonier and lies outside the route of the Forbes Road, which generally followed today's Youngstown Ridge Road south of the park—thus it's beyond the scope of the possible locations for the skirmish. Still, if not within the strict boundaries of the park, this incident, which could have changed the course of American history if Washington had been killed, occurred *near* Idlewild. The proximity of this historic event was just too good not to use in marketing literature to promote Idlewild Park—a 1932 promotional brochure claims that it was here at Idlewild where Colonel Washington had his narrowest escape from death.

"Idle" "Wild"

By August 1878, the press was calling the Ligonier Valley Rail Road's picnic grounds in Ligonier by the lovely name of "Idlewild." Variants included Idlewild Park and Idlewild Parks. How did the name Idlewild originate? Did the land inspire visitors to take time to be "idle" and enjoy the "wild" scenery of the Laurel Highlands? Who named the grounds—the Darlingtons or the Mellons? The most likely scenario is that the Mellons selected this name specifically for the park. Neither of William Darlington's commissioned surveys of the property includes the name Idlewild. Although he referred to the park as Idlewild at least once in surviving volumes of his personal diaries, Darlington tended to call the land in Ligonier that he occasionally visited the Muchmore Tract or the Muchmore farm.

The inspiration may have come from author, poet and editor Nathanial Parker Willis's estate on the Hudson River near Tarrytown, New York, called Idlewild. Author and historian John Newton Boucher claimed in *Old and New Westmoreland* (1918) that the name for the famous picnic grounds came from this source. Now a literary footnote, N.P. Willis was once a very popular writer in America during the latter 1800s, known for his informal, sentimental travel writing and impressions of country life. Excerpts from

Willis's book *Out Doors at Idlewild* (1860) appeared in local newspapers, including the *Pittsburgh Gazette,* as did his sketches describing the ongoing work at his estate, so it is possible that Judge Mellon or his sons could have seen this name in the newspaper.

"Idlewild" was not an uncommon name and evoked romantic images for transportation, products, resorts and homes in the nineteenth century and later. New York's John F. Kennedy International Airport began service as the Idlewild Airport. A parlor car and an excursion steamboat that eventually became the *Belle of Louisville* also boasted the same name. The moniker also identified a type of fine-cut tobacco and a brand of Kentucky flour. Idlewild was the name of an 1870s boardinghouse located on Lehigh Mountain in central Pennsylvania, as well as another resort in Media, Pennsylvania. Ligonier's Idlewild was not the only park or amusement area with this name; there were Idlewilds in Sharon, Pennsylvania, and Newark, Ohio; a community park of the same name in Reno, Nevada; and a pre–Civil Rights Act black vacation resort in Michigan.

No matter its source, "Idlewild" was clearly a fitting description for the Mellons' picnic grove, which was covered in thick maples, oaks, chestnuts, ashes, rhododendron and wild mountain laurel. The *Evening Press* of July 19, 1886, described the park like so:

> *To the lover of the romantic in nature, there are few spots in Westmoreland County more beautiful than the grounds known as Idlewild. "Wild," because set in between towering, thickly wooded hills, forming part of Chestnut Ridge, and adorned with all the beauties of the wild forest. "Idle," because the shadows woo one to rest, and because the spirit of the woods soon takes possession of the visitors and business cares are forgotten. One who has never tried it cannot guess of the tonic, exhilarating effects of a day in the pure mountain air.*

The Smallest Depot

By 1880, newspaper schedules included Idlewild as a station along the Ligonier Valley Rail Road's daily passenger trips between Ligonier and Latrobe. The company naturally added a seasonal stop at Idlewild Park—a flag stop at minimum—to unload visitors arriving for group picnics or camp meetings. An enclosed depot was at some point built at the Idlewild

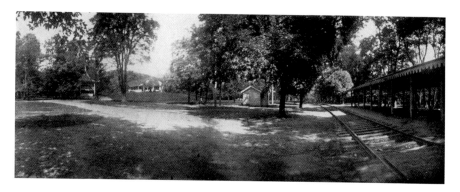

This east-looking view at Idlewild shows the tiny railroad depot in comparison with a covered shelter and the Auditorium and bandstand on the hill. *From the Pennsylvania Railroad's 1902 Idlewild brochure, courtesy of the Detre Library and Archives Division, Senator John Heinz History Center, Pittsburgh, Pennsylvania.*

station. The building is believed to have been erected the same year that the park was established, in 1878, although no financial statements, blueprints or company minutes documenting the building of this structure have been located.[31]

The Ligonier Valley Rail Road probably erected an enclosed depot at least by 1884, as William Larimer Mellon, the judge's grandson, remembered serving as the station agent at Idlewild for that summer in his memoir, *Judge Mellon's Sons*. At sixteen years old, Mellon sold tickets, handled baggage and received telegraph messages. He would not have made those types of business transactions in the open air, so by 1884, the Idlewild station must have consisted of something more permanent than a mere platform or shelter.[32]

Originally measuring only 10.5 feet by 20 feet, by Robert Ripley's standards the one-story wood clapboard structure may have qualified as the smallest full-service train depot in the United States.[33] Despite its size, the compact building contained a waiting room, space for a ticket agent and a telegraph operator and a freight and express office. The building's scalloped fascia hanging below the roof eaves indicates that it is an original Ligonier Valley Rail Road construction.[34] The station originally sat on the creek side of the railroad tracks with an adjacent open-air shelter for more passengers waiting to board a homebound train. In later years, the depot shifted to the north side of the tracks with a bay window added to the front and the neighboring shelter replaced by a larger structure farther west.

First Groups at Idlewild

Idlewild's small depot welcomed many organized groups to the park for excursions that boosted passenger business on the Ligonier Valley Rail Road. As early as 1879, the company advertised reduced rates to excursion parties traveling on its line and free use of the picnic grounds. Folks interested in arranging a day trip could contact Richard Beatty Mellon, the first manager of Idlewild Park.[35]

The first reported groups at Idlewild included religious camp meetings and military encampments. The church meetings could last for several weeks, such as a Free Methodist camp scheduled from July 28 through August 8, 1881, that attracted thousands of attendees. Folks who did not lodge at hotels or private homes in town rented individual tents and camped on site. Services proceeded beneath a larger tent set up at the park. Other religious groups that met at Idlewild included the Evangelicals and a German sect called the Albrights.[36]

Notable military camps included one formally beginning on July 17, 1886, when the Fourteenth Regiment, the Eighteenth Regiment and Battery B of the National Guard of Pennsylvania participated in an encampment on both sides of the Loyalhanna Creek. Pennsylvania's then governor, Robert E. Pattison, inspected the troops that week. A large number of civilians—including many women—rode special trains from Pittsburgh to attend religious services and watch dress parades, regimental drills and mock battles at the encampment. Four trains brought thirty carloads of people on July 18 alone.

One battle reenactment ended in a humorous moment. The Fourteenth Regiment started to attack the deserted camp of Battery B, a move that alarmed the Eighteenth Regiment, which opened fire. Captain Speer of the Fourteenth glanced back at the scuffle as he ran across the suspension bridge spanning the Loyalhanna, straight into Lieutenant Shepperd of Battery B, who was watching his contingent's guns fire back at the Fourteenth as he himself was running at full speed. The *Pittsburgh Daily Post* of July 24, 1886, described their encounter:

> *Neither of the officers hurrying to their commands saw the other. There was a meeting, both men rebounded from the shock and rolled off the bridge into the mud and lay there for several seconds. They were surprised and shaken up, but not badly hurt.*

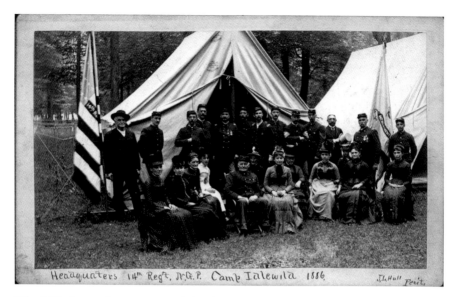

Idlewild Park served as campgrounds for church groups and the military in its early days. This photograph, which shows the Fourteenth Pennsylvania Regiment at Idlewild in July 1886, may be one of the earliest photos of the park in existence. *Used with permission from the Eberly Family Special Collections Library, Penn State University Libraries. "14th Pennsylvania National Guard Regt. Headquarters, Camp Idlewild, 1886." James A. Beaver Papers, HCLA 1433. Historical Collections and Labor Archives, Special Collections Library, Penn State University Libraries.*

The Fourteenth Regiment returned for a second encampment at Idlewild in August 1889. The Duquesne Greys of Pittsburgh, a contingent known as the "Heavies," also camped at Idlewild for two weeks in August 1886, attracting many visitors who took advantage of a special one-dollar excursion rate from Pittsburgh offered by the Pennsylvania Railroad. More than 1,200 people, primarily urbanites, visited on the first Sunday of the Duquesne Greys' encampment. News of the Pennsylvania military camps at Idlewild helped publicize the new picnic grounds.

Early Development

Idlewild's original footprint was much smaller than the amusement park we know today, but the Mellons had managed to squeeze in several conveniences for picnickers by the mid-1880s. Use of these facilities, like general access to the park, was free. The agreement between William Darlington and Thomas Mellon limited the Ligonier Valley Rail Road to

using a narrow strip of land between the railroad tracks and the Loyalhanna Creek plus a few acres on the south side of the creek. The north side of the park encompassed an approximately four-acre area[37] stretching west from an unnamed tributary originating along Clark Hollow Road (Bayard's Run in Darlington's letter) to probably somewhere in the vicinity of today's Lake Bouquet.

The Mellons developed this space as early as 1878. One of the earliest gatherings at Idlewild that summer—a basket picnic and harvest home on August 8—made a great impression on several couples who made the trek from Greensburg and had a "boss" time, enjoying dancing, croquet and boating on the Loyalhanna Creek. Excluding the railroad depot, the earliest structure erected at the park was a "commodious Covered Platform for dancing," added by the summer of 1879. Dancing was a common pastime at Idlewild from its inception, and evening socials filled the eighty- by one-hundred-foot pavilion long into the night. Richard Beatty Mellon kindly placed lanterns around the platform to light the way for merrymakers dancing to the Latrobe String Band at a basket picnic on August 8, 1879, for a Masonic chapter from Latrobe. A few days later, about twenty-five couples from Latrobe enjoyed a nighttime picnic and dance that lasted past 1:00 a.m.

By 1885, Idlewild's other amenities included a dining hall with kitchen and a ladies' waiting room. The park's first refreshment stand was reported in 1886.[38] Guests could also boat and fish in the Loyalhanna Creek, crossing an iron suspension bridge to the south side of the park, the site of the religious and military camps. Mountain laurel and rhododendron thickets covered the wooded southern portion of Idlewild Park, along with rustic seats, swings and a baseball diamond added in 1885. A new wooden bridge replaced the original wire span in August 1884; the new bridge was a little sturdier for foot traffic. Today's bridge is far removed from the first one—the structure was replaced multiple times over the park's history, sometimes after heavy rains caused flooding that washed out the arch.[39]

With no park-wide electricity, as the sun went down picnickers packed up their baskets, boarded the train and headed home. One early experiment to bring light to Idlewild for night meetings failed but sparked an interesting anecdote. In 1887, the Westmoreland and Cambria Gas Company constructed a pipeline between the Cambria Iron Company works in Johnstown and a 2,500-foot natural gas well in Grapeville. A one-inch pipe ran about 1,000 feet from the main line to the Idlewild Park entrance, from

The pavilion in the foreground of this 1891 Latrobe View Company photograph shows how diligently the railroad avoided cutting any trees—the builders constructed the roof overhang around an existing trunk. *Courtesy of the Ligonier Valley Historical Society.*

which smaller ¾-inch branches spread out in all directions, running 15 feet into the air at about one hundred places throughout the park. A relatively small amount of gas distributed into the branches created a five-foot flame of light at each of the spots. During a religious service one evening, the control valve broke, releasing a full 280 pounds of gas pressure through the small pipes. Monongahela's *Daily Republican* of March 22, 1887, detailed the unfortunate result:

> *Its force blew out the flames instantly, and from each of the hundred pipes, which a moment before had spread a mellow light over the worshippers, there came a sound that resembled the shrill notes of a factory whistle more than anything else. Nothing could be done before morning. The* [nearby] *cottagers* [in the village of Darlington] *were afraid to light candles or lamps, because, for all they knew, their houses were filled with the gas, and a speck of fire might cause an*

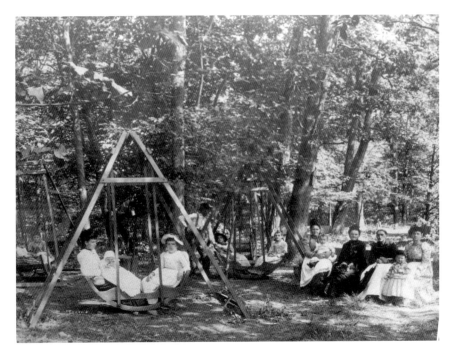

Rustic swings were some of the early amusements at Idlewild Park. *Courtesy of Ramada Inn, Ligonier.*

explosion; they could not talk to each other without shouting themselves hoarse; could not sleep for the infernal noise on every side, and on the whole, the night was most miserable.

A Popular Picnic Spot

The business venture that Judge Thomas Mellon almost declined was a smart investment that ultimately benefited from the addition of Idlewild Park. By establishing a scenic picnic grove accessible from a main railroad artery—the Pennsylvania Railroad—the Ligonier Valley Rail Road enticed more people from Pittsburgh and other cities and towns to spend a day away from the smoke, grime and daily routines of the city. Many recreational parks in Western Pennsylvania were "trolley parks"—picnic areas created or expanded to generate passenger business on electric streetcar lines. Examples include Kennywood Park in West Mifflin

(Monongahela Street Railway Company), Eldora Park near Charleroi (Pittsburgh Railways Company), Olympia Park near McKeesport (West Penn Railway Company) and the nearby Woodlawn Park in Latrobe and Oakford Park in Jeannette (both West Penn Railway Company). However, trolleys did not bring picnickers to Idlewild Park—passengers rode the iron horse.

From its beginning, Idlewild Park was a popular destination that generated decent business for the Ligonier Valley Rail Road. In 1878, the total passenger count on the short line railroad was just under 13,000. By 1880, the count had jumped to 34,461, and by 1884, when William Larimer Mellon manned the Idlewild depot, it hovered around 39,000.[40] "Idlewild was a very busy and important place," according to Ligonier Valley Rail Road historian Jim Aldridge. "In the few reports that give a monthly breakdown, there is a significant increase in traffic in the summer months. Some of this would have been travel to Ligonier, but much would have been Idlewild traffic."

In addition to the military encampments and church meetings, much of the Idlewild traffic consisted of other group excursions. For all, the use of the picnic ground and its facilities was free. Churches, schools, civic organizations and fraternal clubs around Western Pennsylvania hosted annual basket picnics for members and their families at Idlewild. Companies did the same for their employees. Families held reunions at the park as well, including the Mellons themselves, who had fifty members gather at Idlewild on May 28, 1898. Idlewild was crowded on holidays—the Fourth of July in particular, as that day was traditionally reserved by Latrobe's Holy Family Church for its annual picnic. The church's 1885 picnic attracted "the largest number of people that was ever moved over the [rail]road in one day,"[41] and that number kept rising yearly. According to the *Ligonier Echo* of July 10, 1889, "Scores of people came flocking to the park like the spokes in the hub of a bicycle wheel. Trainload after trainload rolled in and swelled the crowd to almost countless numbers."

The Ligonier Valley Rail Road handled the increased business in turn. Besides offering reduced rates for excursions, the company added Idlewild Park to its timetables[42] and scheduled hourly trains to accommodate the traffic. In 1880, the railroad expanded service to Sundays, which boosted business but also caused a backlash from some citizens who believed that running trains on the Sabbath was "in opposition to the laws of God."[43] In 1888, the company purchased a new Baldwin locomotive dubbed "Idlewild" specifically to pull long trains of passenger cars for park excursions. As early as 1887, the Pennsylvania Railroad offered low rates for round-trip

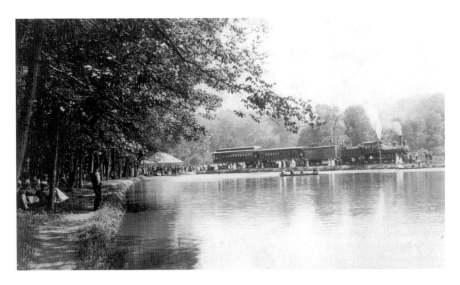

Similar to trolley parks throughout Western Pennsylvania, Idlewild began as a picnic grounds to boost passenger business along the Ligonier Valley Rail Road. *Courtesy of the Ligonier Valley Rail Road Association.*

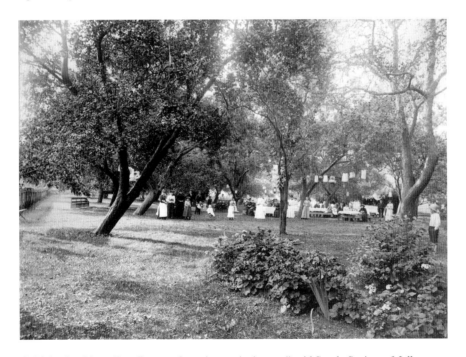

"I think what [the railroad] wanted was just a picnic spot," said Sandy Springer Mellon. The picnickers in this 1891 Latrobe View Company photograph are taking advantage of the rustic tables and seats sprinkled around Idlewild Park. *Courtesy of the Ligonier Valley Historical Society.*

excursions to Idlewild and ran special trains straight to the grounds. When the Ligonier Valley Rail Road converted its track from narrow gauge to standard gauge in 1882, direct trips to the park became possible.

In 1881, the Ligonier Valley Rail Road hired George Senft. As superintendent of the line, he would be involved in the management of Idlewild Park and its upkeep and development,[44] along with Robert Sloan, who was named as the park's overseer in 1889. Within its first decade of operation, Idlewild Park built a glowing reputation and was attracting Pittsburgh-based groups that had previously picnicked at other locations such as Aliquippa Park.[45] In 1889, the *Ligonier Echo* pronounced Idlewild as "the most popular picnic ground in western Pennsylvania," as well as "the most popular resort in this country." This praise perhaps prompted the Mellons and the Ligonier Valley Rail Road Company to develop the park within the next two years.

NEW IDLEWILD

Maybe Idlewild and its story is an old one to you, for you may be one of the hundreds of thousands who know it and love it so well. But whether you are or not, the Idlewild of the end-of-the-century will be a revelation. This queen of picnic grounds has neither stood still nor gone backward, but has been forever improving and taking on new beauties. Today Idlewild is near to perfection.
—Idlewild: A Story of a Mountain Park *(1900)*

After its first decade in business, Idlewild Park earned a reputation as "one of the leading picnic grounds of Western Pennsylvania."[46] Trains crammed full of people debarked at the park's petite station on a daily basis, especially during large group picnics and holidays. Boys reportedly covered the roofs of the passenger coaches pulling into the park for the Fourth of July in 1890, as the trains were so crowded that the conductors could not even collect tickets.[47] Idlewild Park's summer schedule quickly filled with dates for churches, secular and Sunday schools, societies, lodges and companies that claimed their day for a basket picnic. The Pennsylvania Railroad carried thirty thousand folks to Idlewild during the 1890 season, mostly Pittsburghers, and projected double that number for the next year, with fifty excursion dates booked.[48] Business was booming.

The railroad probably needed more space to accommodate the increasing number of picnickers coming to Idlewild for fresh air and sunshine. Hints of a

new agreement between the Ligonier Valley Rail Road and the Darlingtons cropped up in the summer of 1890. On June 6, O'Hara Darlington (William and Mary's son) met with "Mellon and Brandon about Ligonier Farm," according to his diary entry from that day.[49] In July, timber rights on the Darlingtons' estate given to A.W. Brandon only one month before were transferred to Richard Beatty Mellon.[50]

Reports came of picnic activity on the north side of the railroad tracks, which had been previously off limits, and by fall 1890, extensive work on the grounds was in progress for the next season. With the permission of the Darlingtons, from whom they continued to lease the grounds,[51] Ligonier Valley Rail Road management began gradually expanding Idlewild Park beyond its original borders.

Growth in the Gay Nineties

The Gay Nineties marked such a dramatic period of growth that the newspapers dubbed the mountain park "New Idlewild." The year 1891 was a banner one in particular. Management reportedly spent more than $15,000 on all the improvements for that season, which included a new dancing pavilion, dining hall, merry-go-round and man-made lake—all possible with the Darlingtons' permission to develop the park north of the railroad track and the efforts of Superintendent George Senft to arrange the work.

A new dancing pavilion called the "Auditorium" crowned the hill north of the train station. The approximately sixty-six- by one-hundred-foot covered post-and-beam building contained a spacious dance floor, sounding board and three rows of seats on each side. The Auditorium's stage hid a coatroom beneath that was accessible from the outside, possibly added during a later improvement. The pavilion sat at the top of a natural amphitheater: a sloping hill estimated to accommodate twenty thousand picnickers. For several years, a large windmill also stood at the northern end of the Auditorium, although it's unknown if the windmill was added in 1891 or later. At the time, the Auditorium stood as one of the largest dancing pavilions in Pennsylvania.[52]

A pathway heading west from the Auditorium led to a new dining hall also built for the 1891 season. This roughly 40- by 151-foot structure was equipped with a 16- by 32-foot kitchen that contained iron sinks and ranges supplied by spring water and natural gas. An artesian well at the rear serviced

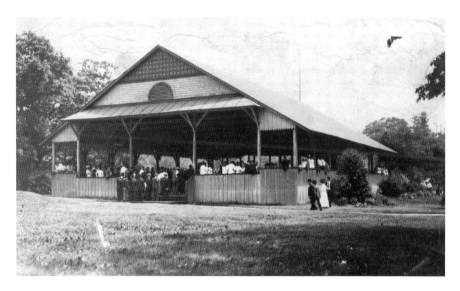

This undated view of the 1891 Auditorium, one of Idlewild's oldest buildings, shows the northern side of the dancing pavilion. *Courtesy of the Latrobe Area Historical Society.*

the facility, dug by the Wilkinsburg-based Pennsylvania Drilling Company. Numerous tables filling the dining hall held at least seven hundred and maybe as many as one thousand people at a time. Senft ordered a light one-horse wagon from the Farmer's Handy Wagon Company to transport baskets and refreshments from arriving trains to the dining room—a novel and practical idea. The railroad improved the dining hall sometime after the turn of the century with a concrete foundation and posts, as well as painted pipe fencing and handrails.

"Mammoth" shelter sheds interspersed throughout the groves and along the creek protected picnickers from the rain and gave them shady spots to spread open their baskets. Benches and picnic tables placed around the park offered even more seating, while springs and hydrants provided drinking water. The railroad also built up the athletic areas, creating a thirty-acre sporting field in 1891 with a new baseball park, tennis courts, croquet grounds and rifle ranges.[53]

The existing superintendent's home was converted into a woman's cottage, or ladies' waiting room, that gave women privacy during their visit to the park. The building offered chairs and lounges, a mirrored dressing room, lavatories and an infirmary—all managed by a matron. Clara McDowell served that post in 1898. A music pavilion also called the Bandstand was built in 1892 just southwest of the Auditorium. The two-story structure had

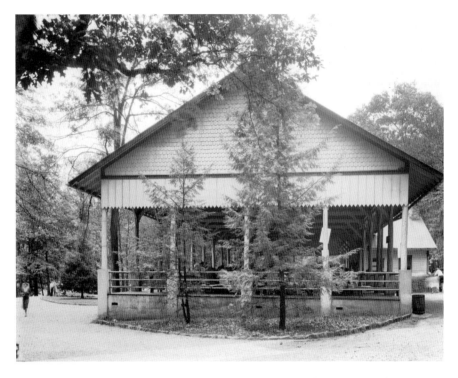

As part of its 1891 expansion, the Ligonier Valley Rail Road built a new large dining hall with kitchen, seen here in the 1920s. *Courtesy of the Pennsylvania Room, Ligonier Valley Library.*

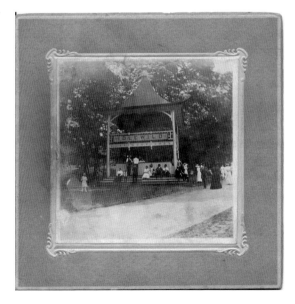

Idlewild's two-story bandstand, seen here in 1914, hosted lectures above and contained a package room below. *Courtesy of the Pennsylvania Room, Ligonier Valley Library.*

an observation deck covered by a pagoda-style roof and a package room below. The Ligonier Valley Rail Road continued to use the older dancing pavilion and dining hall located along the creek, as secondary venues, as neither accommodated as many people as their larger counterparts.

Improvements at Idlewild did not just include buildings, rides and attractions; the Ligonier Valley Rail Road also focused on maintaining the park's natural beauty. The landscape and topography were its chief attributes, and so management enhanced the region's unique features—the surrounding ridges, vibrant trees and the Loyalhanna Creek—by planting shrubs and flowers around the park where needed.

The Merry-Go-Round

In its early days, Idlewild offered swings and sports for its guests, but the park was more than a decade old when it got its first amusement device: a merry-go-round. Multiple newspaper accounts of group picnics mention a merry-go-round or similar type of device at Idlewild as early as 1889,[54] but Idlewild's first merry-go-round affiliated with a known proprietor debuted for the 1891 season. Ligonier Valley Rail Road superintendent George Senft signed a lease with retired oilman Moses Buffum Parsons of Ligonier for a space in the park on which he would operate a "steam riding gallery" for no fewer than fifty-six persons. Parsons's rent was 50 percent of the daily gross receipts, and he was responsible for maintaining rider safety as well as monitoring his employees' behavior.[55]

The revenue that the merry-go-round generated was apparently satisfactory enough for Senft to arrange a new contract for 1892 with a surety and continue a business relationship with Parsons that included a two-year agreement covering the 1895 season.[56] Parsons's apparatus was very popular during its short stay at Idlewild; young and old alike crowded the merry-go-round at the 1894 Lutheran picnic, and the ride did a "booming" business during the 1895 Ligonier Valley Reunion—"there being a rush for horses from morning until night."[57] At two rides per nickel, no wonder the amusement was so successful.[58] The German organ that provided the music for the amusement could be heard at local hotels in the offseason like the National Hotel and the Hotel Loyalhanna in Ligonier.[59]

Parsons's concession only operated through the 1895 season until a "new and larger merry-go-round" replaced it.[60] Senft corresponded that spring

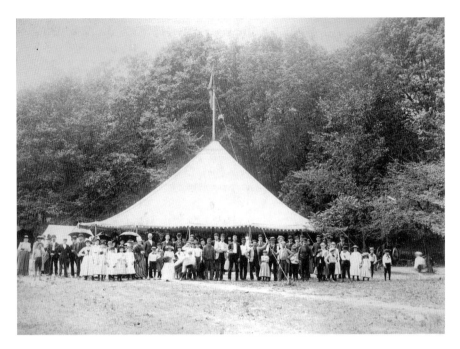

One horse barely appears through the crowd of dapper picnickers obscuring an early merry-go-round at Idlewild Park in this 1891 Latrobe View Company photograph. *Courtesy of the Ligonier Valley Historical Society.*

with Theodore M. Harton, co-founder of West View Park in Pittsburgh. Harton was also a leading builder and operator of various park amusements such as roller coasters, scenic railways and carousels. Senft's letter to Harton indicated that the latter inquired about installing a roller coaster and merry-go-round at Idlewild Park. Of course, Senft had already let the merry-go-round privilege to Parsons and he had no interest in adding a coaster, but he suggested that Harton write him again in the fall.[61]

By the end of that year, however, Senft and Harton were in negotiations to bring a new merry-go-round to Idlewild Park. Senft disagreed with the arrangement that Idlewild would bear half of the costs of labor and parts to operate the attraction and offered to take 45 percent of the gross receipts instead of 50 percent.[62] That deal was amenable to both parties, as the superintendent wrote to M.B. Parsons on Christmas Eve, informing him that "the privilege for operating a merry-go-round at Idlewild for the year 1896 has been let. You still have part of your merry-go-round on Idlewild premises which we desire that you remove at once." Parsons was out and Harton was in.[63]

A three-tiered octagonal pavilion with cupola was constructed from longleaf yellow pine to house the T.M. Harton merry-go-round[64] at Idlewild, one of the company's earliest, possibly its first.[65] Charles Dickson, longtime manager of the Harton merry-go-round at Idlewild, visited the park prior to its opening to set up the machine each season after a winter hiatus in R.M. Graham's warehouse.[66]

Sister Lakes

Continuing with widespread improvements for the 1891 season, the Ligonier Valley Rail Road dug the first of three man-made lakes at Idlewild. Lake St. Clair—the smallest of the trio at about four acres—was located on the north side of the train tracks just east of the Darlington station. The lake was appropriately named after General Arthur St. Clair, who formerly claimed the park property, as mentioned in the first chapter. Lake St. Clair accommodated a fleet of wooden rowboats, some purchased from the Truscott Boat Manufacturing Company of St. Joseph, Michigan, which gave boaters a more confined space than the Loyalhanna Creek. The lake also had a small boathouse on its eastern bank.

In 1896, the Ligonier Valley Rail Road added a second, larger lake across the railroad tracks from Lake St. Clair.[67] Lake Bouquet[68] contained three islands, the biggest one aptly named Flower Island with its beautiful blossoms, plants, trees and canals. The lake's namesake was Colonel Henry Bouquet, who led a decisive British victory over Native Americans in 1763 during Pontiac's War.[69]

Filled with bass, catfish and bluegills, Lake Bouquet also featured a shaded walking trail and bicycle path around its perimeter for summer visitors. During the winter, the frozen lake became an ice skating rink for locals. Picnickers could reach Flower Island by an iron suspension bridge often pictured on souvenir postcards and used for photo opportunities said to resemble "those over the lagoons at the World's Fair."[70] Senft ordered five gallons of black silica graphite paint for the new bridge, but it was later repainted white, perhaps to stand out against the verdant green of the nearby foliage. The island also had a hedge maze called "The Puzzle" planted toward the end of the century and, later, a flowerbed that spelled out "Idlewild." For Lake Bouquet's second year, Senft also ordered shrubs for the island plus water lilies from the Dingee and Conard Company. Other 1897 improvements

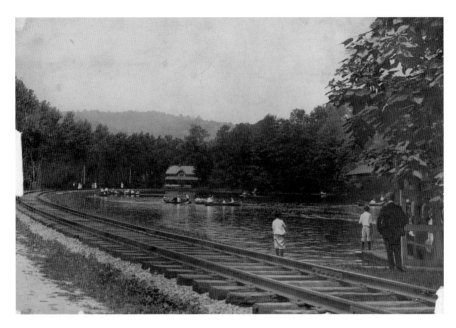

This westbound view of the Ligonier Valley Rail Road tracks along Lake St. Clair shows the Victorian-style Darlington station, where park visitors could purchase picnic fare. *Courtesy of the Idlewild and SoakZone Archives.*

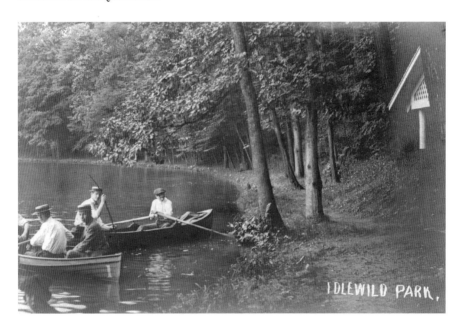

The always-popular rowboats operated at Idlewild Park for more than a century—in both wooden and aluminum forms. *From the Ray Kinsey Collection, courtesy of the Pennsylvania Room, Ligonier Valley Library.*

included increasing the lake's depth, adding minor islands and building a stone wall around the entire lake.

At around three feet deep and spanning about fourteen acres today,[71] Lake Bouquet provided more space for boating, so Senft explored purchasing additional vessels that visitors could ride for ten cents per trip, departing from a large boathouse stationed on the south side of Flower Island. He wrote to several boat companies requesting proposals for a twenty-five-foot launch that could be operated safely in the park, eventually sending a down payment to the Marine Vapor Engine Company of New Jersey for an alcohol or vapor launch, also called a naphtha launch.

Senft reported to the Marine Vapor Engine Company that its product gave the Ligonier Valley Rail Road Company "splendid satisfaction" with its adjustable speed. It carried about ten thousand passengers on ten-minute trips around Lake Bouquet during the 1896 season.[72] By the end of the next year, the railroad had ordered a second launch for Thomas A. Mellon to use in Florida, careful to have the awning only cover the cabin halfway as he planned to fish often.[73] The new launch eventually joined its older sibling in Lake Bouquet for the 1898 season.

The largest of Idlewild's three lakes, Lake Bouquet, featured Flower Island with boathouse, two vapor launches and swan boat. *Courtesy of the Idlewild and SoakZone Archives.*

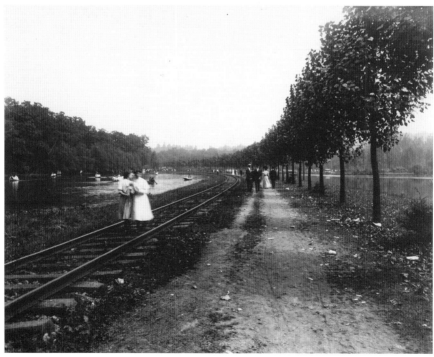

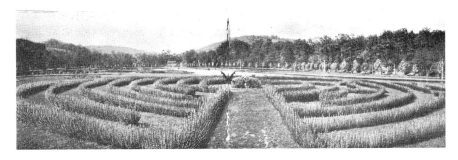

Above: A hedge maze called the Puzzle decorated Flower Island at the turn of the century. *From* Idlewild: A Story of a Mountain Park *(1900), author's collection.*

Opposite, top: An iron bridge led visitors across Lake Bouquet to Flower Island, covered with trees, plants and colorful flowerbeds. Shown are, *left to right*, Hubert Fitzgerald, Clara Yurt, Tom Powers, Ester Zigler and Edna Appel, posing for a photograph during a group date in 1921. *Courtesy of Robert Domenick and Jeff Domenick.*

Opposite, bottom: Trains bringing visitors to and from Idlewild passed between the park's twin lakes. Lake St. Clair *(left)* contained rowboats, while Lake Bouquet *(right)* featured a bicycle track and walking trail around its perimeter. *From the Thomas Baldridge Collection, courtesy of the Latrobe Area Historical Society.*

Senft also purchased a swan boat for Lake Bouquet—an amusement about as old as Idlewild Park itself. Robert Paget originally developed the foot-propelled catamaran for Boston's Public Garden lagoon in 1877. Inspired by the German opera *Lohengrin*, Paget placed large swans on either side of the driver, disguising the paddle-wheel pedal and the steering rudder. The open-air boat featured several rows of bench seats.

Believing the popular attraction would be a way to replace some of Idlewild's skiffs, Senft tracked down the American Swan Boat Company, the manufacturer and concessionaire of the swan boats that operated on the lower lake at Central Park in New York City. He arranged to purchase a twenty-four-foot-long boat with four benches and a canvas roof covering from the Brooklyn-based company and ship it via the Pennsylvania Railroad in time for the park's opening day. He wrote to company president Arnold Tisch on April 4 that he had "not the least doubt that when our general manager sees the boat in the water and sees its performance I [illegible] order a second if not a third."

However, just one swan boat proved to be a headache for Senft as he worked to procure new vessels for Lake Bouquet. What arrived at the beginning of May was not what he ordered. Although the American Swan Boat Company sent four seats and the correct size canopy, it incorrectly

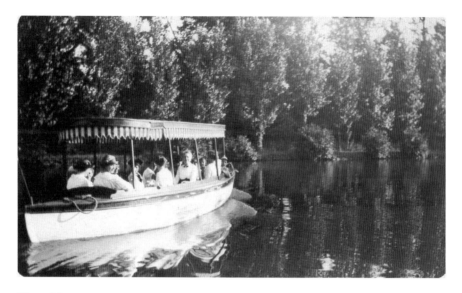

These folks are enjoying a leisurely ride on Lake Bouquet in one of Idlewild's two vapor launches. *Courtesy of the Latrobe Area Historical Society.*

sent a platform and boat for the smaller three-row model. Even worse, Senft found that "the swan is simply a second hand affair that has been patched up and repainted" and was not properly crated in transport. Senft refused to accept something for which he had not paid. "We are not buying second hand swans at any price," he wrote Tisch on May 9, informing him that he would be sending back the swan for a replacement. "I do not understand how you could allow such conduct or mistake to happen. It simply is bad business."

Senft sent back the unsatisfactory swan while his workers tried to convert the boat to a four-row vessel by lengthening the platform, but their attempts failed. Senft again pressed Tisch to make things right by sending Idlewild a new swan and a fifty-dollar refund for the difference in price between the three- and four-row models. Because of this mistake, Idlewild's new swan boat missed its grand debut on the park's season opening, which prompted an impatient and angry Senft to write Tisch again, telling him, "You perpetrated a fraud on us":

> *On May 30 was what we call opening day at Idlewild. It proved to be an exceedingly big day perhaps the biggest of the year—everything was in good shape except the swan boat and it caused a good deal of ugly*

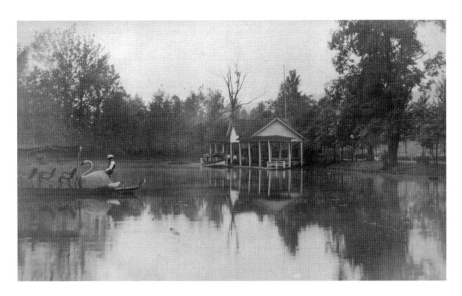

This postcard view shows Lake Bouquet's boathouse and the graceful swan boat purchased in 1896. *Courtesy of the Ligonier Valley Rail Road Association.*

comments....If you do not have things made right by Saturday next, I will go to Brooklyn to have matters squared.

The superintendent's bad luck continued. The replacement swan that arrived on June 3 was in bad shape and damaged in transit—its neck was crushed and it was dented and perforated with holes. Once again, Senft immediately wrote to Tisch: "Some article must have been placed on the head which bent it down to the neck and when straightened out the side of the neck broke....What are we going to do about it?" he asked Tisch.

Did George Senft make good on his threat to go to Brooklyn and settle the matter with Arnold Tisch face-to-face? Besides Senft's letter to the Pennsylvania Railroad notifying them of the situation and asking them to send the broken swan back for the replacement, the correspondence stops there. The American Swan Boat Company presumably sent a new swan, and the Ligonier Valley Rail Road conceded to a three-row boat, as publications, souvenir postcards and photographs show the graceful swan carrying passengers around Lake Bouquet.

Turn-of-the-Century Idlewild

Despite the swan disappointment, Idlewild's management felt that the improvements for the 1896 season pushed the picnic grove into a higher echelon. Senft boasted about the Ligonier park when he wrote to Frank P. Blackmore of Pittsburgh on April 29, 1897, concerning his organization's visit to Idlewild that year: "As far as my experience goes, Idlewild offers the best facilities of any picnic ground in the state and its natural beauty, conveniences and the fact that it is in mountains with good water make it possible to put in a good full day without being wearied."

Picnic excursions continued at Idlewild Park through the Victorian era, with patronage steadily growing in number and in geographic area every year. Almost 85,000 people visited Idlewild during the summer of 1891, with nearly 60,000 coming via the Pennsylvania Railroad and the rest carried by the Ligonier Valley Rail Road.[74] The number of PRR excursionists did, in fact, double from the 1890 season as predicted,[75] and group picnics included two big reunions of at least 12,000 people: the Lutheran and Reformed churches. George Senft wrote to a Philadelphia proprietor, telling him that the 1892 season saw "85 excursions carrying something over 100,000 people this season"—making up about half the Ligonier Valley Rail Road's overall passenger count for that entire year.[76] By 1896, the park was receiving 100,000 to 150,000 visitors from adjoining counties.[77] Idlewild was apparently becoming popular enough to spark allegations that the management was paying people to influence picnic business at the park—a rumor Senft immediately quashed in a June 2, 1897 letter to an unnamed critic:

> *Idlewild Parks is too well known and their popularity too great to require the bribing or buying of individuals to promote the picnic business and until Idlewild loses its hold on the public we will not get into that kind of business.*

On June 18, 1898, Idlewild welcomed the first picnic from west of Pittsburgh: an employee outing for the Standard Horse Nail Works in New Brighton. As such, that same year, the railroad built a new siding at Millbank, just east of Idlewild, to park trains bringing large crowds expected in the coming summer. By the close of the nineteenth century, the Ligonier Valley Rail Road had built Idlewild Park into a popular picnic grove able to attract visitors despite lacking the glittering lights, spectacular

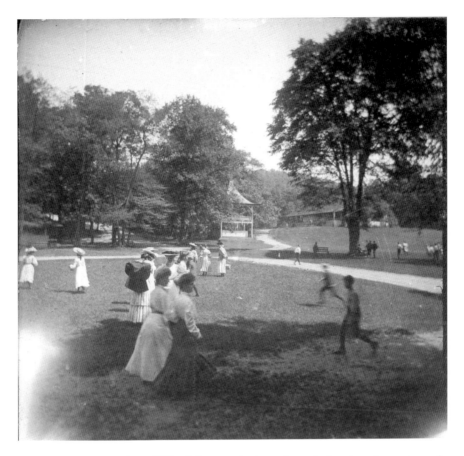

A turn-of-the-century view of Idlewild's expansive lawn shows the bandstand at center and the Auditorium at the top of the hill. Visitors dressed in their Sunday best for picnics at this lovely park. *Courtesy of the Latrobe Area Historical Society.*

entertainment and amusement rides that would soon become staples at exposition-type parks. The surrounding mountains, thick forests and flowing Loyalhanna Creek brought the crowds. As George Senft described in a June 8, 1897 letter to M of N picnic manager C.W. Erbeck, who was bringing his group back to the park that season:

> *There is a freshness—a naturalness about Idlewild that is not found elsewhere. The invigorating mountain air, freedom from all care, good water, shade and convenience that every man, woman and child ought to enjoy.*

Nonetheless, management believed that some additional upgrades were necessary to keep Idlewild fresh. In 1898, the park enlarged the Auditorium with an addition, making it one of the largest dancing pavilions in that region of Pennsylvania.[78] It now boasted a covered enclave on the south side with a carved lion head (artist unknown). The windmill departed the following year. The smaller dining hall and the ladies' cottage were also remodeled.

Additional concessions joined the boat rides and baggage check,[79] starting with a new refreshment house in 1898 containing a soda fountain managed by Frank Kibel, followed by another soft drink stand in 1913. Other concessions included weighing machines, button sales and a phonograph operator. The latter seems to have been a rotating position for different picnics; during the 1898 season, Archie McColly treated folks to music from his phonograph. Since at least 1891, the Ligonier Valley Rail Road also offered guests a photograph concession so they could leave with a souvenir of their visit to the pretty park.[80] Several different photographers were engaged to take visitors' pictures, from Mr. Shade of Latrobe to E.K. Zimmerman and longtime concessionaire Ignatius Grotzinger, a Ligonier man who primarily held the position from 1896 through 1910. By the end of the century, a tented tintype gallery was

Beautiful flowers and foliage covered Idlewild Park in its early days as a picnic grove, especially the aptly named Flower Island in the middle of Lake Bouquet, as seen in this undated postcard. *Courtesy of the Pennsylvania Room, Ligonier Valley Library.*

Left to right: Ester Zigler, Jack Florey and Edna Appel enjoy a refreshing drink from Idlewild's bluestone water fountain during a group date in 1921. *Courtesy of Robert Domenick and Jeff Domenic.*

located on the north side of the railroad tracks near the bridge crossing to Flower Island. Colorized and black-and-white souvenir postcards of Idlewild advertised the park's beauty, and visitors could also purchase trinkets stamped with "Idlewild," from ashtrays to decorative boxes, teacups and saucers.

The Ligonier Valley Rail Road periodically upgraded the landscaping throughout Idlewild Park, planting a line of hemlock shade trees along the border between lakes Bouquet and St. Clair in 1897, with another two hundred North Carolina poplars raised from cuttings added the next year.[81] Led by foreman William Stouffer, park workers added colorful flowerbeds, numerous shrubs and walking paths for the 1899 season. They planted new varieties of flowers throughout the grounds with the help of John Bohler of Latrobe, a diligent landscape florist and gardener originally from Germany who brought in plants from Pittsburgh. An eighty- by fifteen-foot hot-air conservatory built near the park for the 1900 season protected flowers and plants over the winter; a second greenhouse followed by the end of the year.

On the cusp of a new century, the Ligonier Valley Rail Road continued making improvements to Idlewild for the 1899 season, the biggest of which was the creation of a third man-made lake from a swampy area on the south side of the Loyalhanna Creek. Lake Woodland was the centerpiece of a wilder, more rustic section of the park called the Woodlands, located in the grove where the earlier religious meetings and military camps congregated. Lake Woodland did not offer boating, but the ten-acre, figure eight–shaped

lake had several islands and romantic walking paths for visitors to enjoy, shaded by tall virgin timber. Located adjacent to the park's baseball diamond, the Woodlands featured swings, rustic seats and tables.

The Ligonier Valley Rail Road used fine screenings of stone from the nearby Booth and Flinn quarry on the south side of the Loyalhanna gorge to lay walkways throughout the park. Booth and Flinn—or another nearby quarry like the Ligonier Block Stone Company on the north side of the gorge—may have provided the materials for a large four-sided water fountain "made out of fine blue rock stone" installed near the Auditorium in 1899 to quench picnickers' thirst.

PR and the PRR

The Pennsylvania Railroad bolstered much of the railroad traffic to Idlewild Park, bringing folks to and from Ligonier without having to transfer trains at Latrobe once the Ligonier Valley Rail Road converted from narrow gauge (36-inch) to standard gauge (56.5-inch) in 1882. The "Liggie" never became a branch line of the Pennsylvania Railroad, but the two entities had a genial business relationship concerning Idlewild.[82] Superintendent George Senft worked with Pennsylvania Railroad passenger agents, including Thomas Watt, who represented the line's western district, to schedule and promote group excursions to Idlewild for "churches, schools, lodges and other organizations."[83]

According to Robert Stutzman, co-founder of the modern-day Ligonier Valley Rail Road Association, "PRR specials hauled people from stations along its line as near as Greensburg and as far as Altoona. Stations in the Pittsburgh area were the most common origins." The Ligonier Valley Rail Road and the Pennsylvania Railroad arranged round trips to Idlewild from downtown Pittsburgh and surrounding communities including Shadyside, East Liberty, Homewood, Wilkinsburg, Edgewood and Swissvale, enticing burghers by offering special trains at reduced group rates. The Ligonier Valley Rail Road, in turn, received $0.15 for each passenger traveling via the Pennsylvania Railroad.[84] In 1889, the two companies negotiated a $0.50 round-trip rate to Idlewild for Pittsburgh-area churches and schools to help poorer folks who could not afford a $1.00 fare for a one-day excursion. For the 1899 season, passengers traveled round-trip for $0.75. Groups of two hundred or more could lock in special rates for the 1900 season that ranged

between $0.60 and $1.20, depending on the point of origin, with half fares also available.

The Ligonier Valley Rail Road and the Pennsylvania Railroad also collaborated on promotional literature highlighting photographs of Idlewild's most scenic spots alongside train schedules and ticket rates. The descriptions inside waxed poetic, even quoting William Shakespeare and Edward Dyer to emphasize the beauty of Idlewild's woodlands, its natural resources and the comforts added by Ligonier Valley Rail Road management that could be found within, as noted in an 1897 Pennsylvania Railroad Company park brochure:

> *The scene which here greets the eye is one of great beauty and grandeur. Lawns of living green, broken by island-dotted lakes; flower-perfumed bowers amid pristine forests; the infant river and dashing mountain streams with their silvery waters; sloping hillsides, robed in nature's fairest garments, with springs of crystal water gushing from their bases, are but a few of the infinite beauties which the Creator has showered upon IDLEWILD. Above and around all the forest-clad mountains raise their towering heads to shut out the grime and smoke of the distant towns and cities and preserve its perfect atmosphere.*

In addition to the Pennsylvania Railroad, the Ligonier Valley Rail Road also worked with the Pittsburgh, Westmoreland and Somerset Railroad, a short-lived logging railroad (1899–1916) that connected at the eastern terminus in Ligonier. Although its founders conceived the PW&S to transport timber from Laurel Hill to the Byers-Allen Lumber Company in Ligonier, the railroad also provided passenger trips, bringing folks from the town of Somerset to Idlewild Park.

Group Picnics

Collaborating with the Pennsylvania Railroad to promote Idlewild certainly increased ridership on the Ligonier Valley Rail Road, especially during group picnics, which generated revenue essential to maintaining the park. Summer schedules printed in local newspapers like the *Ligonier Echo* attest to the impressive number and wide variety of schools, churches, companies and unions, social and civic clubs, fraternal groups, military veterans and families that booked picnics and reunions at Idlewild Park dating back to at

least the early 1880s.[85] Those who did not come on the train came by foot, horseback or carriage. Group picnics filled the weeks between late May and early September; for example, twenty-six Pittsburgh and Allegheny Sunday schools picnicked at Idlewild in July 1892, one nearly every day that month.

Unions of professions from stationary engineers to horseshoers and railroad employees were already gathering at Idlewild, and by the turn of the century, individual companies based around Western Pennsylvania had also started booking annual employee picnics at Idlewild. One of the earliest company picnics reported was for employees of the Collins Cigar Factory in July 1891, but soon enough some of the region's major industries booked their own days and brought some of the largest crowds to Idlewild, including Westinghouse Air Brake, Westinghouse Electric, the H.J. Heinz Company, Alcoa, the H.C. Frick Coal and Coke Company and Latrobe Steel. The Ligonier Valley Rail Road transported millions of tons of coal and coke used to manufacture the steel that built America, so it seems fitting that some of the industries that benefited from the products of this region came to enjoy the surface beauty at Idlewild rather than the materials beneath.

Many churches across the region also gathered at Idlewild, including mainstream Protestant denominations (Presbyterian, Baptist, Lutheran, Methodist, Episcopalian and Reformed), Catholic churches and Jewish congregations. Fraternal organizations also hosted annual outings for members and their families, including the American Legion, Knights Templar, Tall Cedars, Woodmen of the World, Knights of Columbus, Islam Grotto, Ancient Order of Hibernians and Heptasophs. Social groups, nonprofit organizations and other associations met at Idlewild, from temperance unions to county bar associations, the Red Cross and the Westmoreland Beekeepers Association. The Philharmonic Society of East End Pittsburgh enjoyed its time at the bucolic camp so much that Theodore Hoffman composed the lively "Idlewild Mazurka" for piano or organ "in remembrance of those happy days in camp at Idlewild, PA in 1885."[86]

For community picnics, municipalities completely closed down their businesses to allow all residents to spend the day at Idlewild. A wide variety of cities, towns and school districts around Western Pennsylvania scheduled annual picnics at the park: Irwin, Norwin, North Huntington, Ligonier, Latrobe, Derry, Greensburg, Pittsburgh, Saltsburg, Unity Township, Youngstown, Blairsville, Mount Pleasant, West Newton, Manor and Westmoreland City. Family reunions were frequent, especially for those deeply rooted in Ligonier, such as the Bitner and Ambrose families, two of the valley's oldest clans that began joint annual picnics at Idlewild in 1904.

This page: Communities across Western Pennsylvania hosted annual picnics at Idlewild Park, with games, free refreshments, fireworks and parades, as seen here during the 1920 Latrobe Community Picnic. *Courtesy of Pam Johnston Ferrero.*

The host organization typically offered free refreshments like coffee, lemonade and ice cream. Depending on the group's size, it might arrange a full meal; the Shriners obtained "the largest ox in Pennsylvania" for their August 23, 1907 picnic, "which had been roasting for 26 hours and the odor of the delicious meat could be detected even at the spot from where the crowd disembarked from the train." Of course, guests were also welcome to bring their own basket lunches. Folks traveling eastbound by train to Idlewild from Latrobe or Pittsburgh could stop at the Victorian-style Darlington station at the park's eastern entrance to purchase sandwiches, pies and other assorted eatables, as the depot contained a general store. Frugal children saved their loose change to splurge on some penny candy from the stationmaster.

No matter the group, these picnics offered a mixture of games, contests, athletics and live entertainment for young lovers, married couples, parents, grandparents and children. One highlight was dancing in the Auditorium on the hill to the sounds of a live band or orchestra. Printed programs outlined the committees that arranged the outing and detailed the events planned for the day, like those listed in the *Pittsburgh Press* of August 18, 1907, for the Syria Temple picnic:

> *The special feature of the afternoon will be a boat race, a fat man's race, women's race, boys' race, sack race, girls' race, egg-and-spoon race, three-legged race and stilt race. There will also be a ragtime talking match, between six married women, to be selected by lot, and a cake walk for which prizes will be awarded.*

Today, the baseball field on the south side of the Loyalhanna Creek is the site of athletic competitions and bagpipe performances during the annual Ligonier Highland Games, but through the 2000s, the field hosted friendly baseball games during group picnics. In the diamond's inaugural year, baseball teams from the Latrobe club and G.C. Duncans of Pittsburgh faced each other during the Holy Family of Latrobe church picnic on the Fourth of July 1885. One notable game scheduled for the thirty-eighth annual Ligonier Valley Reunion on August 15, 1929, pitted the Ligonier Valley All Stars against the Homestead Grays, one of Pittsburgh's two historic black baseball teams. The Grays defeated the All Stars by a score of three to one, knocking in their runs early in the third inning. Cy McGinnis scored the lone home run for the Ligonier team. Although the attendance was slightly lower than the previous year, as many as eight thousand people attended the 1929 community picnic, witnessing a "good, clean, classy game" between the two teams.[87]

An unidentified man and woman float high above Idlewild Park during a balloon ascension at the Latrobe Merchant's Picnic on August 5, 1908. *Courtesy of the Latrobe Area Historical Society.*

Although regular daily entertainment would not come to Idlewild until the Depression, as early as the 1880s groups included some kind of performance in the picnic program such as daylight fireworks, parades and hot-air balloons. The Lutheran harvest home picnic in August 1889 featured three balloon ascensions directed by A. Keck of Greensburg. Despite a rainstorm earlier in the day, an unidentified man and woman successfully ascended about two thousand feet in a balloon in front of three thousand folks attending the Latrobe Merchants' Picnic on August 5, 1908. The pair cut loose from the balloon, inflated their parachutes and landed without incident just east of the park. The Woodmen of World, Silver Maple Camp no. 19 of Latrobe, watched a thrilling balloon ascension by Professor Chas Swartz of Humbolt, Tennessee, on Decoration (Memorial) Day, 1910. Once Swartz's airship reached over two thousand feet, the aeronaut leaped from the balloon and fired two cannons before parachuting onto the McConnaughey farm at the west end of Ligonier. Although Swartz landed safely, a strong wind caught his balloon and blew it into a potato patch.

One innocent fireworks display in 1913 turned deadly. During the Elks of Western Pennsylvania's annual picnic on June 24, 1913, fifty-two-year-old Albert Kirsch was killed when a firework demonstration went awry. Kirsch and several other men buried a three-inch piece of pipe filled with dynamite and powder. However, when the men rammed the charge, the pipe exploded, sending shrapnel flying. A piece struck Kirsch in the back, tearing a hole through his body and nearly decapitating him. The explosion injured two others; pieces of pipe bruised a young girl riding the merry-go-round and struck an Allegheny County sheriff's candidate in the face, possibly causing him to lose sight in one eye.

Occasional rain showers sometimes plagued picnics, forcing crowds to huddle together under the park's shelters, but generally they were fine outings

with relatively little trouble. However, there were occasional reports of gambling, thefts and drunken fistfights at Idlewild. As such, Superintendent George Senft began employing uniformed police officers from Greensburg and Pittsburgh to maintain order during picnics.[88] Relatives or associates of the infamous Nicely brothers were arrested in the summer of 1890 for nabbing picnic baskets,[89] while pickpockets fleeced four women at the United Presbyterian church picnic on July 29, 1891. George McElhaney found himself in the Greensburg jail after assaulting truck driver James Laius during a picnic in August 1888. The arrested man related the incident in the *Pittsburgh Daily Post* of August 14:

> *The trouble was due to Laius' being drunk. He insisted on quarreling with me, finally jumping on me as I was walking away, throwing me down and choking me until friends took him off. He tried to strike me with a beer bottle and did hit me with a piece of board. As he tried to hit me again I picked up a club and struck back. I had to do it as I was afraid he would kill me. No ladies were concerned in the affair.*

The Lutheran and Ligonier Valley Reunions

One of the earliest organized group picnics at Idlewild Park—and the largest—was the annual Lutheran reunion, founded in 1882 by Reverend J.L. Smith, newly appointed pastor of the Ligonier Valley charge. Instead of holding separate picnics for each of his four congregations and their Sunday schools—Ligonier, Latrobe, Youngstown and New Derry—Smith proposed one joint picnic featuring religious services, scripture lessons and prayer, as well as music and refreshments. Although the inaugural event in 1882 was not a complete success, the "Lutheran Harvest Home Pic Nic" gained momentum each succeeding year, attracting other neighboring Lutheran congregations like Greensburg, Pleasant Unity, Manor and Irwin and sparking an arrangement with the Pennsylvania Railroad for special excursion rates for Pittsburgh charges. Soon, other mainstream denominations started attending the Lutheran picnic and were naturally inspired to organize their own reunions. Although they were not quite as large as the Lutheran reunion, which brought record crowds to Idlewild (nearly twenty thousand in 1892 alone), the park's schedule filled with not only Presbyterian, Methodist, German Reformed and Baptist outings but also Catholic Church picnics.

The August 14, 1890 Lutheran reunion made news because of a special guest. Pennsylvania governor James Beaver attended that year's picnic, traveling from Latrobe to Idlewild in a horse-drawn coach over the old turnpike. The governor gave a "most felicitous speech" to an audience of about seven thousand gathered in the grove across the Loyalhanna Creek. The Greensburg City Band treated the crowd to music, while several ministers lectured, read poetry and praised Reverend Smith for founding the reunion. Although the weather was a bit overcast and the crowd included one boisterous man and some "nimble-fingered rascals who take pocketbooks not their own,"[90] the 1890 Lutheran reunion was a triumph, as were subsequent years, attracting congregations from all across Western Pennsylvania as far as Pittsburgh, Johnstown, Altoona, Indiana, Uniontown, Connellsville and Scottdale.

A decade after the Lutheran reunion began, in August 1892, a group of Ligonier townsfolk met at a local Presbyterian church to establish a harvest home or union picnic for Sunday schools of all denominations. The result was the Ligonier Valley Reunion, one of the longest-running group picnics at Idlewild. Every Sunday school in the Ligonier Valley received an invitation to the first reunion on September 2, 1892. A crowd of about 1,200 people enjoyed beautiful weather that day, with foot, sack, wheelbarrow and "blind man's" races; baseball; boating; bicycling demonstrations; the merry-go-round; and music by the Ligonier Cornet Band. The *Ligonier Echo* of September 7, 1892, summed up the inaugural event:

> *The picnic was a most delightful affair. All denominations of the valley were represented and as everybody seemed to know everybody it was remarkable for its social pleasure.… It is hoped that this is the beginning of what shall be an annual reunion of the valley in a pleasant, social, enjoyable day at Idlewild.*

A permanent organization for the Ligonier Valley Reunion was incorporated for the fifth annual picnic, with I.M. Graham, then editor of the *Ligonier Echo*, as chairman. He was succeeded by Laughlintown farmer and civic leader John B. Singer in 1921. By 1900, the Ligonier Valley Reunion no longer affiliated itself with the local Sunday schools; instead, committees from the various municipalities within the Ligonier Valley took over the event, traditionally held every August. It remained a separate gathering from the secular school picnic, held earlier in the summer.

The annual event featured picnic lunches, athletic games, contests, music and dancing, as well as the crowning of the oldest residents as King and Queen of the Ligonier Valley Reunion. Folks first came by foot to Idlewild or traveled by train, carriages or hayrides before automobiles started to fill the park grounds. Each year, current and former Ligonier residents looked forward to socializing with neighbors, reconnecting with old friends and long-lost family and reminiscing about their shared hometown at what is simply but affectionately remembered as the "Valley Reunion." Shirley McQuillis Iscrupe, Pennsylvania Room archivist at the Ligonier Valley Library, remembered attending many picnics with her grandparents:

> *I can remember my grandparents just couldn't wait for that....You would count on somebody coming from Turtle Creek or Cleveland or wherever just to come to that. I remember meeting or seeing all these old people. Well, they were my mom's cousins or my mom's aunts or uncles. They were my grandparents' contemporaries. And it was an awful lot of fun.*

By the 1940s, attendance had noticeably declined, leading the Ligonier Valley Chamber of Commerce in 1948 to take over as sponsor of what the town now called the Ligonier Valley Reunion and Merchants Picnic. Through 1971, the chamber organized transportation to Idlewild and provided free ride tickets, while local merchants donated prizes and closed for the day in order to allow everyone to attend the reunion. Idlewild Park's management sponsored the event for the next two years until steadily declining attendance ultimately ended its more than eighty-year run. However, the community picnic soon merged with the annual school picnic to form the Ligonier Valley Community School Picnic, with the chamber's help, and continues in much of the same spirit as the original Ligonier Valley Reunion.

The 1923 Pershing Family Reunion

The largest and most prominent group picnics at Idlewild usually received a fair amount of local newspaper coverage describing the activities, entertainment, crowd size and contest winners. However, one notable family reunion at the park was splashed across newspapers throughout Pennsylvania

and even reported by the *New York Times*. General of the Armies John Joseph "Black Jack" Pershing, best known as the commander of the American Expeditionary Force during World War I, planned to attend the annual Pershing family reunion at Idlewild on September 8, 1923, to dedicate a monument to his twice great-grandfather, Frederick Pershing, an eighteenth-century Westmoreland County pioneer.[91]

To acknowledge Frederick's importance as the founder of the nine-generation Pershing family, a granite monument with an engraved bronze plaque was commissioned and temporarily erected in a grove at Idlewild for the 1923 Pershing reunion. The park is located about eight miles east of Coventry, the original Pershing homestead. The day was marked by great pomp and circumstance due to the general's attendance. A state police motorcade accompanied General Pershing to Idlewild; after arriving, he proceeded to the monument to give an address, escorted by Braden's Fife and Drum Corps of Bradenville, Pennsylvania. The crowds clustered on the hill below the Auditorium to hear Pershing's dedication. Among those invited to the reunion were military veterans of the Civil and Spanish-American Wars and of the 110th Infantry, 28th Division, as well as their families; Girl Scout and Boy Scout troops; and chapters of the Sons and Daughters of the American Revolution.

Following General Pershing's speech, a dozen young girls dressed in white circled the granite and bronze monument, unraveling the red, white and blue ribbons that held its cloth covering. Pershing cut the final ribbon himself, completely unveiling the memorial to his ancestor. Latrobe resident Clark Dalton donned a deerskin period ensemble and addressed the crowd in the guise of the late Frederick Pershing. The general received a cane and crop fashioned out of a log from the cabin in Bradenville, Pennsylvania, where his father, Fletcher Pershing, grew up. Following the ceremony, General Richard Coulter of Greensburg and the 110th Regiment overseas band led a parade to the Auditorium, where Pershing greeted service members in attendance before convening a family luncheon at the dining hall.

The park made special arrangements with the Pennsylvania Railroad to accommodate an expected ten thousand spectators to Idlewild that day. The newspapers reported that more than one thousand Pershing family members and another thousand visitors attended the dedication ceremony. The gathering was believed to be one of the largest family reunions held in the United States at that time.

Later that fall, about eight acres of land near Frederick Pershing's original homestead were purchased and the monument permanently relocated to a

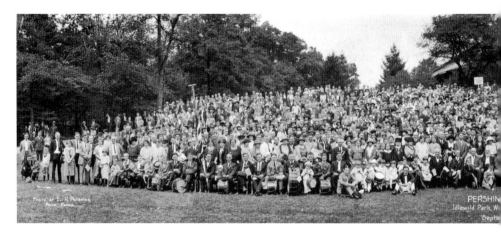

Members of the nine-generation Pershing family and veterans of World War I and the Spanish-American War gather for a group photograph during the September 8, 1923 Pershing family reunion. General John J. Pershing is sitting in the front row, left of center. *Courtesy of the Library of Congress.*

spot along the Lincoln Highway, as close as possible to the site of his home. The monument stands today within the current Pershing Park, a public picnic area owned by the local Knights of Columbus near Youngstown, not far from Idlewild.

A Different Klan Gathering

Idlewild's picnic schedules reveal that the Ligonier Valley Rail Road booked groups from a wide geographic area of religious denominations, political parties, cultures, professions, nationalities and races. Mainstream Protestant, Catholic and Jewish congregations throughout Western Pennsylvania all hosted gatherings at Idlewild. Both Democratic and Republican parties held conventions at the park.[92] Wealthier families could easily afford a leisure trip to the park, but special train fares sometimes opened up excursions to poorer folks. Research indicates that Idlewild was never promoted as a segregated park; in fact, newspapers reported mixed crowds at picnics as early as 1890.[93] Still, black churches and organizations also booked their own picnics. Some of the earliest black gatherings included a camp meeting of the Colored People of the African Methodist Episcopal Zion Churches of Greensburg and Mt. Pleasant in

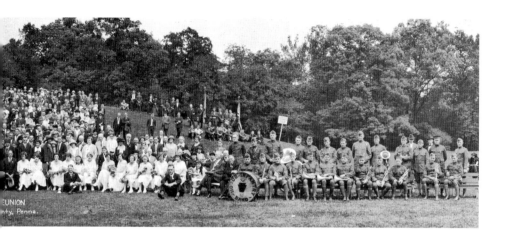

September 1880, a picnic for the Colored Barbers' union in August 1888 and a generalized "colored picnic" in August 1891.

As early as the mid-1880s, the Ligonier Valley Rail Road advertised Idlewild as a picnic spot for this wide range of groups, which also included "unions of secret societies."[94] These included local chapters of the Ku Klux Klan—of Latrobe and Ligonier—that held back-to-back picnics during the organization's Jazz Age revival.[95] Idlewild Park was a central location for these Klan chapters to host two large picnics that were tamer yet similar to other KKK gatherings held elsewhere in Pennsylvania during the 1920s, including Johnstown, Indiana, Scottdale and Pittsburgh, where current members socialized and initiated new followers into the Invisible Empire.

The first annual picnic for the Latrobe and Ligonier Klans, held on September 13, 1924, brought varying estimates of anywhere from eight to twenty-five thousand people to Idlewild Park by car and train from Pennsylvania, Ohio, West Virginia and Maryland, even setting a new record for automobiles parking on the grounds.[96] Although rain spoiled a planned airplane stunt, the day's program was full of games, races, contests, a concert by Greensburg's Neapolitan Orchestra and patriotic sing-alongs. Although not quite as large or boasting many local attendees, the KKK chapters welcomed people from more than a dozen states at their second annual picnic at Idlewild on September 5, 1925, including Pennsylvania grand dragon Sam Rich. The day's events included free refreshments, baseball games, a greased pig race and entertainment from the clown band of Greenburg. Wives and children of Klansmen freely attended the picnic and watched the Klavaliers guard unit perform drills on the lawn, dressed in their white military uniforms.

Accounts of these two picnics depicted events that on the surface were not much different from those of benign groups, yet certain details implied the Klan's secrecy and its disturbing philosophies. A password was required at the gate to enter the picnics, but Klansmen could vouch for any Protestant who did not belong to the organization. Souvenirs bearing the KKK emblem were sold, including caps, armbands and pennants. Local and visiting religious leaders stirred the crowds with lectures; Latrobe United Brethren's pastor gave an address during the 1924 picnic on "The Attitude of the Knights of the Ku Klux Klan toward the Negro, the Jewish People, the Catholics and the Foreigners" and the organization's right to define its members.

The KKK chapters initiated new members into their ranks during clandestine rituals held on Lake Bouquet's island that closed both Klan picnics. At the 1924 picnic, about five hundred Klansmen wearing masks and gowns encircled one hundred new brethren during the evening's naturalization ceremony. Both men and women dressed in "full regalia" during two successive ceremonies at the 1925 picnic that lasted late into the night. The *Latrobe Bulletin* of September 15, 1924, described the spectacle at the first picnic:

> *Crosses, electrically lighted, illuminated the scene, together with the moon and the reflections of the lights and shadows in the waters of the surrounding lake, formed a most interesting scene for those who stood on the outer banks, viewing the ceremony from a distance.*

No violence was reported at Idlewild Park during either of these Ku Klux Klan picnics, from members or opponents. Attendance was primarily from out-of-state visitors rather than locals. Idlewild did not promote these picnics beyond merely listing them on the published picnic schedules in the local newspaper. Although other Klan meetings occurred in the Ligonier Valley during the 1920s, the September 1924 and 1925 picnics are the only organized Ku Klux Klan gatherings reported to have taken place at Idlewild.

Romance and a Moonlight Dance

Idlewild's beautiful flower gardens, lush green lawns and private wooden bowers also inspired romance between young couples who often spent the day at the park with small groups of friends, dressed in their "Sunday best."

Men sported straw hats, suits and ties, while women wore full dresses or long skirts with long-sleeved high-necked blouses and fancy hats as they walked along the railroad tracks or floated in a rowboat on Lake St. Clair.

Small wonder that engagements and marriages took place after visits to Idlewild. William Larimer Mellon allegedly proposed to his wife, May Taylor, following an excursion to the park in the summer of 1895. Longtime Ligonier Valley Rail Road employee Robert E. Householder and his sweetheart, Sarah Nell Jones, courted at Idlewild Park before they married in 1908. Their granddaughter, Sara Jane Bitner Lowe, remembered stories about the Householders' daytime trips to Idlewild with friends and their lifetime relationship with the park.[97] The couple would walk together to Idlewild, perhaps all the way from Kingston Dam or from the Darlington train station at the western entrance. The young people dressed in their finery for the afternoon outings—Robert in a suit coat and straw hat and Sarah in a white shirtwaist and big feathered hat. Robert would kick off his shoes, hike up his pant legs and wade into Lake Bouquet to catch frogs, which he then took home to cook. Idlewild frogs' legs were a great delicacy.

Dancing was a common pastime at Idlewild from the park's inception, and its popularity extended well into the twentieth century. Couples attended formal moonlight dances held in the Auditorium at Idlewild

Jeannette natives Clara Yurt and Hubert Fitzgerald had their first date at Idlewild in 1921, posing for photographs with friends at all the scenic spots around the park. *Courtesy of Robert Domenick and Jeff Domenick.*

as early as the 1890s that continued after World War II.[98] For a nominal admission fee, sweethearts danced to the sounds of jazz and big band orchestras led by Bert Lown, Nick Roy, Paul Specht and Tom Gerun that performed on the Auditorium's stage. The park contracted local talent to serve as the house orchestra for the season and worked with the American Federation of Musicians to book touring acts for individual appearances. Starting in 1922, John C. Huffman, M. Saxman Rise and H. Donald Paxton sent as many as 1,450 invitations to their moonlight dances series at Idlewild. For more than a decade, the trio booked groups such as Detroit's Ted Weems and his twelve-piece Victor Reading Orchestra and Virginia-based Jennings Campbell and his Cadet Ramblers; Kay Kyser's big band was even reputed to have performed at Idlewild.[99]

Albert Henry Smola of Trafford picked up his sweetheart, Alberta Reese, from neighboring Pitcairn and drove to Idlewild Park for some dancing in the Auditorium during summer weekends before the couple got hitched in 1943. The Smolas' story shows just how big a draw Idlewild Park had across Western Pennsylvania—people from the Greater Pittsburgh region made the fifty-mile trip to the park for a special date. Their granddaughter, Hillorie Monsour, remembered her grandmother Alberta's stories about the couple's courtship at Idlewild:

> *My grandmother spoke of this memory fondly when she was alive and she made sure to tell me about it when I took my own children to visit the park in 2012. Both times, she wanted me to walk her over to that wooden pavilion so that she could tell me that was where she had attended the moonlight Big Band dances with my grandfather and that they enjoyed it so much and were married soon thereafter.*

Dances were often included on group picnic itineraries as one of the day's featured events. A mixture of ages and musical tastes at these outings naturally created disagreements. Older and younger generations clashed at the Frick Veterans Association picnic on July 23, 1914, when the floor manager shut down the music and threatened to send the St. Clair Orchestra home if the young people would not stop their risqué dancing. The veterans association disliked trendy new dances such as the tango and did not want members to perform them at the picnic. As the *Daily Courier* reported, "The whole association was against the wiggles, the creeps, the hesitations and such stuff." However, there were folks who disobeyed the posted warning and did, in fact, perform the latest dance steps, much to the association's chagrin.

A New Era

In 1913, Ligonier Valley Rail Road superintendent William Van Kirk Hyland told the *Latrobe Bulletin*, "The natural beauty of the park and the fact that it is so different from other picnic grounds, are what make Idlewild so attractive." Despite the gradual additions of a merry-go-round, launches, boats, concessions and refreshment buildings, the Mellons and their railroad continued to promote the park's natural qualities, believing its fresh air, clean water and vibrant foliage were enough to entice visitors to the Ligonier park.

As early as the 1890s, the Ligonier Valley Rail Road began receiving—and refusing—proposals to install rides and games at Idlewild or to purchase the park outright. Prior superintendent George Senft declined a proposal from C.D. Reynolds of Pittsburgh to erect a roller coaster at the park: "I beg to inform you that the company have decided not to rent any privilege for such purpose. In other words, we do not want to encumber the grounds with anything of a permanent character," he wrote to Reynolds on January 27,

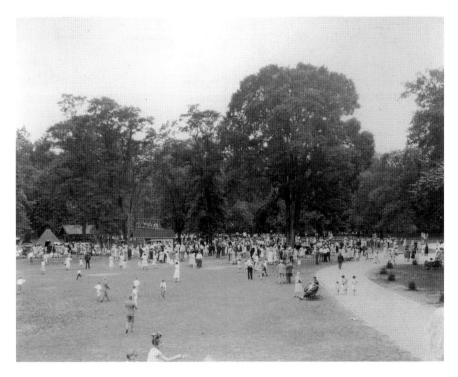

This early twentieth-century view of Idlewild shows a grassy midway and the bridge spanning the Loyalhanna Creek. *Courtesy of the Ligonier Valley Historical Society.*

1893. T.M. Harton was likewise interested in installing one of his company's coasters at the park in 1895. Senft also declined Harton's offer, replying, "I can't see that I can give you any encouragement for your Roller Coaster.... The company is averse to placing any more attractions than we now have at least not this year."[100] C.H. Lohr of Latrobe asked to place a shooting gallery on the grounds during a picnic on August 7, 1895, but Senft refused this request, explaining, "In the first place, it is an amusement or past-time not suitable for a picnic ground besides it is entirely too dangerous even in the hands of the most careful."[101] Although Ferris wheels began to appear in towns and at fairs and other parks after George Washington Gale Ferris Jr.'s massive attraction debuted at the 1893 Chicago World's Fair, the Ligonier Valley Rail Road bucked the trend.[102]

Regardless, practical improvements continued after the turn of the century despite management's aversion to games and rides. Additional facilities followed over the next decade, including a ladies' rest house in 1903, a new men's toilet building in 1906, a second ladies' toilet building in 1908 and both a concession house and a parcel check house in 1920.[103] That same year, the newspapers reported that Idlewild might soon have electric lights,

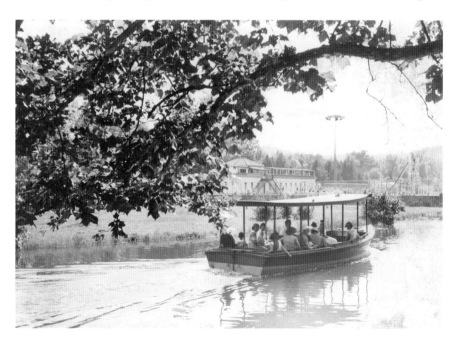

In 1930, the Ligonier Valley Rail Road replaced the vapor launch and swan boat with a motor launch, which transported passengers around Lake Bouquet into the 1950s. *Courtesy of the Idlewild and SoakZone Archives.*

with the extension of West Penn Power lines from Latrobe to Ligonier.[104] A new motor launch purchased in 1930 to carry seafarers on Lake Bouquet replaced the earlier vapor launches and swan boat. At thirty feet long, with colorful awnings, *Miss Idlewild* could comfortably seat twenty-five passengers for a half-mile trip about the lagoon.

Eventually, the Ligonier Valley Rail Road's philosophy changed. By 1916, the company leased 123 acres of the Darlington estate for its park enterprise.[105] Judge Thomas Mellon, who first negotiated the use of Idlewild, had passed away in 1908, and a third generation of the family—his grandchildren—were now involved in the railroad and Idlewild ventures as stockholders and directors. After almost fifty years managing the scenic picnic grounds, it was time to jump into full ownership. On February 26, 1923, the Ligonier Valley Rail Road purchased Idlewild Park for $50,000 from the Darlington heirs[106]—a total of about 327 acres of timbered land, according to the deed.[107] Two days later, the company also purchased almost 75 acres of an adjacent farm owned by Elmer, Ella and Rebecca Deeds,[108] adding more property to the park, which they would gradually continue to do in succeeding years.

The sale heralded immediate improvements at the famous Idlewild Park, including a new concrete dancing pavilion, a station made from native stone, a cottage building, a larger checking stand and an expanded entrance with widened access road. A concrete swimming pool fed by mountain water was also slated to be built.[109] Although some of these projects were still years away, the public announcement of such dramatic changes at Idlewild indicated that a new era for the scenic picnic ground was on the horizon.

THE MACDONALD YEARS

"Spend the day in America's Most Beautiful Park. You Can't Beat Fun!"
—Latrobe Bulletin *(1941)*

For more than a half century, the Ligonier Valley Rail Road managed Idlewild Park as a peaceful picnic ground. The company promoted Idlewild's natural setting—the surrounding mountains, lush trees, colorful flowers and refreshing waters. The park had few buildings and minimal activities—boating on the Loyalhanna Creek and lakes, dancing in the Auditorium, baseball on the athletic field and the steam-powered T.M. Harton merry-go-round. Simplicity was a conscious decision.

Now that the Mellon family owned Idlewild Park, they perhaps felt the freedom to expand further than they could by only leasing the property after seeing other local parks add their own amusements. Less than a decade after the Ligonier Valley Rail Road purchased Idlewild, the park began its transition from a simple picnic grove into a traditional amusement park.

The Idlewild Management Company

By the end of the Roaring Twenties, the Mellons were poised to make extensive changes at Idlewild, first establishing a subsidiary management

company to handle the park's affairs while the Ligonier Valley Rail Road maintained ownership. The Idlewild Company, in turn, leased two hundred acres of land containing the park to the Idlewild Management Company, a second subsidiary incorporated on April 29, 1931.[110]

This corporate move created a new division of labor. Previously, the superintendent or general manager of the Ligonier Valley Rail Road generally assumed the responsibility of managing Idlewild Park. Along with arranging maintenance and repairs of the railroad's rolling stock, equipment, buildings and track, as well as ensuring that all bills were paid, the superintendent also scheduled picnics at Idlewild Park, made arrangements with Pennsylvania Railroad agents for passenger excursions and ordered tickets for these special trips.[111]

The Mellons decided to hire an amusement park veteran to manage Idlewild for the 1931 season under terms of a partnership. The man selected for that job was Clinton Charles ("C.C.") Macdonald, who had more than thirty-five years of experience. Macdonald's first job in the industry was operating a peanut and popcorn concession at Hiawatha Amusement Park in Mount Vernon, Ohio, in 1895. From there, C.C. and his wife, Grace Ruby Macdonald (née Mix), operated a nickelodeon in Beeville, Texas, and worked at several parks in Ohio and Michigan before taking over Rock Springs Park, a trolley park in Chester, West Virginia, in 1926. The Depression left Macdonald in financial straits, so during the offseason at Rock Springs Park, he came to Pittsburgh to work at Motor Square Gardens, a sports and entertainment venue in East Liberty owned by the Mellon family. Impressed by his skills and the revenue he earned for the Pennsylvania Railroad through Rock Springs excursions, the Mellons asked Macdonald to come to Ligonier, believing him to be the right person to modernize Idlewild Park.

The Idlewild Management Company authorized an agreement with Macdonald to manage Idlewild with no salary through the end of the 1932 season. Macdonald's performance and the park's attendance would determine whether the company extended his contract with salary.[112] If business were not successful, the agreement would be terminated and his stock purchased by the company. Macdonald joined the board of directors, along with Grace Macdonald, Richard King Mellon, Ligonier Valley Rail Road superintendent Joseph P. Gochnour Jr. and Howard M. Johnson.[113] As director, vice-president and general manager, Macdonald held 49 percent of the company stock, while the Idlewild Company[114] held the majority.

C.C. Macdonald was not the only Macdonald who would shape Idlewild Park over the next half century. He and his wife worked as a team at Idlewild,

as they did at previous parks. Grace R. Macdonald, as she was usually credited, was the financial backbone of Idlewild; she served as secretary and treasurer for the board of directors and handled all of the park's money in the business office. For four years, Grace also traveled between Idlewild and Rock Springs Park, before the Macdonalds' daughter, Virginia, took over the latter with her husband, Robert Hand, in 1935.

C.C., Grace and their two sons permanently moved to Idlewild, eventually living in a farmhouse across from the park on the north side of Route 30. Sons Clinton Keith ("Jack") and Richard Zane ("Dick") would also play important roles in moving the park forward. Eleven years older, Jack worked at both Rock Springs Park and Idlewild early on, serving as assistant manager and running concessions at the latter. It would be several years and a stint in the U.S. Air Force until nine-year-old Dick would take on an active role at Idlewild, but until he reached adulthood, he enjoyed all the novelty an amusement park had to offer a mischievous boy.

Modernizing Idlewild

The 1931 season launched a period of the most widespread development at Idlewild since the Ligonier Valley Rail Road's Victorian era improvements. Joining the Macdonald family at the park was grounds superintendent and master mechanic Pat Masterson and chief engineer George Baker. It took the Idlewild Management Company's dedicated staff and outside contractors—about fifty laborers in all—to complete the park's transformation over that spring. The company hired Ligonier-based help, awarding W.L. Darr and Company a carpentry contract and hiring W.K. Egner for painting work.[115]

The Idlewild Management Company invested about $35,000 into new buildings, rides, landscaping and infrastructure at Idlewild for the 1931 season,[116] all of which was allegedly completed without removing a single tree from the park.[117] New attractions included a rifle range, a "Skooter" auto amusement house, a children's playground with kiddie Swan Swings, a Skee-Ball building, a small zoo and a new (to Idlewild) carousel. The most significant change was the addition of electricity; in 1931, West Penn Power extended service to Idlewild, enabling the park to install more than five thousand electric light bulbs throughout the grounds, including strategic flood lighting on Lake Bouquet's main island. Park-wide electricity meant

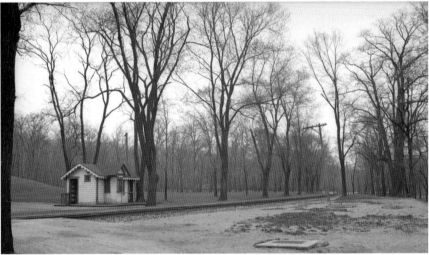

This page and opposite: This panoramic shot taken on April 22, 1931, shows Idlewild Park in transition from a simple picnic ground to a traditional amusement park with rides, refreshment stands and daily live entertainment. *From the Philadelphia Toboggan Coasters Inc. Archives, courtesy of Tom Rebbie, president/CEO.*

that Idlewild was not limited to steam-driven rides and could consistently stay open after dark—previously, the park only had a few night-lights powered by a Studebaker engine.[118] The Idlewild Management Company also installed a new drinking water system with pipes that supplied one thousand gallons of deep rock artesian mineral water per hour.

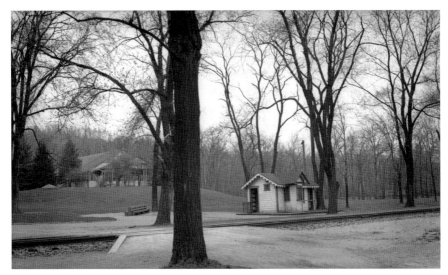

The Idlewild Management Company rebuilt the Auditorium's stage and floor to create a new ballroom for afternoon and moonlight dances. Brand-new buildings included a two-story frame dwelling that replaced the original railroad station. The multipurpose structure contained an apartment for the Macdonald family above and a new railroad ticket office and passenger waiting room below and also sold souvenirs and refreshments.[119] The existing depot was moved slightly east, rotated 180 degrees and converted into the park's first aid station, supervised by nurse Elsie McAdoo. The building had a small addition tacked onto its eastern side sometime in the 1940s.

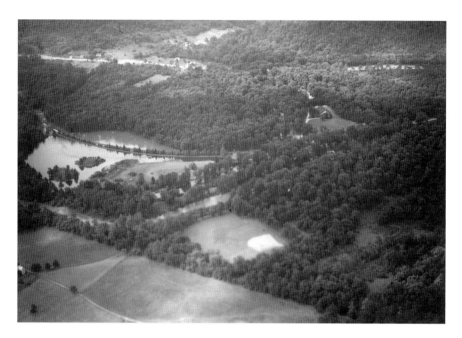

This 1931 aerial view shows off the foliage that makes Idlewild so unique. Landmarks spotted among the trees include the Auditorium, Skooter building, carousel pavilion and baseball diamond. The Darlington station stands at the park's western entrance, where the Ligonier Valley Rail Road runs between Lake St. Clair (*top*) and Lake Bouquet (*bottom*). *Courtesy of Dr. John Smetanka and Sandy Luther Smetanka.*

By 1931, the Ligonier Valley Rail Road's passenger business had noticeably dwindled,[120] but automobile traffic to Idlewild was steadily gaining. To better accommodate an influx of cars, the Idlewild Management Company also improved the park's entrance, pushing the gates back about fifty feet, and cut the parking fee in half from fifty cents to twenty-five cents later that summer.

Over the succeeding years, multiple concession stands selling sandwiches, ice cream, root beer and popcorn popped up across the park, beginning with a twenty- by thirty-foot refreshment stand located at the bottom of the grade between the Auditorium and the dining hall. The new wooden buildings were built in the same simple style as Idlewild's existing buildings. All of the park's structures were repainted white with green trim, some accessorized with American flags and pennants.

A new men's restroom with a sandstone veneer covering a brick interior replaced an older one at the eastern end of the park. Workers used native stone from the Ligonier Valley for all the stonework around the park, including various small bridges, abutments, walls and buildings. Adolf E. Johnson, a

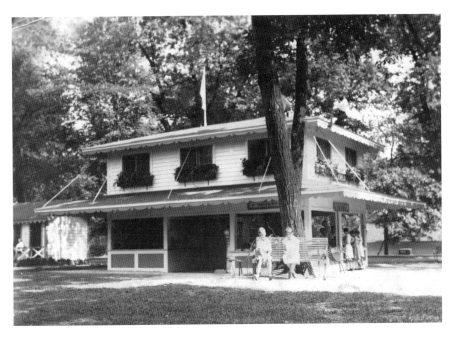

A new two-story building served as a new railroad station and park offices during the Macdonald era, pictured here in 1932. *Courtesy of Dr. John Smetanka and Sandy Luther Smetanka.*

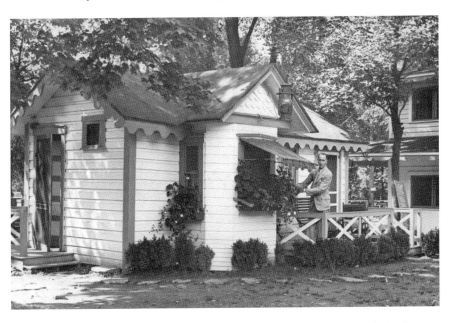

Manager and eventual owner Clinton Charles (C.C.) Macdonald stands outside the first railroad depot, built to service Idlewild, which became the park's first-aid station when a new two-story station was built in 1931. *Courtesy of Richard Z. and Ann Macdonald.*

Swedish stonemason from the nearby village of Darlington, partnered with his brother Arthur Johnson to erect the small bridges around Lake Bouquet, and build the foundation for the park's future swimming pool.

Despite the attention paid to the park's modern attractions—rides, games and eateries—management was careful to preserve, and not detract from, Idlewild's natural beauty. Macdonald also launched an extensive landscaping project; gardeners planted grass throughout the four-hundred-acre property and ten thousand shrubs around the park grounds. Folks resting on Idlewild's many dark-green painted iron benches could admire large shade trees like white oaks, maples and sweet-smelling lindens. All the pathways around the park were strewn with crushed gravel and bordered by closely trimmed hedges, as former Idlewild employee Carol Oravetz remembered:

One of the many special memories I have is the beauty of the carefully raked gravel. Every night, secret elves would rake the fine gravel free of litter, leaving the pathways looking like a Zen garden. Before the park opened, I would tread carefully so as to preserve the pristine loveliness as long as possible. Didn't matter that this effort would remain unappreciated by the public. The elves kept returning to ready things for the next day.

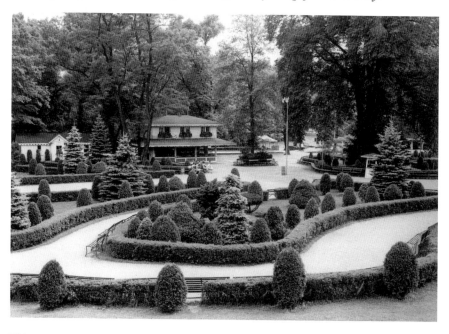

This 1954 western view of Idlewild's mall shows the meticulous landscaping and gravel walkways that defined the Midcentury Modern park. *From the Fantastic Fotographica Collection, courtesy of Harry Frye.*

Most of the initial improvements were finished by Idlewild's official opening on Decoration Day, May 30, 1931, a holiday marked as the park's public debut under its new management. A crowd of fifteen thousand people enjoyed baseball games, dancing to live music provided by the Colleens, a ten-piece all-girl orchestra from Akron, Ohio, and a grand finale of fireworks—a fitting start to the new season at one of Western Pennsylvania's most popular amusement parks.

The Philadelphia Toboggan Company Carousel

One notable improvement that C.C. Macdonald made in his first season as manager was to replace the park's longtime steam-driven merry-go-round with a new electric model. The T.M. Harton Company carousel, managed by Charles Dickson for more than thirty years, performed well, grossing as high as $1,200 on some days. Perhaps management simply felt that it was time to convert to modern technology.

At that time, the Philadelphia Toboggan Company, a renowned carousel and coaster manufacturer based in the Germantown section of the eastern Pennsylvania city, sought a new home for one of the last carved wooden carousels the company built. The 1929 stock market crash had launched the United States into the Great Depression, and not surprisingly, amusement parks and ride manufacturers suffered financially, including PTC. As its carousel sales dwindled, PTC shut down its factory in August 1929 with no immediate plans to resume production except to finish some in-progress machines.[121]

By the end of that year, PTC's shop had reopened on a limited basis and was on track to complete and assemble its no. 83 carousel by the spring of 1930.[122] The exquisite three-row carousel sported forty-eight beautifully painted and jeweled steeds—twenty-eight jumpers and twenty standers[123]—plus a pair of two-row chariots accented by angels. Artists carved sections of each individual horse from basswood—first by machine, then adding the trappings by hand—before gluing the pieces together using a substance created from boiled rabbit skins. PTC appears to have used the best horses from its existing stock because one unique feature of this carousel is the number of its lead horses, considered the most ornate of the team. The outer row includes not one but three steeds sporting the PTC crest: no. 9, a white horse with pink trappings; no. 11, a circus horse with a feathered

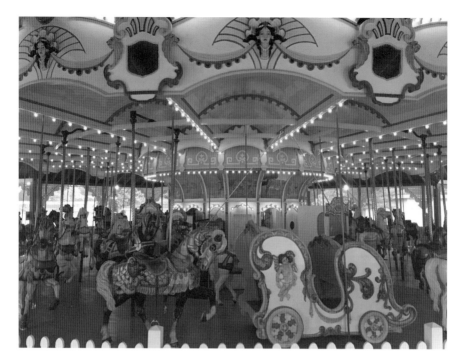

Philadelphia Toboggan Company Carousel no. 83 consists of three rows of carved wooden horses and chariots and two band organs, seen here on October 29, 2016. *Author's photo.*

bridle; and no. 14, a black armored steed traditionally considered the lead of the trio.

Philadelphia Toboggan Company artisans spared no attention to detail on the rest of the machine. The carousel's other ornamentation includes a multi-mirrored rounding board decorated with carved eagles, lions and Cleopatra busts and twenty stenciled oil paintings on the center pole façade. The murals depict a dozen scenes of people and nature interspersed by four smaller panels of flowers and butterflies. The upper ring includes a cowboy riding a bucking bronco, a Native American woman paddling a canoe, a horse-drawn sleigh in winter, a hunter flanked by a pair of dogs, a boy sitting on a bench with his begging pup, mother and baby foxes surrounding a kill, flying hawks, a fisherman and girl in a rowboat, a boy cuddling a litter of puppies, a hunter near water, an accordion player serenading a dog and two boys pulling a little red wagon. Four additional waterscapes appear below: a shipwreck on a sandbar, a lakeside scene, a waterfall and a river with cliffs in the background.

Carousel no. 83 spent its early life on the New Jersey seashore before permanently moving to Pennsylvania. In March 1930, General Manager George P. Smith reported to PTC's board of directors that he contracted with novelty store proprietor William F. Weber to install no. 83 at Connecticut Avenue and the Boardwalk in Atlantic City.[124] The carousel opened on the Saturday before Easter, April 19, 1930, and grossed $6,860.85 in its first season.[125] PTC initially leased it to Weber on a 25 percent basis but expected a definite sale later.

The sale never happened. PTC no. 83 only spent a single season on the boardwalk. By January 1931, the company already knew that it would probably have to vacate Atlantic City. Weber had gone bankrupt, leaving the property lease and building loan unpaid and no chance of him buying the carousel.[126] The company now sought a new home for its attraction.

One possible location for no. 83 was Jefferson Beach Park in New Orleans, but the owner would not consider erecting a carousel building at the park's expense and PTC would not agree to build it if the device only operated as a concession.[127] Another option was a space at the municipal convention hall in Wildwood, New Jersey, owned by the Hollybeach Realty Company Inc.[128] PTC also contacted an amusement park in Wildwood about three used carousels it had that were available for sale, including no. 83.[129] PTC secretary K.S. Gaskill quoted Henry Maholm of New Philadelphia, Ohio, a price of $15,000 describing this option as "a three-row, very fine Philadelphia Toboggan Company machine, with ceiling and electric music. This machine is almost new."[130]

However, only four days after Smith sent his letter to Maholm, he was on his way to Pittsburgh to negotiate "the placing of the Atlantic City carousel, with C.C. Macdonald and the Mellons in Idlewild Park."[131] The park's long reputation as a beautiful and successful picnic spot may have convinced PTC that this was the best and most profitable home for its machine, especially in light of all the planned improvements and attractions for the 1931 season. The fact that the park had an existing carousel pavilion might also have been a selling point. Nevertheless, by Smith's own account, this was his preferred new home for the carousel.[132] By early May 1931, no. 83 had relocated to Idlewild and operated on the same 25 percent basis plus 20 percent of picnic receipts. The machine was estimated to earn at least a $500 profit that year, although that was unlikely given that the Idlewild Management Company took control of the park after most of that season's picnics were already booked and was preoccupied with renovations.

With more picnics slated for 1932, the carousel's receipts for its next season were more optimistic. PTC's executive committee ruled in October 1931 that no. 83 "is in a good picnic section and should show excellent future results. In fact the T.M. Harton interests considered it their best carrousel location and were loath to move their carrousel." Although the carousel never matched its profits at Atlantic City during its first two seasons at Idlewild, it made an additional $200 in 1932, an encouraging sign that it would steadily become a popular ride in its new home.

Like with Weber, PTC expected to sell this beautiful carousel to Idlewild within a year or two. This time, the company's prediction came true. No. 83 operated as a concession only for the 1931 and 1932 seasons at Idlewild Park. After the 1932 season ended, the Idlewild Management Company and the Philadelphia Toboggan Company negotiated a sale, with C.C. Macdonald purchasing the carousel, plus organ and Capehart music outfit[133] for only $7,250—in *cash*. PTC only reclaimed less than half of the ride's value, as its book value exceeded $19,000, but in the recessed economy, with its factory down and no new products rolling out, cash was probably welcome. The sale was completed by November.

Since PTC no. 83 became a permanent Idlewild resident for the 1933 season, it has remained in the same location at the park, beneath the T.M. Harton pavilion, for more than eighty years. The carousel retained not one but two alternating music devices that serenaded its riders with cheery music: a Wurlitzer Model no. 103 band organ with an Artizan Style "D" façade and a Wurlitzer Caliola (an air-operated calliope). Neither machine may be original to PTC no. 83 when it arrived at Idlewild in 1931, but both have been part of the carousel for most of its life.[134] Having two organs meant that after the roll ended on one device, the second continued to play music while the first rewound.

Dick Macdonald remembered how as a little boy he filled the carousel's ring dispenser installed on one of the pavilion pillars. Folks riding the outer row of stationary horses leaned out with arms outstretched, hoping to grab the prized brass ring that could be redeemed for a free ride. However, the park eventually removed the dispenser because the leather saddle straps risked breaking with more and more boys and girls reaching out from their horses.

Memories of riding the beautifully painted horses have stuck with many patrons, like Sara Jane Bitner Lowe, even years after their last visit to Idlewild Park:

> *I remember that carousel. In fact, I can, in my mind, picture the horses because I had two horses that I always had to ride on. And one was*

stationary and it was a huge big white stallion and he had very, very vivid...trappings and big blue stones on his bridle and so forth and I loved him. I just loved that horse. And then if I wanted to get on one of the ones that went up and down, there was a small brown one that was close to him and I would get on that one. But those were the two that I always, always, always rode on.

The carousel was also a favorite ride for Sandy Springer Mellon, wife of Seward Prosser Mellon, Richard King Mellon's son and the judge's great-grandson. Mrs. Mellon lived with her parents on Main Street in Ligonier, within walking distance from the Ligonier Valley Rail Road station. She fondly remembered her mother taking her to Idlewild Park as a little girl, the pair riding the gas-electric Doodlebug from town along the railroad. After repeated rides, Mrs. Springer would get quite dizzy and ask someone to take her place on the carousel so daughter Sandy could keep riding around and around in circles.

The Finest Swimming Pool in PA

The first rumors of a swimming pool spread after the Ligonier Valley Rail Road purchased the park in 1923, but it took almost a decade for the pool to materialize. Over the winter of 1931–32, construction finally proceeded on a modern swimming pool at the center of Lake Bouquet's Flower Island.[135] The Idlewild Management Company spent nearly $75,000 on the project,[136] bringing in local labor and a steam shovel to dig the foundation and install the two-hundred- by eighty-foot reinforced concrete pool, which was designed by a specialist from Terre Haute, Indiana, and constructed under the supervision of an expert engineer from East Liverpool, Ohio. The pool had two concrete islands and three diving boards, including a high dive. A tall floodlight illuminated the water for night swimming. In addition, a fourteen-thousand-square foot sand beach spooned the new pool, perfect for sunbathers. The complex also included a bathhouse containing five hundred lockers and one thousand baskets, plus showers and bleacher seats on the roof for those who preferred to observe rather than swim.

The 550,000-gallon pool opened May 30, 1932 to a crowd of fifteen thousand people celebrating Decoration Day. It was heralded as the most modern, most sanitary in pool technology—the cleanest and purest pool

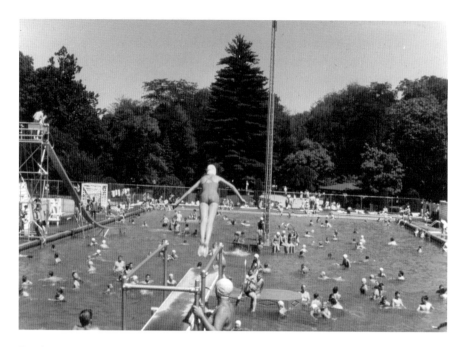

For the 1932 season, Idlewild built a grand swimming pool on the main island in Lake Bouquet that featured a large slide, three diving boards, concrete islands and a large floodlight for night swimming. "It was always the most beautiful blue," remembered Darlington native Jean Gordon Sylvester. *Courtesy of the Idlewild and SoakZone Archives.*

in Western Pennsylvania. Idlewild did not just talk the talk; not only was the swimming pool equipped with the latest Scaife sand-filtering technology, its soft chlorinated water was changed nearly three times per day and the bottom scrubbed twice a week. In 1938, the Pennsylvania Department of Health tested the water and found it to be purer than common drinking water. The nearly seventy-five-degree water was allegedly germ-free enough to drink and so transparent that you could see a pin laying at the bottom of the deep end.

Idlewild's swimming pool became a popular feature at the amusement park and enjoyed heavy use by the local community. By the mid-1930s, the park offered free swimming lessons for kids and adults as part of a National Swim Week campaign to promote health and safety. Swimming meets were frequently scheduled and Idlewild offered a 10-cent discounted admission every Monday for Kiddies Day. Many children from the Darlington community had season passes and spent entire summers at the Idlewild pool. Although it competed with Nick Gallo's pool at the Ligonier

A fourteen-thousand-square-foot sand beach complemented the island swimming pool at Idlewild Park, seen here in 1953. *From the Fantastic Fotographica Collection, courtesy of Harry Frye.*

Valley Bathing Beach, located on Route 30 east of Ligonier, there seemed to be an underlying geographic division—the town kids mainly enjoyed the beach while the rural kids preferred Idlewild.

You Can't Beat Fun

Idlewild fared better than many trolley parks and picnic groves in Western Pennsylvania, many of which succumbed to the economic strains of the Great Depression, likely due to the revenue its group picnics generated and its strong management. The park continued to operate and make capital improvements when only a small percentage of its peers were profitable.[137] In fact, Idlewild's attendance and revenue increased each succeeding season. Massive crowds estimated from fifteen to twenty thousand on the Fourth of July 1931 and during an August 15 Moose Club picnic ensured that C.C. Macdonald's first year as manager was a success. Receipts for 1932 were double what they were the prior year, certainly helped by the new

swimming pool. Revenue was up about 55 percent by Fourth of July 1933 and overall about 20 percent—another attendance record-breaking season where nearly 100 percent of groups rebooked for the next year.[138] "Despite the Depression, everyone seemed to have money to spend at the various amusement places."[139]

By 1941, Idlewild Park had adopted its classic slogan "You Can't Beat Fun"—a motto that encapsulated the Macdonald years and characterized the development of the park throughout the midcentury. In later years, a grinning sunshine often accompanied park slogans splashed across its promotional literature, souvenirs and newspaper advertisements.

From Memorial Day through Labor Day, Idlewild was open daily until midnight for families, couples, children, teens, adults and seniors to come "play, dance and picnic." As the park expanded in later years, Idlewild began closing on Mondays for general maintenance. Admission to the park and use of its buildings remained gratis. Revenue came primarily from Ligonier Valley Rail Road fares, a nominal parking fee for automobiles, individual ride and refreshment tickets, game booths and swimming pool passes.

Each day began with a public address announcement and the strains of a John Philip Sousa march broadcast through Western Electric amplified speakers, which were added throughout the park in 1932 and 1933. C.C. Macdonald began scheduling daily entertainment at the park—called free acts—that included trapeze and high-wire artists, musical groups, comedians and circuses. Folks who did not pack a picnic basket could buy refreshments such as popcorn and root beer at the various stands added throughout the park.

C.C. Macdonald was careful to create a "high class moral atmosphere" at Idlewild. The park did not sell beer or alcohol at all, or even any drinks in glass bottles, and it strictly prohibited folks from bringing alcohol onto the grounds. Macdonald also banned gambling machines. Enforcing prohibition was difficult, especially during moonlight dances when folks snuck it in, but it was extremely important for Macdonald to maintain Idlewild Park's reputation, according to son Dick:

> *My father was adamant that we not bring beer and things like that into the park. We didn't want that....I know we had thrown some of my buddies out when they brought beer in. It was just a wholesome family* [park]— *just a wholesome business. My dad insisted it be kept that way.*

This circa 1947–51 midway view shows much of what Idlewild had to offer both kids and adults. *Left to right*: Carousel, Miniature Cars, Idlewild Express, Miniature Swan Swings, kiddie Whip, Rollo Coaster, shooting gallery, Penny Arcade and root beer stand. *Courtesy of the Idlewild and SoakZone Archives.*

After each fun-filled day, Lead Belly's folk standard "Goodnight Irene" played over the public address system as the park prepared to close for the evening. Dick's wife, Ann Macdonald, remembered that after a whole season of hearing "Goodnight Irene, goodnight Irene, goodnight," her father-in-law had enough, grabbed the record from the phonograph player and smashed it over the head of the young operator, telling him, "You won't play that damn thing anymore!"

The Park Beautiful

The Idlewild Management Company continued to add new rides, entertainment and infrastructure to Idlewild Park throughout the Depression. Each season saw several new additions to satisfy the public, although C.C.

Macdonald was reluctant to call the modern Idlewild an amusement park, preferring to classify it as a "recreational park" because the vast majority of the grounds contained natural forests, lakes and a wildlife refuge[140]— qualities that certainly justified its earlier motto, "The Park Beautiful."

Riding the success of the 1932 season, then reported to be the most successful in Idlewild's history, the Idlewild Management Company began another round of work by building a new automobile entrance in 1933. The outdoor elements that Macdonald pointed out strongly influenced the park's architecture. The gateway plans included several log buildings: an octagonal-shaped blockhouse described as a replica of Fort Duquesne[141]; a log cabin housing the Trading Post general store; and a Gulf Refining Company service station with gas pumps, another Mellon enterprise (William Larimer Mellon was one of Gulf Oil's founders). The complex also included an existing Rolling Rock farm stand, which opened the year before, that sold produce, honey and other products from the Mellon family's Ligonier estate.[142]

The Macdonalds' hunting trips to New Brunswick, Canada, may have directly inspired the park's entrance design, with its heavy use of log structures. A log fence stretched from either side of the gateway crowned by a simple sign with logs spelling out the name "Idlewild." C.C. Macdonald shipped in Canadian white cedar logs for the buildings, gate and fence and used fieldstone to construct the gas station building and blockhouse base. Several hundred evergreen and pine trees were planted behind the fence to create a rustic backdrop. Blueprints of the entrance show that the park incorporated existing three-foot-diameter red oaks and white oaks into the design.

During the fall of 1932, workers cleared out woods east of the park between the Lincoln Highway and the railroad tracks to increase automobile parking, which was becoming the more prevalent means for visitors to reach Idlewild, as traffic over the past season indicated. Rustic bridges built over Idlewild Run (formerly Bayard's Run) linked the park to the new parking lot. The cleared trees became free firewood that stocked numerous stone fireplaces sprinkled around the grounds for guests' use. A new fifteen-acre parking area east of the park entrance added in 1935 made space for hundreds of additional cars. Although management generally adhered to William Darlington's precept (by placing iron benches around existing trees, for example), certain projects like this necessitated the removal of some foliage.

To compensate, landscapers continuously planted new shrubs, redesigned the island flowerbeds and tended to the park's many elder trees. Nature trails abounded throughout the old Woodlands area where, in 1933, the Westmoreland County Federation of Women's Clubs started a Memory Lane of trees in that

area to honor past federation presidents.[143] In 1936, management also brought in a team of surgeons from West Virginia to treat a 621-year-old white oak along the park's nature trail that had started to decay after a limb was torn from its massive trunk. The 165- to 180-foot tree was believed to be the oldest and largest in Pennsylvania, perhaps even the East Coast. Sadly, despite this intervention, the giant toppled over the next year. The park planted an additional 3,800 shrubs in 1936, including barberry hedges, Colorado blue spruce, Norway spruce, arborvitae and spreading juniper. A slew of new evergreens, exotic deciduous species and flowers appeared throughout the park for the 1937 season, from Tennessee sweet gums and junipers to red buds and forsythia. The island flowerbeds boasted unique species such as Texas bluebonnets, the only ones reportedly growing in Pennsylvania at the time.

Idlewild's board of directors focused on improving the park, but not so drastically that it would change its character. At the November 1936 board meeting, Chairman R. Stewart Scott suggested drafting a plot plan for future units and buildings, pools, tree plantings and flowerbeds at Idlewild "in order that none should be built or planted that would detract from the

This mid-1930s view of Idlewild's rustic auto entrance shows a Gulf gas station, the Trading Post general store, the park entrance sign, the blockhouse and a produce stand offering products from the Mellon family's Rolling Rock Farms. *Courtesy of the Idlewild and SoakZone Archives.*

natural beauty of the park." The result was a perfectly groomed midway bordered by privet hedges and "the prettiest grass in Ligonier Valley." C.C. Macdonald had a clear vision of Idlewild Park's future, as he told *The Billboard* in the September 30, 1933 issue:

> *As I look out over the park I estimate the crowd of patrons at not less than 3,000, all enjoying the sunshine of a delightful fall day in this mountain resort, with no special attraction of any nature, and most of them from Pittsburgh, 50 miles away.... The prospect for the future of the park industry looks mighty good, and we will all prosper providing we use business methods and common sense and work hard to give our patrons what they want, along with the best of service.*

A Ticket to Ride

Although admission to Idlewild Park was free, patrons purchased tickets to ride each attraction. Folks plunked down their money in exchange for strips of red ride tickets at small white ticket booths strategically placed around the park. Each ride cost a designated number of tickets. Groups hosting summer picnics at the park, like school districts, could often purchase ticket books at a discount prior to their outing.

In addition to the Philadelphia Toboggan Company carousel, one of the earliest adult amusements added during the Macdonald era was the Skooter, also known as the Dodgem ride, added in 1931 at the eastern end of the park. Drivers of twenty electrically operated bumper cars made by Lusse Brothers of Philadelphia tried to ram one another while speeding around a greased steel-plated floor in a roughly forty-two- by eighty-foot covered building. The novelty of this popular auto ride was the freedom to "drive 'em yourself."

Added in 1933, the Custer Cars ran along a seven-hundred-foot winding concrete track set up between the swimming pool and supply building at the lower end of the park, near the future Caterpillar site. Drivers operated the two-seater self-guiding cars by pressing their feet down on a button set into the floor of the cars, which ran on batteries that recharged overnight. Invented circa 1925 by Levitt Luzern Custer of Dayton, Ohio, these miniature autos ran on any type of track, making them perfect for amusement parks, as it was easy to turn a vacant, unused space into an Auto Speedway.

Now replaced by more modern bumper cars, Idlewild's Skooter ride originally featured twenty Lusse Brothers cars. *Courtesy of the Idlewild and SoakZone Archives.*

Operating for more than eighty years, the Skooter is one of the first rides C.C. Macdonald brought to Idlewild Park in 1931. *Courtesy of Jean Gordon Sylvester.*

A trio of new rides debuted in 1934: an Airplane Circle Swing, a Ferris wheel and a portable Whip. The first two were located close to the creek bank—the Ferris wheel left of the bridge crossing, with the Airplane Circle Swing, also called the Aeroplane Swing, farther east. Scant info about Idlewild's first Ferris wheel exists, only that it was a concession run by a Mr. Hocking. Made by the Charles Anderson Company, the eighty-four-foot-tall Airplane Circle Swing had suspended white wooden airplanes that swung out over the creek as the tall tower revolved.

The Whip sat near the Skooter and only lasted through the 1937 season. After a one-season hiatus, a Whip returned to Idlewild in 1939, but it appears to have been replaced by a new model in 1941: a twelve-car W.F. Mangels Company Whip,[144] which the Macdonalds allegedly ordered from the company's Brooklyn-based factory during their visit to the 1939 World's Fair in New York City.[145] The classic ride "whips" the two-seater tub-shaped cars around each end of an oval wooden track.

A German import called the Dangler only spent three seasons at Idlewild Park, from 1935 through 1937, placed between the Whip and Skooter. Described as a forty-two-passenger swing ride,[146] the Dangler appears to have been a Kettenflieger, a type of amusement known as a swing carousel or chair-o-plane, which involved a high revolving wheel with chairs suspended below on chains. According to German ride manufacturer

The wooden planes of the Airplane Circle Swing flew riders out over the Loyalhanna Creek. *From the Ray Kinsey Collection, courtesy of the Pennsylvania Room, Ligonier Valley Library.*

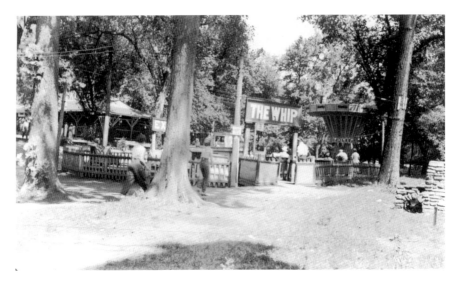

Idlewild's earliest rides included the Skooter, the Whip and the short-lived Dangler, seen here circa 1935–37. Note one of the park's many stone fireplaces, usually stocked with free wood. *Courtesy of the Idlewild and SoakZone Archives.*

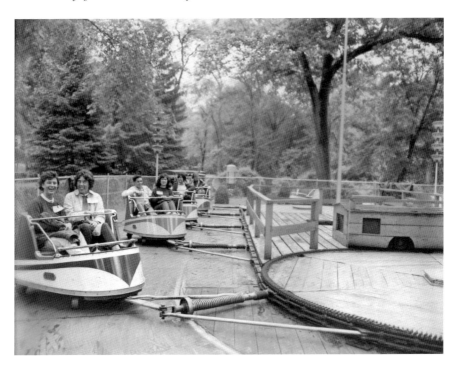

American Field Service students ride the W.F. Mangels Company's twelve-car Whip. *Courtesy of the Idlewild and SoakZone Archives.*

Peter Petz, Idlewild's Dangler was not a fancy model and came to the park during a time in Nazi Germany (1933–45) when German showmen with Roma or Jewish backgrounds were pressured to leave the country with their amusement equipment. The Idlewild Management Company may have decided to sell the Dangler because it was the lowest moneymaker compared to the park's other rides.[147] The park took a loss when it sold this device for fifty dollars in May 1938 to Charles Arthur (C.A.) Pressey, who owned two Pennsylvania trolley parks: Shady Grove Park in Lemont Furnace and Oakford Park in Jeannette.[148]

Another early attraction was a pony track, added in 1938, featuring fourteen live ponies. A Mr. Van Kirk first managed the concession, followed by Roy "Spider" Weller in later years. The ponies trotted along the Loyalhanna Creek west of the bridge, with stables located across from the minor islands in Lake Bouquet.

Macdonald's Menagerie

C.C. Macdonald also added a menagerie of animals to Idlewild that entertained park guests and kept the staff on their toes. The first group of animals brought to the park in 1931 included a pair of Canadian black bears (shipped from Michigan), a warren of raccoons and a gang of cheeky monkeys. The bear couple, Barney and Queen, soon added three cubs to their family: Amos, Andy and Ruby (the girl died of pneumonia). The bears lived in a fieldstone house, expanded in 1938 with a new concrete and steel bear pit with three separate cells and running water. Macdonald had a close call with Barney in March 1935 when he stepped into the cage and attempted to feed the 650-pound patriarch some dates he brought back from Florida. Barney lunged at Macdonald, who narrowly escaped the attack, coming back with a rifle to shoot the bear.[149]

Macdonald added more black bears to the zoo over the next decade—Idlewild had as many as seven at once—primarily relocated from Rock Springs Park, including a bruin name Bob and two females named Rosie and Queenie (both of which also bore young, including Mack and Minnie). Another Rock Springs transplant, a one-year-old bruin named Alphonso, escaped his temporary residence, an empty monkey cage, and set the Macdonalds and park staff on a wild chase around the park. The *Latrobe Bulletin* described the humorous scene:

As [lumberman Fred] *Martin warily approached the bear the animal suddenly loped towards him. This took Martin by surprise. He spun around and took to his heels with the rotund bear after him. The chase led across the Ligonier Valley Rail Road tracks and towards the bridge, leading toward the back of the park, while the other men were assimilating this unexpected development. When Jack Macdonald, the manager's son, attempted a rescue, Alphonso turned on him, and the boy emerged unscathed only after belaboring the angry bear with a broom. Mr. Macdonald, the manager, himself then took an active part in the excitement. He and Alphonso engaged in an impromptu boxing match, standing up and swiping at one another with hands and claws. The bear refused to be subdued and Mr. Macdonald retired from the battle to think up some more extensive measure.*

After several turns around the carousel, park staff tired Alphonso out and eventually returned him to his cage.

Over time, Idlewild's small zoo grew to include gray squirrels, a gray fox, a wildcat, deer, pheasants and a tame barred owl named "Chief Kol-Chaf-Te-Wa," originally cared for by Superintendent Pat Masterson and then keeper Obediah Rhodes. A fish pool added in 1940 displayed various fish native to Pennsylvania. However, by the early 1940s, the zoo had dwindled

C.C. Macdonald also filled Idlewild's small zoo with Canadian black bears, which lived in a stone house. *Courtesy of the Idlewild and SoakZone Archives.*

to the bears, monkeys and deer before it was eventually phased out after World War II.

The monkeys, who were probably the most popular of all the animals, escaped several times during their tenancy at Idlewild, most notably during the 1932 off season. Sometime on October 13, an unknown person unlocked the cage and set seven monkeys free. Idlewild was a perfect playground for the simians, who took their antics to the treetops. The monkeys eventually left the park boundaries, following the railroad tracks west toward Latrobe. Spotted at different locations around Darlington, Buttermilk Falls and as far away as Lycippus, the monkeys feasted on nuts and handouts, spied on construction workers and Lincoln Highway traffic and peeped into various residences.

Park management offered a reward of three dollars per monkey to anyone who captured the escapees, which stymied peace officer Mike Sagan's every attempt to reclaim them. Over the next month, local residents were able to capture most of the monkeys, the first one being the boss monkey, "Skivery," who joined Blanche McMahon at the Darlington train station breakfast table, as reported in the *Latrobe Bulletin* of October 18, 1932:

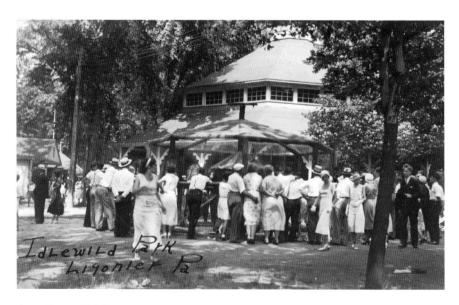

According to Dick Macdonald, his father, C.C. Macdonald, set Idlewild's monkeys free from their cage to generate publicity for the park. The monkeys escaped several times during their residency. *Courtesy of the Idlewild and SoakZone Archives.*

It seems that "Skivery" had been lurking around the Darlington station, which is also the home of the McMahons, while Mrs. McMahon was cooking breakfast. The appetizing aroma of the frying sausage was too much for the monkey "boss" and the kitchen door being open, he quietly walked right in and sidled up to the breakfast table. Quickly making the most of her opportunity, Mrs. McMahon handed "Skivery" a nice big pancake dipped in sausage gravy, and as he started to eat it with considerable gusto, she closed the kitchen door and the capture was complete, without ever a ripple of excitement.

The 1932 monkey escape generated a good deal of free publicity for Idlewild Park, as KDKA Radio and various Pittsburgh and New York papers covered the breakout. A series of front-page news articles in the *Latrobe Bulletin* dramatically described the monkeys' adventure as they traveled westbound from the park. The park sold two monkeys that were returned, but residents who captured four others decided to keep them. The seventh fugitive did not survive the winter. Each time the monkeys escaped—another five ran loose in June 1934 and were given to Pittsburgh's Highland Zoo—the culprit was never caught or identified.[150] However, Dick Macdonald suspected that his dad was the one who let the monkeys loose as a gimmick to generate publicity for Idlewild.

That's why it was done. I accused my dad of that. I said, "You just wanted the publicity." So he let the monkeys out. I don't know whether that's true or not, but he got a grin on his face when I said it.

Midway Amusements

In addition to rides, in 1931 the Idlewild Management Company also introduced the first of many diversions that tempted kids throughout the park's midway. The shooting gallery, Penny Arcade, Fishing Pond and other midway games were great opportunities for kids to plunk down their change for chances to win some neat prizes with luck and skill.

The shooting gallery, or rifle range, was contained in a small one-story frame building near the carousel. The W.F. Mangels Company, a popular manufacturer of shooting galleries, probably made Idlewild's model. Chained to the counter were ten rifles with real .22 Short lead shot that amateur sharpshooters used to hit a variety of painted cast-iron moving

targets in various shapes: ducks paddling on a lake, fountains squirting colored balls, squirrels climbing trees, birds, bull's-eyes and parachutists. The sounds of the soft lead pellets hitting the iron targets and the casings falling into the shot trap resonated throughout the park. In later years, the rifles were replaced by air-compressed guns.

One of Dick Macdonald's favorite stories about growing up at Idlewild Park involved the shooting gallery and his pal Bill Lemon, who worked that concession:

> *I used to have a slingshot and that slingshot had a handle on it. And it had a reservoir for BBs. I got pretty good with it—my dad ran me out of the park a couple of times because he was afraid I was going to hurt somebody....And the fellow who ran the rifles, the rifle range, was a fellow jokester of mine. We were always pulling pranks on people. So I decided I'd pull a prank on him. I was standing beside the shooting gallery one day and this good-looking gal walked by with her boyfriend. When they got down below the rifles...I let fly a BB and I knew I was on target right away when I let it go. And I turned to him and I said, "Hold this for me," and I handed him the slingshot. The girl yelled when that thing hit her, she said, "Yeaaaahhhh!" And her boyfriend looked around and saw my buddy with the slingshot and he came back....He didn't know what he was getting hell for.*

It took a few years for Idlewild's Penny Arcade to settle into a permanent location next door to the shooting gallery. For the 1931 season, the park converted the older, smaller dining hall located along the creek to house five Skee-Ball lanes. In 1933, the lanes relocated to a new dedicated Skee-Ball building squeezed in between the shooting gallery and adjacent root beer stand, which became the park's first official Penny Arcade. Although a new arcade building was added in 1934, the Skee-Ball lanes were once again transferred in 1936 to yet another new fifty- by sixty-foot two-story frame building near the carousel that replaced the existing root beer stand. As many as fifteen Skee-Ball lanes, other coin-operated games and a replacement root beer stand were all contained on the ground floor of the building, which operated as the park's full-blown Penny Arcade for about seventy years. The top floor was designed as a summer dining room with open sides that accommodated up to 250 people by reservation, but in 1937 the space was closed in to house park offices.

Rainy days meant a crowded, and noisy, arcade. The roar of the hard wooden balls rolling up the Skee-Ball lanes plagued Idlewild staff working in

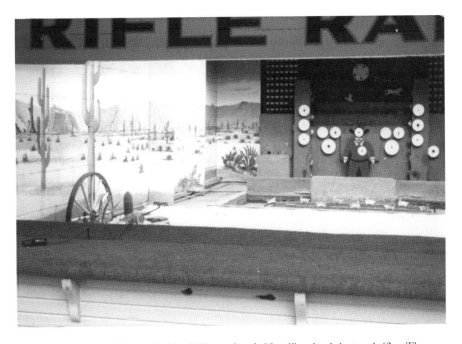

Idlewild's shooting gallery, added in 1931, used real .22-caliber lead shot and rifles. The sound of shots fired at the cast-iron targets reverberated across the park. *Courtesy of Dr. John Smetanka and Sandy Luther Smetanka.*

the second-story offices. Along with the Philadelphia Toboggan Company Skee-Ball machines, the Penny Arcade featured a variety of coin-operated amusements, including a weight machine, a recording booth, hand-cranked film viewers and, in modern times, video games. It also housed a photo booth concession where guests could take instant pictures of themselves to commemorate their day of fun, long before the days of cellphone selfies. Other machines stamped silver medallions engraved with the date of your visit, or your sweetheart's name, and spit out postcards with photographs of movie stars—Troy Donahue, Connie Stevens, Randolph Scott and Bette Davis. Another popular fixture was the Grandmother's Predictions fortune vending machine, which featured Esmerelda, the gypsy who dealt you a future-gazing card in exchange for your small change. Sara Jane Bitner Lowe described how the machine worked:

> *You put a coin in, it was just a glass case with an upper torso of a fortune teller, a woman, with a kerchief over her hair and she had big earrings and spangles and everything.... You put a coin in and she went through all these*

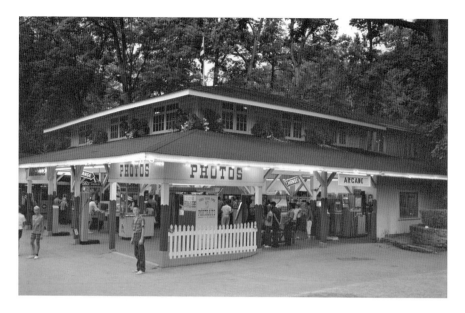

Seen here in the 1960s, Idlewild's Penny Arcade tantalized kids with coin-operated games, a photo booth and the Grandmother's Predictions fortune teller. *Courtesy of the Idlewild and SoakZone Archives.*

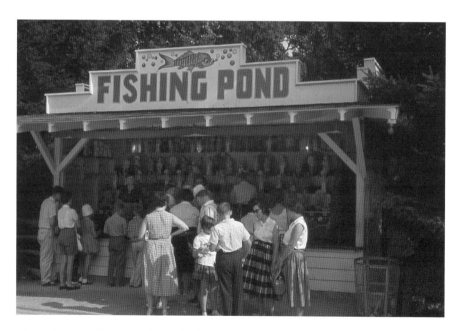

Those who reeled in fish no. 32 could choose any prize they wanted from the Fishing Pond game, where every player is a winner. *Courtesy of the Idlewild and SoakZone Archives.*

gyrations with her hands, moving her head, and eventually a card would come out and it would be like a fortune cookie. It would tell you something about what was going to happen in your life. I was just mesmerized by that as a child.

Besides the Penny Arcade, other games of chance and skill populated individual booths scattered around the midway, ranging from darts and basketball to ring toss, water pistols and milk bottle toss. Some of the lesser-known short-lived games and sports[151] included a football machine (1931, briefly), and two rounds of bingo (first in 1932 and then from 1936 to 1938 as a Jack Macdonald–run concession[152]). Special skates were used to protect the floor in the Auditorium during roller skating nights three times a week in 1934, run by V.C. Parks. During the 1941 season, an archery range was managed by instructors that showed novices the finer points of the sport. In the 1960s, a spin-art paint booth became a crowd favorite.

In 1936, C.C. Macdonald brought the park's longest-running game to Idlewild: the Fishing Pond, an amusement based on a 1909 patent developed by C.A. Pressey.[153] Jack Macdonald also operated this game booth as a concession in its early years. Players used a plastic rod to hook numbered plastic fish floating in a trough filled with vibrant blue running water. Each fish's number corresponded to a specific toy or knickknack—no. 32 was the Holy Grail, allowing you to choose your own prize. Many workers went home with blue hands at the end of the day, but all players went home with a treasure.

The Rumpus

The carnivalesque billboards on the sides of the old Penny Arcade along the creek promised folks, "Of all the rides, you'll like the Rumpus." Inside this building was Idlewild's only dark ride, located right of the bridge in one of the park's oldest buildings. The Rumpus is one of Idlewild's intriguing mysteries, as few extant records and media accounts of the attraction exist and photographs of it are scarce. The Rumpus was a Pretzel Amusement Ride Company creation, one of thousands of Pretzels that the New Jersey dark ride manufacturer installed in the majority of amusement parks across the country. Rock Springs Park already had an almost exact duplicate Pretzel ride that was attracting up to eight thousand riders per day, so it was

This rare 1940s glimpse of the Rumpus shows silly billboards meant to entice guests to brave the dark ride: "Of all the rides you'll like the Rumpus," "Grandma likes the Rumpus" and "If you love your wife, ride the Rumpus." *Courtesy of Mike Mesich.*

logical for C.C. Macdonald to bring a replica to Idlewild expecting the same success. Leon Cassidy, co-inventor of the Pretzel and owner of the Pretzel Amusement Ride Company, installed the Rumpus ride at Idlewild in 1936 as a concession, afterward selling it to the park in December 1938.[154]

No photographs of this dark ride's interior have yet to come to light. However, by the end of 1941, the Idlewild Management Company had approached the Philadelphia Toboggan Company to design some modifications to its "Pretzel Ride" that reveal its inner workings.[155] Newspaper reports and memories from folks who braved the Rumpus add up to a standard description of a dark ride: for the approximate four-minute journey through the Rumpus Caverns, riders sat in seven two-seater cars operated by an outside control as they wound through the building along a single electric rail, encountering paper snakes, fake monster heads, skeletons and other surprises that sprung up at a moment's notice.

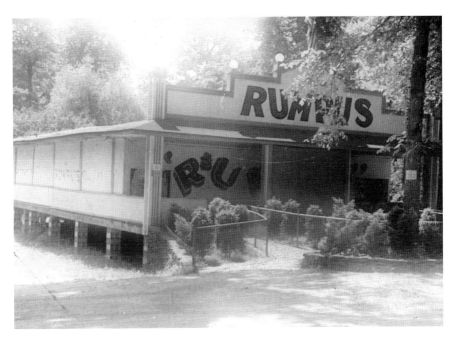

Two tickets got you a ride on the Rumpus, Idlewild's dark ride installed in the former Penny Arcade/dining hall along the creek. *Courtesy of the Idlewild and SoakZone Archives.*

Merriam-Webster defines the word *rumpus* as "a usually noisy commotion." Sure enough, "You'd hear the girls screaming their heads off" from inside the ride, according to Connie Deemer, who grew up next to the park at Millbank and remembered riding the Rumpus frequently as a young girl. She had the inside scoop, as her father, Earl Ritnour, was the head of maintenance at the park during the late 1930s and early 1940s. Deemer knew exactly what surprises lurked around each corner, including the blow-hole installed under the walkway—a stunt typically found in funhouses that blew air up girls' skirts as they walked over a grate. Laffing Sal, an animated female figure created by the Philadelphia Toboggan Company, stood about five feet tall at the ride's entrance, welcoming visitors with an eccentric dance and a screeching laugh produced by a concealed turntable and speaker. "People used to stand for hours and imitate. You'd end up laughing, no doubt about it," said Deemer, recalling the rotund mechanical lady.

Although it was a "silly-scary" ballyhoo ride designed to thrill riders and give couples an opportunity to sneak a kiss in the dark, the Rumpus was too extreme for at least one patron. In 1938, its paper snake stunt frightened one woman with a heart condition so severely that she fainted. The "paper

PR400101

A November 1941 proposal for track changes shows more than a dozen stunts in the Rumpus. Riders encountered paper snakes, fake monster heads, skeletons and other surprises that sprang up at a moment's notice. *From the Philadelphia Toboggan Coasters Inc. Archives, courtesy of Tom Rebbie, president/CEO.*

Laffing Sal (*left*), a Philadelphia Toboggan Company creation, welcomed visitors to the Rumpus with her screeching laugh. A few Pretzel Amusement Ride Company stock cars roll by behind Sal. *Courtesy of Mike Mesich.*

snakes" that the *Ligonier Echo* described could have been spools of thread that typically dangled from the ceiling of Pretzels and tickled riders as they moved through the dark ride.[156] The paper snake incident sparked rumors that a child died after being bitten by a copperhead at Idlewild—one of many unfounded snake rumors that persist today.[157]

Rollo Coaster

Although former management declined multiple offers for a roller coaster, by the fall of 1937, C.C. Macdonald had contacted the Philadelphia Toboggan Company with plans to bring one of their kiddie coasters to Idlewild Park. By the end of the year, the two parties had struck a deal. On December 22, 1937, the respected coaster and carousel manufacturer approved a contract with the Idlewild Management Company, selling the park kiddie coaster plans and equipment for $3,600.[158] The company also purchased various machinery and equipment including six two-seater coaster cars that linked to form two trains.

The junior coaster, PTC no. 101, was designed by Herbert P. Schmeck, Philadelphia Toboggan Company chief engineer, head designer and eventual president, who plotted out nearly ninety roller coasters for the company during his career. Schmeck probably traveled to Idlewild Park to check out the proposed spot for the coaster in order to develop the resulting out-and-back design that incorporated the park's natural topography.[159] Constructed along a small hillside dotted with trees at the west end of the park, the coaster is another example of how seriously Idlewild's management adhered to the unspoken rule of building around the trees.

After ascending a lift hill, the coaster train races along the top of the knoll toward Lake St. Clair, sweeps down and carries riders along the bottom of the hill back to the station—all through the momentum of gravity. The only driving mechanism is the lift hill. For a junior coaster reaching a top speed of twenty-five miles per hour and a maximum height of 27 feet, the Rollo nonetheless gave its first riders a thrill as it swept them through the trees along the nearly 1,100 linear feet of track before manual skid brakes brought them to a stop at the station.[160]

Contemporary newspaper reports of Idlewild's coming attraction confirm the long-standing local legend that the roller coaster was built using oak trees felled and harvested from the park property.[161] During the winter, the timber

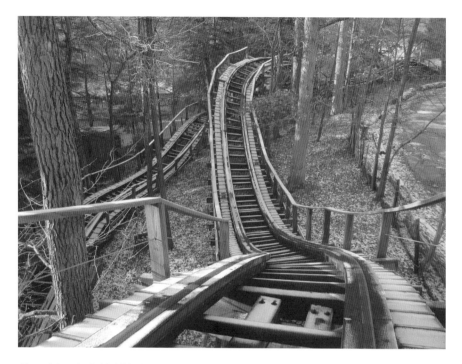

Above: After the initial lift hill, gravity provides the momentum for the Rollo Coaster, whose trains sweep passengers atop a tree-covered hill and then return to the station along the bottom. *Courtesy of Torrence Jenkins Jr.*

Opposite: Although it is a junior coaster, both kids and adults have enjoyed the thrills of the Rollo Coaster for eighty years, as seen in this 1950s photograph. *From the Fantastic Fotographica Collection, courtesy of Harry Frye.*

was cut and processed through a sawmill built near the Lincoln Highway entrance to the park.[162] The track rails were fashioned from ten thousand pounds of quarter-inch-thick steel purchased from the Railway Steel Spring Company in Latrobe (formerly the original Latrobe Steel Company).

Philadelphia Toboggan Company workers commissioned to repaint the park's carousel and shooting gallery also oversaw the coaster's construction. However, it was common for PTC to sell only the design for a roller coaster, plus the machinery, leaving the client to purchase materials (in Idlewild's case, harvest on site) and hire its own workers to build the ride. It was also cheaper for the buyer. Family lore of grandfathers and uncles helping to build the coaster indicate that the Idlewild Management Company hired local labor for this project, including Eugene "Gene" Ambrose, who mentioned during family get-togethers that he helped build the Rollo

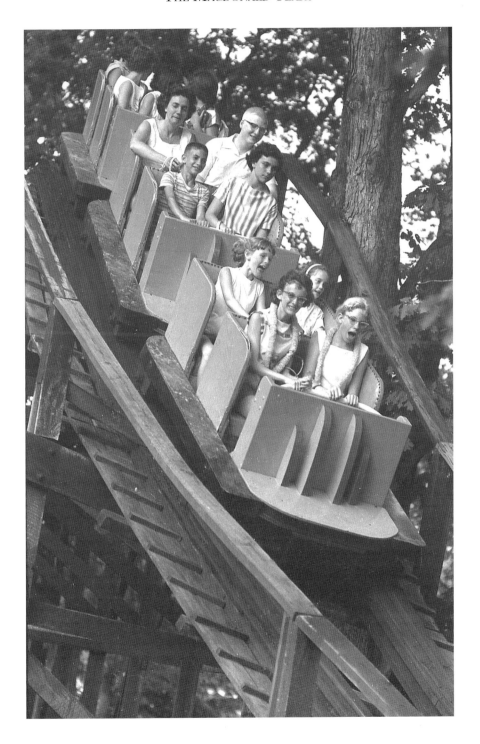

This Plan and Profile of Coaster at Idlewild Park shows Philadelphia Toboggan Company engineer Herbert Schmeck's out-and-back design for the Rollo Coaster. *From the Philadelphia Toboggan Coasters Inc. Archives, courtesy of Tom Rebbie, president/CEO.*

Coaster. Gene and his brothers, Jim and William, owned the local Ambrose Brothers Construction company. Wayne Johnson also remembered that his uncle from Darlington, Richard E. Bates, worked with chief carpenter Morrison Noel on the coaster build.

Construction wrapped on Idlewild's roller coaster in time for opening day, May 21, 1938. More than eighteen thousand guests crowding the park on Decoration Day had the opportunity to try out the new thrill ride. The coaster debuted without a name, as park officials wanted to see what clever suggestions people would come up with after their first ride.[163] Idlewild held an official name contest where kids from local school districts could drop their submissions into a box set up near the coaster station. Thirteen prizes were awarded to the top suggestions, with the winning name netting a top prize of five dollars.[164] Several years after the coaster opened, the *Latrobe Bulletin* described what by then was named Rollo Coaster as a "Ghost Train," as the cars glided along the tracks in silence. However, the coaster did not

PLAN AND PROFILE OF COASTER
AT
IDLEWILD PARK LIGONIER, PENNA
PHILADELPHIA TOBOGGAN CO.

7-1071

sound quiet to Idlewild's neighbors, like Jean Gordon Sylvester, who grew up in the nearby village of Darlington:

> *After all these years I can still hear the "clack-clack-clack" as the cars go up the hill and the "whoosh" as it goes down and around. You could hear it from our house, all summer long.*

Since its debut, Rollo Coaster has remained one of Idlewild Park's oldest and most popular rides. It proved to be the park's biggest moneymaker during its inaugural season, bringing in $10,755.75 for 1938, and continued to top revenue lists in the succeeding years, with both kids and adults cashing in tickets for a ride on the coaster. According to Dick Macdonald:

> *It was built primarily as a kiddie coaster. It wasn't a big coaster, like the big coasters you see at Kennywood and those places. It was not meant to be a big coaster, but after it was built, you couldn't keep the adults off of it.*

The Idlewild Express

Perhaps a nod to Idlewild's origins, in 1939 the park introduced the Idlewild Express, a nearly mile-long miniature railroad that ran along the perimeter of Lake Bouquet, giving riders a scenic view of the island, motor launch and waterfowl. Manufactured by the Dayton Fun House Company (renamed the National Amusement Device Company after World War II), the attraction had two Zephyr streamlined gasoline-powered locomotives (no. 102 and Old no. 97, the latter called the Casey Jones Special) that each pulled five roofless cars holding up to forty passengers. More than three thousand white oak ties and twenty-four thousand spikes laid the two-foot-gauge track.

After leaving a sixty-five-foot-long covered depot near the lake bridge, the miniature train paralleled the Ligonier Valley Rail Road track between Lake Bouquet and Lake St. Clair before reaching the Darlington station. The Idlewild Express then chugged south along the western end of Lake Bouquet and back east between the lake and the Loyalhanna Creek. Several thousand evergreens added around the area enhanced the scenery. Before returning to the depot, the trail ran through a seventy-foot tunnel and then over a two-hundred-foot wooden trestle built over the lake and under the

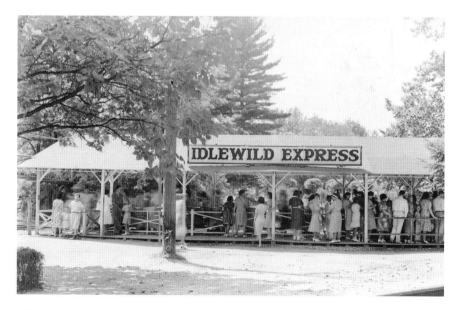

This page and next: The Idlewild Express, a gasoline-powered miniature railroad that traveled the perimeter of Lake Bouquet, debuted in 1939. *Courtesy of the Idlewild and SoakZone Archives.*

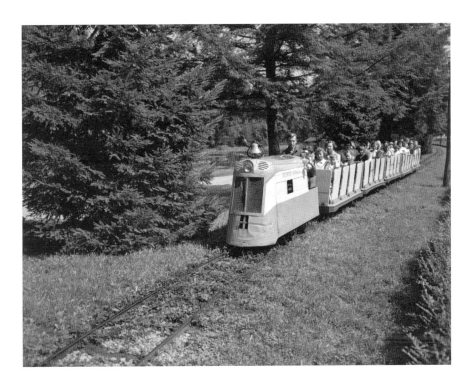

pedestrian bridge. The trestle eliminated the need for a train crossing over the main pathway to the pool.

After nearly a decade leasing the ride, in May 1948 the Idlewild Management Company bought the Idlewild Express miniature railroad concession, including track and tunnel, for $5,500 plus 65 percent of gross operating receipts, then co-owned by Jack Macdonald, R.S. Scott and N.E. Garver. Special effects later added to the scenic railway included a ghost town scene with a Music Hall building and four animated cowboy skeletons that greeted riders as the train passed along the south side of Lake Bouquet. Two National Amusement Device Company locomotives designed to look like traditional steam trains later replaced the original Art Deco engines.

Sweet Treats

Although Idlewild visitors were always welcome to bring their own picnic baskets to the park, filled with meals from home or goodies purchased from the Darlington train station, fragrant smells from the park's multiple eateries

tempted their taste buds. For the 1931 season, the Idlewild Management Company built a refreshment stand, an ice cream stand and a popcorn stand. The park's refreshment buildings initially contained charcoal stoves fed by fuel created on the park property. Once he realized that the charcoal the park bought from a Pittsburgh wholesaler was actually harvested from the Ligonier Valley, C.C. Macdonald decided to cut out the intermediary and produce charcoal in a series of seven kilns installed on the south bank of the Loyalhanna Creek.

Idlewild offered guests a variety of treats from which to choose: hamburgers, warm bags of peanuts, French fries served in a paper cone, candy and caramel apples, hand-spun cotton candy and frothy root beer. The one treat that C.C. Macdonald was especially fond of was popcorn; in 1938, he organized a local popcorn club where Boy Scouts planted a one-eighth acre of white corn that Idlewild purchased when harvested. Macdonald also strategically placed a refreshment stand near the entrance to the pool to entice hungry kids with the smell of the freshly popped kernels after they spent all of their energy splashing around in the cold water. Nothing went to waste—extra kernels became animal feed, available in vending machines on the island bridge. Although not quite edible, folks could also purchase cigars at the refreshment stands.

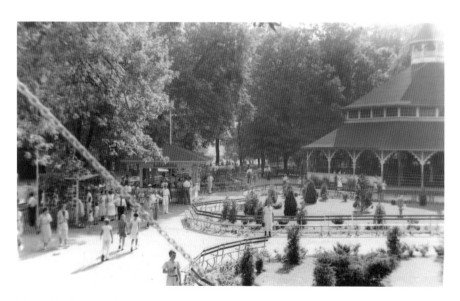

Idlewild had plenty of seating for patrons enjoying refreshments thanks to the many green iron benches placed around the park. A small ice cream stand can be seen just left of center in this undated photograph. *Courtesy of Dr. John Smetanka and Sandy Luther Smetanka.*

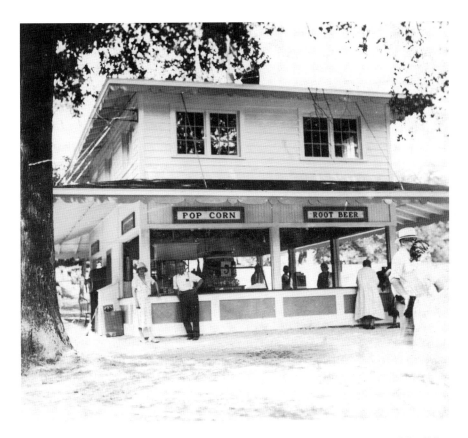

As C.C. Macdonald was especially fond of popcorn, the park offered the treat at Idlewild's refreshment stands, with one seen here in 1932. "The smells of popcorn and cotton candy wafting through the park would knock you down," remembered Jean Gordon Sylvester. *Courtesy of Dr. John Smetanka and Sandy Luther Smetanka.*

The Idlewild Management Company continuously upgraded its kitchen equipment and facilities, adding a new cold storage refrigerator and an ice cream plant in 1940. A new ice cream building called the Dairy-Go-Round—marked by a spinning mobile on the roof—replaced the previous ice cream stand for the 1952 season and served a creamy frozen custard called Frosted Fun.

In addition to the refreshment stands, in 1937 Idlewild opened a new restaurant in a forty-seven- by thirty-six-foot renovated building that served "good food in plate lunch style." A year later, in 1938, another new restaurant opened at that location featuring a steak-themed menu. Chef James Pergamalis led the Steak House in 1941, and his fare came from local sources—vegetables from nearby gardens and dairy products and eggs from

certified Ligonier Valley farms. Diners enjoyed the shaded porticos on the restaurant, which was located on the south side of the railroad tracks near Lake Bouquet. The central theme changed over the succeeding years: a revamped steakhouse (1948), the Carrousel Restaurant (1966), Three Platter Restaurant (1970s), Pasta Warehouse (1986), Italian Warehouse (1993), Pasta Works and the Back Porch Restaurant (2006). Since 2014, the restaurant has operated as Boardwalk Pizza.

The Group Picnic Tradition

Communities, schools, churches, clubs, companies and families continued to host picnics and reunions at Idlewild Park under the Macdonalds' tenure. By 1940, Idlewild was hosting more church and community groups than any other park in Western Pennsylvania.[165] A list of the visiting groups posted at the entrance gate told visitors who they could expect to see at the park that day. Sometimes these picnics were a family's only opportunity to visit an amusement park that year, so the day was a treasured experience, rain or shine, said Shirley McQuillis Iscrupe: "I can remember driving past the old front gate all throughout my childhood and teenage years and we'd slow down so we could look over and see the names of the picnics that were happening."

Picnic programs incorporated many of the same activities as earlier days, including baseball and mushball games, live music, dancing and special entertainment from the resident free act. The Idlewild Management Company even issued a small pamphlet describing numerous games. Some activities ran traditional, like potato sack and egg spoon races, tug-of-war, horseshoe pitching, pie-eating contests and sawdust scrambles. Others challenged athleticism, balance and coordination, like the crab walk, three-legged race and shoe scramble. Some were more creative, such as the balloon bust, where contestants protected inflated balloons tied to their waists while their competitors tried to pop them with rolled-up newspapers. Some games invited gender politics: women could participate in a husband-calling contest, a nail-driving contest or the rope-skip race, deemed "best for young girls," while men competed for the champion smoker title. There were also contests for the youngest, oldest, tallest, shortest and heaviest man and woman in attendance, plus the farthest traveled.

The most exciting event of the third annual Greensburg picnic in 1931, however, was the race to capture a greased pig let loose from its cage. The

This photograph shows a fun pie-eating contest on Idlewild's stage during the Alcoa company picnic in June 1946. A games brochure suggested that "good juicy berry pie gives best results." *Courtesy of the Idlewild and SoakZone Archives.*

Greensburg Review announced that the prize was—what else?—the eighty-pound oinker itself:

> *Eighteen young men made a dash for the pig, which ran rapidly through the crowd and took to the hill east of the dancing pavilion. The scene was one succession of thrills as women and children were pushed aside as the crowd of men followed the racers. Edward Palmer was the first young man to catch the pig but it broke away from him while leading it down to the pen. A second grand rush was made for the pig and this time Ray Hahn caught and took it to the pen.*

Local businesses typically closed during the community picnic days to allow everyone in town a day at Idlewild. Stores donated prizes for the various contests, games and raffles, from housewares and televisions to sporting equipment and toys—even automobiles. They also sponsored free refreshments such as gallons of hot coffee, freshly squeezed lemonade, cold pop, bricks of ice cream and lollipops. Families continued to tote baskets of

Shoe scrambles, where kids placed their shoes at a distance and raced to pull them back on, were one popular contest during group outings, as pictured here during the Latrobe Community and Schools picnic on June 12, 1962. *From the Fantastic Fotographica Collection, courtesy of Harry Frye.*

food and spread tablecloths across the numerous picnic tables throughout the park where they laid out their feasts.

School districts in particular made up a significant chunk of Idlewild's group picnic business; each year, the number of schools and groups visiting the park increased. For example, the 1938 season saw 30 different schools hosting outings at the park from six different counties in Western Pennsylvania. More than one hundred major picnics plus numerous small groups visited during the 1939 season, with a 60 percent return rate. In 1940, Idlewild expected approximately 150,000 kids that year—the largest kiddie attendance in the park's history to that date, with 180,000 in 1941. The picnic schedule for 1953 included 120 school outings, 70 employee picnics, 30 community reunions, 75 family reunions and more than 40 church picnics.

Agricultural groups celebrating Western Pennsylvania's farming industry at annual picnics can be traced back to early gatherings like the first Ligonier Grange no. 928 picnic in September 1891. Later, groups such as the Westmoreland County Farmers' Association, Clover Farm Stores and the 4-H Club, which C.C. Macdonald particularly supported, began their own traditions at Idlewild. Events spanned several days, with various displays of animals, farm equipment, baked goods, crops and crafts. The

A crowd watches a woman's nail driving contest on the stage during a group picnic. *Courtesy of the Idlewild and SoakZone Archives.*

Westmoreland Agricultural Fair and Recreation Association selected Idlewild Park as the site of the long-running Westmoreland Fair for the event's first two years, in August 1955 and 1956, before the county event moved to its own permanent location.[166] Along with crowds of people, herds of cattle filled the picnic grounds and pavilions. Unique competitions and activities included the cow and hog calling contests, guinea hen and greased pig chases, log-sawing contests and round and square dancing, capped off by the coronation of the County Fair Queen.

Many of these groups traveled to Idlewild via Pennsylvania Railroad excursion trains or on the local Doodlebug (known locally as the "Dinky"), one of the self-propelled railcars the Ligonier Valley Rail Road employed for daily trips between Ligonier and Latrobe beginning in 1928. Lengthy trains unloaded passengers at the Idlewild depot, turned around in Ligonier and parked at a siding near the park for the journey home at the end of the day.

Jim Ramsey, who grew up on West Vincent Street only a few blocks from the Ligonier terminus, had a good view of the Pennsylvania Railroad specials that brought employees and their families to Idlewild Park for company picnics:

Idlewild's rustic pavilions, like this one shown here in 1933, hosted community, school, church and company basket picnics each year. *Courtesy of Dr. John Smetanka and Sandy Luther Smetanka.*

4-H Club fairs at Idlewild featured cattle displays set up in the park's picnic pavilions, like one shown here circa 1950s. *Courtesy of Dr. John Smetanka and Sandy Luther Smetanka.*

I think one I remember most, because my dad worked at Westinghouse in Derry, was the annual Westinghouse picnic....And they brought trainloads of people from east Pittsburgh and that area primarily out to Idlewild. And they brought the train out with maybe 10, 12, 18 passenger cars....They would come out, they would let the people off and the train would come up and it was so long that they couldn't make the switch [at the wye in Ligonier] *to change direction to go west. They had to break the train into sections to make it go west. They would back up the cars. There were four tracks that went across Vincent Street. And they would park the cars on three of those tracks and the engine would be parked up by the roundhouse (now Holy Trinity Catholic Church on West Main Street).*

Locals predicted how big the crowds at Idlewild would grow by counting the number of cars on the excursion trains. Toward the end of the day, enterprising kids lingered near the trains ready to whisk groups home after a long picnic day at the park, as those with leftover ride tickets sometimes threw them from the windows into eager hands. But as time passed, Idlewild received an increasing amount of traffic from folks traveling by car along the Lincoln Highway. One of the biggest employee picnics was Westinghouse Air Brake, which set a new daily attendance record of thirty-five to forty thousand people at Idlewild during its forty-ninth annual picnic on August 25, 1934. The park's entrance gates closed early after all parking spaces filled, and traffic became gridlocked on Route 30 for several miles.

Reports of group picnics were generally favorable; perhaps the most common thing to spoil the day of fun was inclement weather. Yet despite the ban on alcohol, there were infractions. Idlewild's remote location did not isolate the park from real-life social issues taking place, either. In 1935, Governor George H. Earle III signed Act 132, the Pennsylvania Equal Rights Bill, which amended an 1887 civil rights act to penalize owners or managers of public accommodations, including amusement and recreation parks "who shall refuse to accommodate, convey or admit any person or persons on account of race or color."[167] That legislation was purportedly the cause of trouble that broke out during a Works Progress Administration picnic at Idlewild Park in June 1936, where two young men—one white, one black—were arrested for fighting in the woods near the Auditorium. Organizers called off the WPA's evening dance for fears of "a possible outbreak due to racial feeling."[168]

Despite these relatively isolated incidents, Idlewild's group picnics generated nostalgia and good comradeship among the communities, organizations, schools and companies that hosted outings there. The

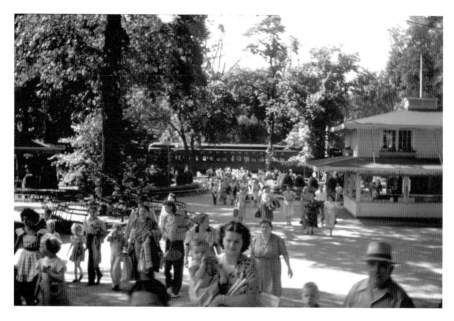

A Pennsylvania Railroad train chugs through the center of Idlewild on a busy day, passing one of the park's refreshment stands, still used today as the Sweet Treets confectionery store. *Kennywood Slide 135, courtesy of the Detre Library and Archives Division, Senator John Heinz History Center, Pittsburgh, Pennsylvania.*

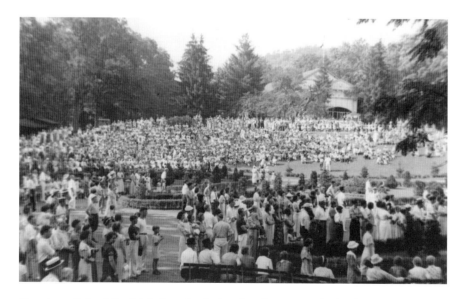

Crowds swelled at Idlewild during school, church and company picnics. In this undated photo, hundreds of guests gather on the lawn, probably watching an exciting free act. *Courtesy of the Idlewild and SoakZone Archives.*

picnics made the longest-lasting memories of Idlewild, according to Sara Jane Bitner Lowe:

> *The main thing I remember about Idlewild, though, are the picnics, because that was really the big thing at the park. We had community picnics, the whole town would go....The school districts always had a day, right at the end of the school year....And then churches had picnics, they would have a Methodist Day or a Presbyterian Day....Just about everybody would take their picnic lunch and they had a lot of shelters scattered around the trees and picnic tables and so forth. My whole entire family would go—aunts and uncles and cousins and everybody. Back in the good old days, you could just put [your basket] down and it would be there when you came back. That was the purpose for going. You socialized, you saw everybody that you knew in town. And then as a kind of an afterthought, they had some rides and things like that. But picnics were the main reason for going to the park for a long, long, long time....It was just a community place to get together, the gathering place where you saw your friends and you took food and people got together.*

Free Acts

Guests knew that the free act was about to begin when the opening notes of John Philip Sousa's "The Stars and Stripes Forever" streamed over the park's public address system. Fireworks, parades and balloon ascensions often entertained group picnics during Idlewild's early history, but the Idlewild Management Company took these acts to new heights—treating its patrons to more consistent, exciting shows at no additional charge. C.C. Macdonald booked a variety of local and national performers for twice or thrice daily shows during multi-week engagements: trapeze and high-wire artists, high dive and cannonball stunts and circus troops. The traveling acts often lodged in cottages along Darlington Hill Road (now Idlewild Hill Road) across from the Darlington train station. Dick Macdonald described his father's idea behind the free acts:

> *That was the way you attracted people to the park, by bringing in free acts. We called them free acts. And we brought people, we brought flying trapeze people in and all kinds of free acts and they would run maybe two weeks or a month and that would change.*

The hill below the Auditorium was the prime spot for guests to watch daredevils dance on a rigging set up on the grounds next to the Skooter, according to Sara Jane Bitner Lowe:

What I remember of the layout of the park back in those days, is in the middle of the park there was that hill, that grassy hill, and people would spread their blankets and so forth and sit on that. And then down at the bottom of the hill there were benches so that people who couldn't really climb up and sit on the ground could sit there. My grandmother always sat on those benches. And it faced the place where they had the entertainment.

The circus was always a popular draw, with clowns, live animals and dramatic stunts. C.C. Macdonald brought in several different troupes, the first of which was Madam Maree's circus, whose trained ponies, dogs, monkey and mule performed under Ringling-Barnum at New York City's Madison Square Garden before appearing at Idlewild in 1931. The Dutton Society Circus enjoyed a long tenure at Idlewild Park, beginning in the early 1930s, as the Macdonalds were close friends with founder Nellie Dutton. The Dutton Circus presented a variety of acts twice a day during its residency, from trapeze performers to tight-wire walkers and equestrians. The review was also famous for its unique trained camel and elephant acts. During off hours, the troupe sometimes bathed the elephants in the Loyalhanna Creek, which made a convenient bathtub. Dick Macdonald remembered how one of the elephants was recruited to help clean up debris around the park after a flood, lifting scattered trees with its trunk.

Elephants frequently appeared at Idlewild from the 1930s through the 1960s. Pinky and June Madison brought their baby elephants, who danced and rode tricycles. Before them, Rosalie Adele Nelson's Dancing Elephants had a summer residency at the park, often boarding at the nearby Shirey Farm, where Lawrence and Ruth Shirey ran a motel and cottage complex. The performing pachyderms followed the Ligonier Valley Rail Road tracks east toward the farm where they treated the Shirey children Robert, Betty and Dean to free rides.

High-wire and trapeze acts were also some of the most common free entertainment the Macdonalds introduced at Idlewild Park every summer. Billets included the Wallenda Duo—a high-wire act formed by two members of the famous Flying Wallendas—that appeared in August 1966. The Hustreis, a family boasting a three-hundred-year history in the industry, demonstrated their high-wire bicycle act. Female daredevils were also

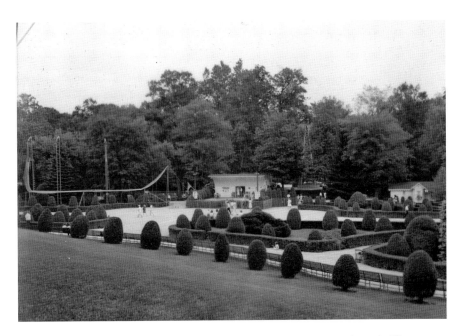

The hill below the Auditorium was a great spot to watch free acts perform thrilling stunts or listen to musical groups on the park stage. Idlewild's adult Whip, Tilt-a-Whirl, Rockets and original railroad depot also appear in this undated photo. *Courtesy of the Idlewild and SoakZone Archives.*

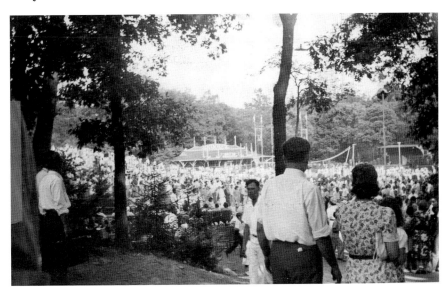

Human cannonballs, trapeze artists and high-wire acts were booked consistently throughout the summer at Idlewild, drawing massive crowds to watch from the hill below the Auditorium. *From the Rose Mary Steinmetz Collection, courtesy of the Latrobe Area Historical Society.*

Rosalie Adele Nelson's Dancing Elephants often boarded at the nearby Shirey Farm during breaks from the show's engagement at Idlewild Park in the 1930s. The Shirey children— Betty, Dean and Robert—pose here with one of the performers along the railroad tracks. *Courtesy of David Shirey.*

promoted, like the Flying Valentinos and Shirley Gretona, the youngest high-wire artist in the world, whose flying family performed at Idlewild in 1948 without using a safety net. The park also brought in the Bob Eugene Troup of Ringling Brothers Circus fame to perform in 1940, which incorporated comedy into its high aerial bar act. But the most popular and dramatic act that appeared at Idlewild was the human cannonball. Maddalena Zacchini, third generation of the storied Zacchini family who first developed the stunt, dazzled the crowd by launching herself from a cannon during multiple 1960s appearances.

Unique acts included Japanese high diver Bee Kyle, who splashed down at Idlewild during several seasons in the 1930s. For her night performance, Kyle doused her clothes with gasoline and set herself on fire before leaping from a 110-foot ladder into a water tank. A team of cowboys and cowgirls starring in California Frank's Rodeo Show chased down six of the act's Brahman steers who escaped their corral in May 1933, crossed the Loyalhanna Creek and crashed a baseball game in

progress. Audiences laughed at Mr. Coco & Company, a chimpanzee comedy act that appeared on *The Ed Sullivan Show*, as the animals rode bicycles and performed acrobatics on stage in 1961. Oscar V. Babcock brought his famous bicycle stunt, "Looping the Death Trap Loop," in the summer of 1936, where he rode down a sixty-five-degree incline into a twenty-six-foot loop followed by a giant leap through the air. The sixty-four-year-old only performed this hazardous act once a day in good weather conditions. Dot Lind, touted as a "modern Annie Oakley," performed alongside marksman husband Ernie Lind for a shooting exhibition at Idlewild in June 1950.

Bob Fisher's Five Fearless Flyers, an internationally famous aerial troupe, gave visitors an added treat on August 12, 1932, when two of their members married on the trapeze rigging just prior to their evening performance. Reverend Herbert Brant, pastor of Donegal Lutheran Church, joined Grace Moore and Harold Jenders in holy matrimony from a platform high above a crowd of several thousand onlookers. The ceremony capped off the troupe's two-week engagement at the park that summer and was the first ceremony of its kind in circus history. Bob Fisher and C.C. Macdonald developed a strong business relationship and friendship since the troupe's debut at Idlewild in July 1932, and as such, Fisher's Famous International Flyers would continue to return to Idlewild each year to entertain the crowds. Fisher became manager of Idlewild Park's refreshment stands in his retirement.

These death-defying stunts continually thrilled guests, but one performance ended in tragedy when a veteran parachutist fell to her death in front of a crowd of more than five thousand people attending an Independent Order of Odd Fellows picnic. On the evening of August 12, 1933, forty-year-old Juanita Arnold (married surname Rowell) of the Parent Balloon Company harnessed herself to a platform attached to a large balloon and took to the skies, intending to perform her triple parachute jump as she had done every night that week. However, something went terribly wrong this time—before the balloon reached five hundred feet, one side ripped open and the canvas turned inside out. Rowell had no time to deploy any of her parachutes before she plummeted to the ground.

Jim Ramsey witnessed Rowell's accident that evening. Every night over the past week, the seven-year-old boy and his older brother, Bob, watched the balloon rise above the treetops from the backyard of their home on West Vincent Street in Ligonier. The brothers kept asking their parents if they could watch the balloon ascension at the park. Finally, one evening they

A rigging set up near the Skooter building supported free acts such as Bob Fisher's Five Fearless Flyers, who frequently dazzled crowds with their trapeze stunts. *From the Ray Kinsey Collection, courtesy of the Pennsylvania Room, Ligonier Valley Library.*

agreed. After parking near the Darlington station, Ramsey said the two boys ran along the railroad tracks toward the balloon as it began to rise. All of a sudden, Jim saw the balloon burst and fall to the ground, its heavy brown canvas covering Rowell: "I remember looking at the balloon laying on the ground. It was like a patchwork quilt."

Although several doctors and nurses present at the park tried to revive Rowell, who suffered a broken neck and legs, she never regained consciousness and died by the time she arrived at Latrobe Hospital. Dick Macdonald also remembered the tragedy:

> *That's stuck in my memory. I watched that woman parachute out of the balloon. Back in those days, you rode a hot-air balloon and when you left the balloon, it turned upside-down and, exhausted, it came down. It let out all its air. And this woman rode this seat she was on, after the balloon split, it dropped her down. I watched her come down. She landed right in front of the dance hall. I can remember her heel marks were there for a long while.*

Folks also crowded the hill to watch radio, television and comedy stars perform on an outdoor stage added between the Skooter building and first-aid station in 1933. With the acoustical benefit of a curved roof, Idlewild's

stage attracted a variety of regional and nationally acclaimed entertainers. Country and bluegrass acts were standard fare, such as Grand Ole Opry star Little Jimmy Dickens, known for his short stature (four-foot-eleven) and rhinestone-studded suits, and Slim Bryant and His Georgia Wildcats, a country band that had a twenty-year run on the early morning radio show *KDKA Farm Hour*. The Wildcats began performing at Idlewild in 1941 and included Slim Bryant on guitar, Jerry Wallace on banjo, Ken Newton on fiddle and singing tenor and Loppy Bryant on bass fiddle. Abbie Neal and Her Ranch Girls, an all-girl western band, closed the park's 1956 season, showcasing Brookville, Pennsylvania native Esther "Abbie" Neal's mastery of the fiddle and steel guitar and the group's vocal harmonies. Neal hosted and starred in live radio and television shows in the Pittsburgh area, and her fifty-year career included a longtime stint with Cowboy Phil's band on radio station WHJB in Greensburg. Jimmy Martin and the Sunny Mountain Boys brought their innovative "Good 'n Country" beat to Idlewild's stage in the early 1960s, mixing snare drum with mandolin and tight vocal harmonies in their bluegrass standards. Martin began his career with Grand Ole Opry star and bluegrass music pioneer Bill Monroe and was inducted into the International Bluegrass Music Hall of Honor.

In 1933, the park began a series of Sunday programs featuring nationally known radio and stage stars, including the Westinghouse Band, a pioneer music group booked by the Westinghouse Electric & Manufacturing Company to perform concerts during the experimental stages of KDKA, the world's first radio broadcasting station based in Pittsburgh. The band appeared at the park on July 9. Another special guest on August 6 was Albert "Rosey" Rowswell, who would become the Pittsburgh Pirates' full-time play-by-play announcer in 1936; the sportscaster was known to throw out creative catch-phrases during the Buccos' games. Jacqueline Sloan, who danced with the Rockettes at New York's Radio City Music Hall and in the Pittsburgh Civic Light Opera Ballet, appeared at the park in July 1947.

Idlewild also featured programs with cultural and educational import. Members of the Hopi Indian tribe visited the park in August 1932—the first of their several visits in the 1930s—when the Arizona cliff dwellers performed their snake dance for only the second time in the eastern part of the United States. The tribe was accompanied by Hopi advocate Milo (M.W.) Billingsley, who had arranged a previous promotional tour in 1926 to help defend their snake dance in front of Congress. Just before their Idlewild visit, the Hopis performed the ceremonial dance in Washington, D.C., while appearing before a Senate committee that was investigating

Country-western and bluegrass acts were popular entertainment at Idlewild. Here, Nashville's Jimmy Martin and the Sunny Mountain Boys pose for a picture on the park's outdoor stage in the early 1960s. *From left to right*: Bill Yates (bass), Bill Emerson (banjo), Jimmy Martin (guitar), Paul Williams (mandolin) and Lois Johnson (guitar). *Courtesy of the Idlewild and SoakZone Archives.*

The Sunshine Boys, a nationally known western and gospel music quartet, perform at Idlewild on either August 30 or Labor Day 1959, per the handbill in the background. *Left to right*: Fred Daniel (tenor), Ace Richman (baritone), Burl Strevel (bass) and Eddie Wallace (lead). Daniel and Strevel also sang with the Blue Ridge Quartet, another popular gospel vocal group that appeared on stage at Idlewild. *Courtesy of the Idlewild and SoakZone Archives.*

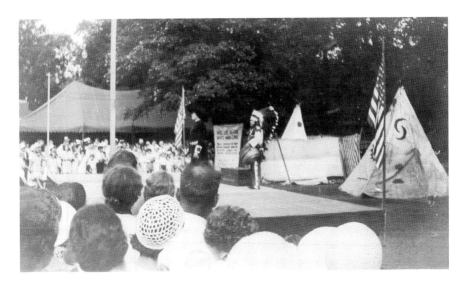

The Hopi Indians first visited Idlewild Park in 1932, when the tribe performed its ceremonial snake dance for enthralled audiences. *From the Thomas Baldridge Collection, courtesy of the Latrobe Area Historical Society.*

the case of the Navajo Indians encroaching on Hopi territory in Arizona. The Bureau of Indian Affairs had proposed a bill that would dispossess the Hopis' homestead and transfer it to the Navajos, and so the tribe's engagement at Idlewild was part of a nationwide campaign to educate the public about their culture and raise support for their plight.

The Hopis repeated their ritual—performed with deadly snakes and led by Chief Soloftoche ("Evergreen Shoes"), the tribe's chief snake priest—several times during their stay through Labor Day, including the annual Ligonier Valley Reunion. The tribe adopted both C.C. and Jack Macdonald during their six-week encampment, christening C.C. with the name "Quan-Mong-Wee" (Eyes of the World) and pledging him to their cause. The Hopis bought snakes from locals to use for their dance. Peter Snodgrass, who grew up in Ligonier's Longbridge community, recalled as a young boy of eight or nine catching rattlesnakes with his dad and older brother above the Booth and Flinn stone quarry on the north side of the Loyalhanna Creek in the 1930s. They sold the snakes for five dollars each to the tribe, who defanged them before performing the dance.

World War II

Within its first decade overseeing the amusement park, the Idlewild Management Company consistently improved the venue each year by installing new rides, expanding parking and adding picnic seating. Neon tubing—three thousand feet in total—was installed for the 1940 season, a modern addition to the sexagenarian park. A third picnic pavilion built along the creek west of the bridge in 1941 was paired with a large fireplace that boasted a looming chimney. In 1942, the Macdonalds erected a totem pole created by the Raven Clan of the Tlinget tribe of southeastern Alaska in the middle of a small grassy island on the eastern side of the carousel pavilion. Animal and mystical figures carved on the totem pole told the legend of the Raven, explained on an accompanying plaque. Idlewild advertised the new addition as the first time such a totem pole appeared at any amusement park.[169]

However, business came to a grinding halt after more than sixty years of continuous operation. Idlewild remained open during World War I, only declining to host a Decoration Day picnic in 1918. The park had also survived and even thrived during the Depression, when many local picnic groves and trolley parks had closed. But World War II had a much more severe impact, causing Idlewild to close for nearly three full seasons—the only time the park has gone dark in its history.

By 1942, Idlewild Park was feeling the impacts of World War II, a global conflict that increasingly intertwined with everyday American lives now that the United States had officially joined the war. Initially, management kept the park's gates open and continued to give back to the community, which kept attendance numbers high in turn.[170] The park advertised various war-related fundraisers in the local newspapers and contributed 10 percent of its gross receipts every Wednesday to the Army and Navy Relief Society. It also donated eight Skee-Ball alleys to the American Red Cross for Camp Reynolds in Greenville and the Deshan Hospital in Butler—four complete machines and another four salvaged for parts. The park abstained from launching fireworks, as the chemicals and powder were needed for the war. C.C. Macdonald joined forces with Fred Barker of Johnstown to arrange transportation for wards from the Cambria County Children's Home to ensure that the orphans' second annual outing would still happen despite widespread gas and rubber rationing.

By 1941, a battery of six anti-aircraft machine guns called the Sky Fighters had been installed at the Penny Arcade to amuse the general public and give

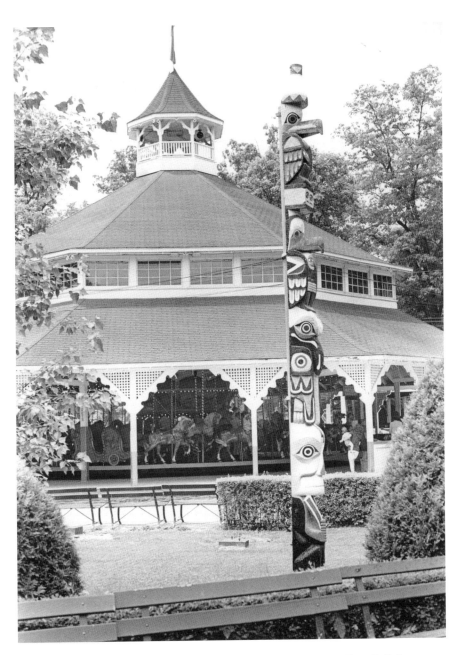

A Native American totem pole once stood near Idlewild's carousel pavilion. Built for a previous T.M. Harton merry-go-round, the pavilion currently houses Philadelphia Toboggan Company carousel no. 83. *Courtesy of the Idlewild and SoakZone Archives.*

them an idea of what their boys were doing overseas. Idlewild hosted a picnic for the Westmoreland County Civilian Defense Units in August 1942 that was educational as well as recreational. The picnic featured demonstrations of air raid sirens, bomb extinguishing methods, first-aid treatment, a parade of civilian defense units and a three-minute blackout finale. Guests could take in exhibitions of victory gardens, the Red Cross and Army Ordnance bombs and other military equipment. One of the few bands of its kind in the United States, the Veterans of Wars Girl Band of Mount Pleasant, performed at the park in 1941. A new fawn born at the park in May 1942 was christened "Pearl Harbor," a reference to Japan's December 7, 1941 attack on the United States.

Ultimately, Americans across the country felt the war's squeeze. Gas rationing and rubber collections stranded the family car at home on blocks. Railroads shunted passenger trains to the side to prioritize military convoys delivering supplies and transferring troops. Communities, schools, churches and companies halted their annual picnics. In wartime, sacrifices had to be made. People simply did not have the means or the money to travel to local amusement spots. The Idlewild Management Company board made the difficult decision to halt operations for the 1943 season—the first time Idlewild Park closed since it was established in 1878. C.C. Macdonald explained the closure in the *Ligonier Echo* of May 28, 1943:

> *Due to conditions over which we have no control and which would cause us to lower the high morale that has been maintained at Idlewild for many years, we have decided to keep the park closed for the 1943 season. We regret very much to take this action and can only state to our friends and patrons that, when the war is over, we will endeavor to show them a bigger and better Idlewild along with our usual clean, wholesome fun and entertainment.*

The Idlewild Management Company tightened operations, hoping that the park could reopen on a limited basis during the war, perhaps only on weekends. The board of directors reduced staff and director salaries and sold several pieces of equipment, including the new Lusse Brothers Skooter cars just purchased in 1941 and the Custer Cars. The park's fish hatchery also temporarily closed for business; in October 1943, Lake Bouquet was drained, and the Pennsylvania Fish Commission transferred about thirty thousand fish—mainly bass, bluegills and catfish—to a hatchery in Reynoldsville, Pennsylvania, before stocking them in various streams.[171] The

board also terminated the park's contract with the Ferris wheel and popcorn stand concessionaires as of December 31, 1943. The park gave its live bears to the Pittsburgh Zoo, effectively ending the small zoo's run.

Idlewild Park remained closed through the 1944 season and overall did not operate completely full time for three years. The board voted to open Idlewild for holidays and weekends in 1945 until the termination of hostilities in Europe, when it would then return to full-time operation. Now it was able to follow through. The park was not ready in time for Decoration Day, instead reopening on June 2, 1945, but it operated three days a week initially (Wednesdays, Saturdays and Sundays) before returning to a six-day schedule. The swimming pool's opening was likewise delayed until June 15, and it appears that practically no free acts or entertainment were booked for that summer. Only some of the rides and refreshment stands were open, due to a shortage of labor. Still, the limited 1945 season allowed the park to generate some income that year. People missed Idlewild and came back. In fact, the Fourth of July crowds in the Ligonier Valley overall were the largest the region had seen since the country went to war. Idlewild Park shut its gates in early afternoon because of the sheer number of people who had saved their gas rations for the holiday.

Postwar Resurgence

In late 1945, a flurry of activity began as Idlewild prepared for a full 1946 season after its nearly three-year hiatus. Taking stock of the grounds, in August 1945 the board of directors authorized Jack Macdonald, now general manager, to make necessary repairs to the park, which was in a "somewhat run down condition."

More than $50,000 was invested into a two- to three-year round of construction that sparked a long period of improvements at Idlewild Park throughout the baby boomer years. A new stone gate and four-lane road were built at the main entrance to alleviate traffic jams, although the blockhouse was retained. A neon "Idlewild" sign now welcomed visitors. Inside the park, work started with the island area: the swimming pool was completely resurfaced, the beach filled with fresh sand and the boathouse revamped with a new sandwich shop and soda fountain. The Skooter ride received a new floor and twenty new Lusse Brothers cars that replaced the ones sold during the park's closure. The Penny Arcade was also renovated with new

concrete flooring. The nature trails on the south side of the Loyalhanna became the Shadowlands, a similar rustic area with educational signs affixed to trees noting their Latin and common names. The Idlewild Management Company also paid attention to the food produced and sold at the park, purchasing new popcorn and peanut units and lunchroom equipment. A picnic pavilion behind the park office became a combination butcher shop, refrigerator and cold freezer to store beef, ice cream and local produce.

Idlewild reopened on May 19, 1946, with 55 school picnics booked for a season anticipated to be the park's most successful to date. Management projected the following season to be even bigger, with 130 picnics scheduled—schools making up 78 of them alone—and the Idlewild Management Company looked forward to making more upgrades that year.

Unfortunately, the 1947 season began with the loss of one of Idlewild's popular rides. The Rumpus had thrilled guests for about a decade before an overnight fire consumed it less than a week after the park's opening day. C.C. Macdonald reported details of the event a few weeks later in a June 11 letter to Ligonier Valley Rail Road superintendent Joseph Gochnour. A passing motorist noticed flames coming from somewhere in Idlewild and called on C.C. and Grace Macdonald at their home around 1:30 a.m. on Friday, May 23, to alert them that their park was on fire. The blaze turned out to be at the Rumpus building.

"It was beyond saving," remembered Harry Frye, a former photographer for the *Latrobe Bulletin* who served on the city of Latrobe's volunteer fire department, one of the hose companies dispatched to the Rumpus fire. According to Frye, almost everything in the Rumpus ride was wooden and therefore instantly combustible. The Rumpus also served as temporary storage for equipment purchased for Idlewild's new restaurant slated to open later that season, plus a selection of equipment from Rock Springs Park and the park's entire sugar supply for soft drinks, then a rationed commodity. The fire completely consumed the Rumpus ride, the restaurant equipment and the Rock Springs Park stash. Laffing Sal never screeched again, as she, too, perished in the fire.

The Rumpus was housed in the park's old Penny Arcade, which itself was converted from an earlier dining hall, so the blaze also cost Idlewild Park one of its oldest original buildings. Even worse, neither the building nor its contents were insured, because of the high insurance cost for amusement park property. Macdonald could not give Gochnour an exact amount of the loss, but the papers reported the park took a $24,000 hit.[172]

Nothing that we could do with our own fire apparatus or that of the Ligonier, Latrobe or Waterford Fire Companies could save the building and consequently, this fire proved a complete loss on the above mentioned building and equipment.

The newspapers initially reported that faulty wiring caused the Rumpus fire. However, this was not the case. Fred Clawson, Idlewild's night watchman on duty the night of May 22 into May 23, was missing. Police first believed that Clawson perished in the fire, as they found his watch in the rubble. No one had seen him since he clocked in for his shift. According to Macdonald's letter, the Watchman's clock proved he punched the no. 1 station at 12:00 p.m. and then punched the no. 5 station at 3:15 a.m., therefore proving he was alive.[173] The Pennsylvania state police found Clawson at home, intoxicated, and brought him in for questioning. They released him after a week at the state barracks in Greensburg, related Macdonald:

It is the opinion of the Investigator that he might have had something to do with this fire. However, nothing has been proven. We do know that he was negligent. If he had been on the job, he would have detected the fire in time for us to hold our loss at a minimum.

Whether the fire was accidental or intentional remains unknown. Sadly, Idlewild never replaced its Rumpus ride, but management learned a hard lesson and investigated increasing the park's fire insurance coverage. The ride's loss dealt a financial blow to the Idlewild Management Company, which had spent another $50,000 on improvements to the park for the 1947 season, but there were plenty of new attractions at Idlewild to compensate.

The Idlewild Management Company initially considered purchasing an Octopus the previous year but scrapped that plan after hearing negative feedback on the eight-armed spinning car ride from an industry peer. Instead, the park selected a flat ride called the Caterpillar. Invented by Hyla F. Maynes in 1925, the ride consists of a train of connected cars that speed along a circular, undulating track. When completely covered by a green canvas canopy, the train resembles a wiggling caterpillar. The centrifugal force generated from the high speed of the train causes the inside rider of each car to slide into and squish the outside rider, creating a perfect opportunity for some canoodling, especially underneath the

A canopy covered passengers midway through their ride on Idlewild's Caterpillar, allowing couples an opportunity to sneak a kiss. *Courtesy of the Idlewild and Soak Zone Archives.*

canopy. Riders also felt a blast of air from a fan positioned beneath the undercarriage. Installed near the Rumpus building on the former site of the Custer Cars, Idlewild's Allan Herschell Company model thankfully escaped the fatal fire. The now rare bug-themed ride operated until 2012, when the park decided to remove it and place it in storage, as it is in need of a full restoration.[174]

Idlewild also opened a new two-story popcorn stand in 1947 and prepared the planned new restaurant for full operation in the 1948 season. The unnamed eatery served steaks that came from Hereford steers raised on C.C. Macdonald's Texas ranch and transported to Ligonier, where they grazed on a farm near Idlewild Park, along with pen-fed chickens also on the menu.[175] Additional upgrades followed throughout the next several years, including new restroom facilities, a new warehouse and refreshment stand renovations. By the 1950s, Idlewild was back in full-time operation after its wartime closure, and the Macdonalds continued to make capital improvements to their park. Rides were repaired, buildings painted,

Shiny, futuristic rockets updated the Airplane Circle Swing for the 1948 season. *Courtesy of the Idlewild and SoakZone Archives.*

grounds cleared and new themed areas conceived. The intent was to keep Idlewild in good repair and offer something new for guests each season, even if it was a simple change to an existing ride; for the 1948 season, the airplane-shaped seats on the circle swing were replaced by stainless steel finish Buck Rogers–style rocket ships "which flash through the air with lightning speed."[176] Carol Oravetz remembered the rush of riding the futuristic ride:

> *The Rockets were fabulous. Not too scary. Not too flashy. Just the wind in your face as the centrifugal force sent them sideways and nearly parallel to the creek. Waaaaaay out over the creek. And the very best part of the ride was the serene sounds of silence. The ride made virtually no noise to distract the fantasies of those who went boldly where no one had gone before.*

Kiddie Land[177]

Idlewild has offered smaller rides for children ever since the Idlewild Management Company took helm of the park.[178] The first kiddie ride installed in the children's playground area was the Miniature Flying Swans in 1931—a device made exclusively by the W.F. Mangels Company of Coney Island, New York. The Swan Swings featured eight swan-shaped seats suspended from individual arms attached to a radiating center pole masked by decorative steel panels.

One decade later, the park established a more distinctive area for Idlewild's smallest fun seekers. A W.F. Mangels Company Roto-Whip, purchased for the 1941 season, consisted of eight small cars that swung around "in an eccentric course on a circular platform," rather than an oval platform like the adult version. The addition of that ride established an official Kiddie Land in 1941 in the west plaza area near the Rollo Coaster.[179] A chain link fence surrounded the area that was guarded by a large metal sign in the shape of a clown beating a drum. Besides these two miniature rides, Idlewild's first Kiddie Land also included various children's games and the park's resident bears.

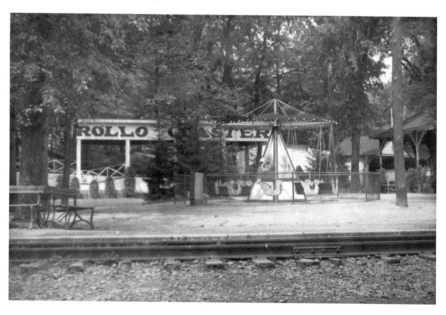

A rare view of the Miniature Flying Swans, Idlewild's first official kiddie ride. *Courtesy of Dr. John Smetanka and Sandy Luther Smetanka.*

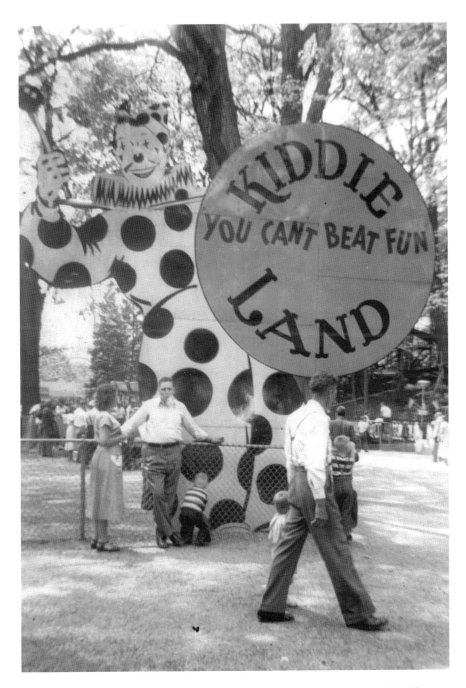

C.C. Macdonald established Idlewild's first Kiddie Land in the west plaza in 1941. Along with popcorn, peanuts and other refreshments, the park at one time sold cigars, clear from the puffs of smoke coming from one patron standing in front of an early Kiddie Land clown sign. *Courtesy of the Pennsylvania Room, Ligonier Valley Library.*

Two more rides followed by the end of the decade. The Miniature Cars filled in the west plaza area in 1947—an Arrow Development creation featuring ten painted metal speedsters that revolved on a circular turntable. An aquatic version of that same concept—the Miniature Boats—appeared in 1949, featuring six colorful fiberglass boats that rotated in a concrete tank of water. Kiddie rides bought for the 1950 season included two from the Allan Herschell Company: the Pony Carts with eight painted two-wheel horse-drawn carts and the anthropomorphic Miniature Airplanes with painted faces and faux machine guns.[180]

The more kiddie rides Idlewild offered, the more space the park needed to contain them. In 1951, the Idlewild Management Company relocated Kiddie Land to the former location of the Rumpus—an open space along the Loyalhanna Creek to the right of the bridge.[181] The new Kiddie Land was bordered by stone walls and rustic fencing, along with a new sixteen-foot-tall clown sign at the entrance painted by park artist Anthony "Tony" DiMinno. It also contained the live pony track.

By the end of the decade, Idlewild had a sizeable Kiddie Land that offered children almost a dozen rides. The six-car Miniature Ferris Wheel was added in 1952. Also new that year was the Turtle, a smaller version of

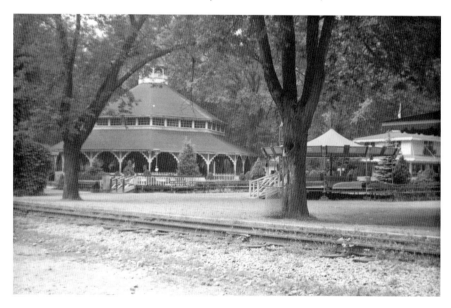

Now called the Scampers, the Miniature Cars are one of Idlewild's oldest kiddie rides, added in 1947. *Courtesy of Dr. John Smetanka and Sandy Luther Smetanka.*

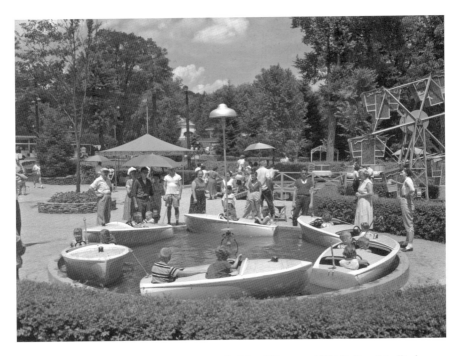

The Miniature Boats were a popular feature in Idlewild's second Kiddie Land, built along the Loyalhanna Creek. *Courtesy of the Idlewild and SoakZone Archives.*

The Miniature Airplanes were one of multiple rides added to Idlewild's Kiddie Land throughout the 1950s. *Courtesy of the Idlewild and SoakZone Archives.*

A little girl enjoys a turn on the 1950 Allan Herschell Pony Carts, a staple of Kiddie Land for more than thirty years. *From the Thomas Baldridge Collection, courtesy of the Latrobe Area Historical Society.*

the classic Tumble Bug ride manufactured by the R.E. Chambers Company Inc. of Beaver Falls, Pennsylvania (formerly the Traver Engineering Company). The Turtle is distinct from most of the park's other kiddie rides since adults can also enjoy this attraction—one adult per turtle. The popular Hodges Amusement Hand Cars, which enabled kids to self-propel along a winding narrow-gauge track, were added in 1954. A red-and-white miniature railcar made by San Antonio Roller Works also joined Idlewild's arsenal of kiddie rides. Named the Doodlebug, the little ride was a nod

Kiddie Land moved to an enclosed area along the Loyalhanna Creek in 1951 and welcomed the Turtle and the Ferris wheel the next season. *Courtesy of the Idlewild and SoakZone Archives.*

The kiddie Hand Cars, now called Little Rascals, have operated at Idlewild since 1954. *Courtesy of the Idlewild and SoakZone Archives.*

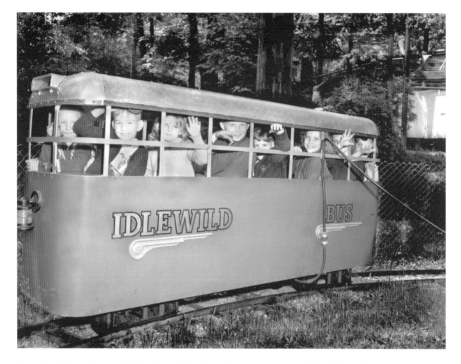

A nod to the self-propelled railcars that brought passengers to Idlewild Park in the later days of the Ligonier Valley Rail Road, the Doodlebug was added to Kiddie Land in the 1950s. *From the Fantastic Fotographica Collection, courtesy of Harry Frye.*

to the Doodlebug railcars used in the final years of the Ligonier Valley Rail Road.

After the burst of development in the 1950s, Kiddie Land's growth started to slow down in the 1960s, with only a few new rides brought in to replace older ones until the next major overhaul of the area decades later. The Flivvers, an antique car ride with winding track installed in 1968, was made by the Allan Herschell Company. The miniatur e Model T cars probably replaced the Swan Swings after their long tenure at Idlewild. The Motorcycles—another San Antonio Roller Works ride featuring six pairs of miniature Honda bikes—were added in 1970. Kiddie Land also featured the Jitterbug, a tilting spinning ride with eight metal and fiberglass tubs,[182] as well as a Rob Regehr Enterprises inflatable Moon Walk added in 1972 for only a few seasons.

The End of the (Rail) Road

Beyond the tightrope walkers, popcorn stands and thrill rides, Idlewild remained, at heart, a railroad park. Idlewild would not have existed without the impetus of the Ligonier Valley Rail Road and the Mellon family's dedication to complete and operate the line. Between 1878 and 1952, about 4.5 million patrons rode the Ligonier Valley Rail Road to spend a day at Idlewild Park.

But after seventy-five years, times had changed. In 1913, the Lincoln Highway—the country's first transcontinental road—was established, linking cities and towns together from New York City to San Francisco. Ligonier was one of the fortunate towns to benefit from the cross-country traffic. Consequentially, Idlewild Park became a roadside attraction along the Father Road. Families had the option of driving to Idlewild instead of taking the train. Instead of paying the passenger rate for the train, they could pay a nominal parking fee. Admission to the grounds was free either way.

Automobile traffic and attendance steadily increased at Idlewild Park, particularly during holidays, which drew record-breaking crowds. In the early 1920s, Idlewild Park began to see record numbers of cars,[183] which only increased each year, coming from all over Western Pennsylvania and beyond, according to Dick Macdonald:

> *I'd say Ohio was probably our biggest state that we got from. I can remember many times we'd go through the parking lot and record every license in the country....We had 2,000 cars, we had a full day. It takes a lot of land to park 2,000 cars. We had a big park there.*

Sometimes the parking lots were inadequate to handle the overflow, so folks squeezed their cars where they could at the park, as Sara Jane Bitner Lowe remembered:

> *I always think about parking in among those trees, because you just drove around until you found space between a couple of trees where there were no picnic tables and you just pulled your car in there. It wasn't real organized or anything, but it was always nice because it was nice and shady and nice and cool.*

Jim Ramsey remembered some thrifty visitors would find alternate parking spots outside the park to save a little money for rides or refreshments:

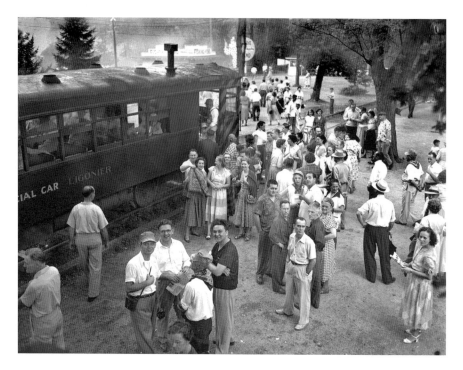

Folks traveled to Idlewild Park along the Ligonier Valley Rail Road first via steam locomotives and then self-propelled railcars called Doodlebugs. The railroad's M-10 Doodlebug is seen here at Idlewild during the line's last run on August 31, 1952, as the final car in the consist. *From the Fantastic Fotographica Collection, courtesy of Harry Frye.*

A lot of local people would park out on Route 30 or they would go down by the Darlington railroad station and park there and walk up the railroad tracks, which went through the park.

As automobile traffic and bus service[184] to Idlewild Park steadily increased over the years, rail travel fell out of vogue. By the mid-twentieth century, industry had declined in the Ligonier Valley, hurting the freight business that supported the Ligonier Valley Rail Road. The coal mines and coke ovens closed, and the stone quarries slowed production. By the end of the 1940s, the railroad's fate appeared sealed. The decision was made to abandon the Ligonier Valley Rail Road and turn the line over to the Pennsylvania Department of Transportation (PennDOT).

The Mellon family saw the end of the line coming, taking steps to ensure that the park would remain under the care of a worthy steward. In

September 1942, the lease between the Idlewild Management Company, the Idlewild Company and the Ligonier Valley Rail Road was canceled and a new twenty-year lease created so that the Idlewild Management Company leased the approximately four hundred acres of park property directly from the Ligonier Valley Rail Road Company with the option to purchase the property at any time during their lease.

In 1949, the Ligonier Valley Rail Road then sold the entire Idlewild Park property to the Idlewild Management Company for $62,000—about one-third in cash and the rest in a ten-year mortgage with interest.[185] The next year, Richard King Mellon and railroad general manager Joseph Gochnour both resigned from the board of directors. The Macdonald family also bought out the Mellons' share of the Idlewild Management Company in 1950 to own the park completely.[186] The impending end of the short line railroad brought the end of the Mellon family's long association with Idlewild Park.

After seventy-five years of active service, transporting 9 million passengers and 32 million tons of freight, the iron horse was corralled. The Last Run of the Ligonier Valley Rail Road occurred on August 31, 1952, the train heralded with various celebrations at stops along the way, including Idlewild, with many people lining the tracks to bid their old friend adieu. Judge Thomas Mellon and his sons invested time, money and effort into a project long desired in the Ligonier Valley, and the resulting railroad helped bring industry, tourism and commerce to the region. Now Idlewild Park stood on its own. The railroad's demise ultimately did little to affect the park's popularity or attendance. By that time, most of Idlewild's patrons primarily arrived by bus or automobile, so the death of the railroad, which had birthed the park, did not hurt its business.

However, the pending expansion of the Lincoln Highway threatened Idlewild Park's future. News rumblings started as early as 1948, but finally, in the spring of 1951, the park's board of directors acknowledged a big change literally coming down the road. PennDOT planned to expand the Lincoln Highway (now designated U.S. Route 30 in that stretch) from two lanes to four lanes by using the roadbed of the Ligonier Valley Rail Road. That meant that the two new eastbound lanes of Route 30 would slice through Idlewild Park.

Jack Macdonald traveled to Harrisburg to petition state representatives against building the new eastbound lanes through Idlewild and relocating them instead, a possibility highway engineers had suggested several years prior. His argument was more for safety reasons—cars speeding through

a park full of people presented a danger—than the fear that the highway would spell the end of the amusement park, his brother recalled.

Macdonald's persistence paid off. Instead of using the portion of the railroad bed running through the amusement park, PennDOT condemned a sixty-foot-deep strip of Idlewild property fronting the highway to accommodate a section of the new eastbound lanes from Darlington Road (now Idlewild Hill Road) to Millbank just east of the park. Latrobe Construction Company removed about fourteen acres of virgin timber for the first stage of this project—about a twenty-five-thousand-foot frontage containing evergreens, white oaks, red oaks and poplars.

The trees came tumbling down in July 1955, and the two-year expansion moved forward. This was a major yet unavoidable violation of William Darlington's original precept protecting the trees that the Mellons and Macdonalds followed since Idlewild Park's creation. It was also necessary

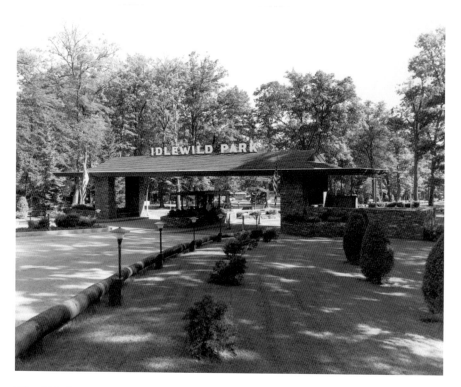

Idlewild built a new stone entrance/exit to replace the earlier gate lost when PennDOT built the eastbound lanes of Route 30. *Courtesy of the Pennsylvania Room, Ligonier Valley Library.*

to relocate the park's entrance, as the new lanes were plotted to run through the existing one. A new stone entrance, exit gate and access road replaced the remnants of the early 1930s log entrance. The $35,000 investment was completed in 1956, the same year that a related yet separate attraction opened next door to Idlewild Park.

STORY BOOK FOREST

*I wanted to build a park that was different....I wanted to build a park
that was based on emotion and not on motion.*
—Art Jennings[187]

In June 1956, a new attraction for the young—and the young at heart—opened next door to Idlewild as a separate yet related venture for the Macdonald family. America's postwar baby boom in the 1950s had created a market of young families with disposable income for whom a place based on childhood nostalgia would naturally appeal. Walk-through children's parks featuring scenes from nursery rhymes and fairy tales appeared across the country, some inspired by and others completely independent of the juggernaut Disneyland, which in 1955 opened its doors in Anaheim, California. Story Book Forest bloomed from the creativity and drive of a partnership between C.C. Macdonald and Arthur Jennings, an engineer and entertainer who conceived the idea of a fantasyland built for children.

Arthur Jennings

By day, Art Jennings was an industrial model builder with the Elliot Company in the city of Jeannette, but by night, the traveling juggler and magician was a client of KDKA Pittsburgh radio icon "Uncle Ed" Schaughency's

Before he created Story Book Forest, Art Jennings was an industrial model builder and part-time entertainer who became Idlewild's mascot, Happy Dayze, in the 1950s. *From the Fantastic Fotographica Collection, courtesy of Harry Frye.*

entertainment agency. Around 1950, C.C. Macdonald hired Jennings to appear at Idlewild in the guise of his silent tramp character, the Bum Juggler. Over time, the pair struck up a simpatico business relationship. Later that year, Macdonald asked the entertainer to create a clown character for the park, which he developed over the succeeding summer.

Jennings's new alter ego, Happy Dayze, became Idlewild's goodwill ambassador during the early 1950s. Sporting heavy makeup, colorful

costumes and oversized shoes, the friendly clown greeted patrons around the park and often balanced on stilts or his unicycle. He enjoyed talking to people and frequently gathered useful feedback from guests. During the off-season, Happy Dayze served as an alternative marketing strategy for the park; instead of radio and newspaper ads, Jennings performed his one-man show at area schools and community events to promote Idlewild's picnic seasons beginning in 1953.

Life as a traveling entertainer could be lonely, but it could also inspire some artistic brainstorms. While on the road dealing with some personal struggles, Jennings developed the basic concept for a walk-through attraction with scenes presented on a smaller-than-normal scale for children. By 1954, he had fleshed out the idea for Story Book Forest but failed to generate any interest in it until he brought it to C.C. Macdonald for consideration. Macdonald had faith in the idea and was willing to partner with Jennings to bring it to life.

Originally named the Enchanted Forest, Jennings's fairy tale park was approved, with the Macdonald family contributing the needed land and financing.[188] A separate corporation from Idlewild, Story Book Forest Inc., was created on November 28, 1955, to oversee the new attraction, with its own board of directors,[189] including Jennings, who also became manager. The new company arranged to borrow no more than $50,000 from the Idlewild Management Company for its operating capital and initially leased (and then eventually purchased) from the IMC a piece of property east of the existing park for $2,772.[190]

Planting the Forest

The land used for "Art's Folly" wasn't ideal—a more than seventeen-acre parcel adjacent to Idlewild Park, half hillside, half swamp, that was considered useless—but it would have to do. By the fall of 1955, work had begun on transforming this swampland, located north of the former Ligonier Valley Rail Road siding, into a kiddie wonderland. Trees and earth were moved to clear open space. Workers dug a pond in the middle of the property to collect water from nearby springs and drain it into the Loyalhanna Creek; local legend says the crew used a mule and shovel to dig the pond.[191] Spider Weller, who managed the Kiddie Land pony track, brought in horses to help clear logs and dig a trench for the spring water

and the general area before any bulldozers and equipment could break through the thick foliage.

With enough open space, the crew poured concrete for the buildings' foundations and then built the wood frames, attached metal lath and plastered some of the structures. Work continued through the winter, rain or shine...or snow. Even Art Jennings's young son, Art Jr., helped with construction, chopping logs for a planned bridge and steering a bulldozer.

Story Book Forest consumed Jennings from the onset; in his own words, the project became an obsession for the next several years. Jennings supervised the on-site work during the day and poured over his drawing table at night, sketching out each unit in detail, sometimes only twenty-four hours before breaking ground. Tapping into his engineering background, he created a topographical model of the forest and arranged proposed scenes to determine the overall flow of the park.

Story Book Forest replicated more than a dozen scenes from some of the most popular stories parents read to their children before bedtime. The exhibits combined brightly painted Homasote buildings, composition figures, live characters and animals set among vibrant flowers and greenery: the Old Woman Who Lived in a Shoe; Little Bo Peep and Farmer Brown; Humpty Dumpty; Hickory Dickory Dock; Flopsy, Mopsy, Cotton-tail and Peter Rabbit; the Three Little Pigs; Alice in Wonderland's Keyhole; the Good Ship Lollipop; Ding Dong Bell Pussy in a Well; Peter Peter Pumpkin Eater; Three Billy Goats Gruff; Goldilocks; Bambi and Faline; a giant storybook entrance; Hansel and Gretel–themed restrooms; a charitable Wishing Well; and King Arthur's Enchanted Castle.

Story Book Forest's master plan was no small undertaking. There were challenges to overcome before this new children's park could be built. Jennings's designs for the storybook scenes, with their eccentric proportions, were too unorthodox for industry contractors, so he trained locals to translate his detailed drawings into a three-dimensional world. The twenty-eight-foot storybook required major engineering to ensure that the internal steel structure supported the massive plaster pages. Jennings docked the Good Ship Lollipop instead of floating it around the pond, as he originally envisioned, after learning that the vessel would need U.S. Coast Guard certification and insurance. Instead, he anchored the ship to a submerged concrete base.

No detail in Story Book Forest escaped attention. The shield hanging above the Enchanted Castle's arched entryway depicted the Jennings Coat of Arms. The Good Ship Lollipop, whose design suggested the Pilgrims'

The Pittsburgh Pirates boarded the Good Ship Lollipop during their visit to Story Book Forest on June 30, 1958. Ted Kluszewski described Story Book Forest as "unbelievable." *Left to right*: Kluszewski, Bill Virdon, Bob Smith, Dan Kravitz, Captain Candy, Hank Foiles, Don Gross, Bob Skinner and Bob Porterfield. Bob Friend not pictured. *Courtesy of Art Jennings Jr.*

Mayflower, displayed individually carved balustrades, gold leaf accents, a sailor's knot board and a stained-glass window. Every window had a blueprint for its own unique pattern. Individual shingles were hand-cut and arranged in erratic patterns on the roofs of the houses and then painted to create a weathered look.

Story Book Forest's famous characters came alive through the hands—and brushes—of two craftsmen: Jennings and Idlewild Park artist Tony DiMinno, an accomplished painter and church interior decorator who was notable for

painting the iconic Kiddie Land clown sign and as the first artist to airbrush the carousel horses. The pair worked together in a small shop converted from Idlewild's former entrance blockhouse. Each figure comprised several layers of a material called celastic—a canvas cloth impregnated by an adhesive—commonly used in building obstacles for miniature golf courses. Jennings and DiMinno first sculpted each figure in clay and then covered it with tin foil. They dipped the celastic in a solvent—usually methyl ethyl ketone—and molded it around the sculpture. After hardening, the pair cut the celastic off the model, creating two halves of a hollow figure that they then reassembled, painted and accessorized, dressing the characters in fine layers of celastic.

Time and patience were essential to build each character—six weeks alone for the larger figure of Old King Cole, a later addition, along with his fiddlers three. Some of the characters and scenes were articulated, including Humpty Dumpty, who wiggled precariously on top of a concrete block wall, and Hickory Dickory Dock, which had a swinging pendulum in the clock and a mouse who peeked out from the clock face.

Humpty Dumpty, still on his wall, was one of the inaugural Story Book Forest units created in 1956. *Author's photo.*

Story Book Forest was a mix of colorful buildings, sculpted figures, actors and live animals. Here, Farmer Brown helps one of the three little pigs greet two human visitors. *From the Fantastic Fotographica Collection, courtesy of Harry Frye.*

Live animals complimented some of the scenes, including four fluffy bunnies,[192] Farmer Brown's cow, Little Bo Peep's sheep, three piglets, two goats named Eenie and Meenie[193] and two tame deer who had the run of the park during the off-season, Bambi and her fawn, Faline. Animals presented a different set of challenges, however. The Three Little Pigs needed to stay

little, so the park swapped out the piglets with new ones every few weeks. A live cat initially resided in the Ding Dong Bell Pussy in the Well unit, but it was replaced by an artificial figure after visitors became concerned about its small living quarters. The original plan was to bring back live bears for the Goldilocks unit on a seasonal basis, but that idea was scrapped when the Pennsylvania Game Commission would only provide bears for Story Book Forest if the park owned them completely. Goldilocks lived alone until three bear figures moved into the log house for the 1966 season.

Opening the Book

By the spring of 1956, the crew had wrapped up the final round of work needed to complete Story Book Forest, laying out the gravel pathways, installing fencing and using wire and plaster to disguise tree stumps as decorative mushrooms. The park's opening was delayed because bad weather halted the ongoing work to expand Route 30 from two lanes to four lanes, which didn't finish until October. In fact, the entrance to Story Book Forest was not complete by opening day, so visitors had to take transportation from Idlewild Park to get to the attraction. Finally, on June 23, 1956, Story Book Forest officially opened to the public, drawing at least sixty-five thousand visitors in its inaugural season (according to Art Jennings in the April 5, 1957 *Ligonier Echo*; however, the April 1958 issue of *Funzone* magazine reported that Story Book Forest drew sixty-nine thousand adults and fifteen thousand children in 1956).

Folks entered the new make-believe world through a door set into the larger-than-life storybook, which had two smiling children painted on either side that were stylized likenesses of Jennings's children, Linda and Art Jr. A clever two-price admission structure was implemented where smaller visitors paid a reduced fee to Story Book Forest—seventy-five cents for those taller than fifty-nine inches and thirty-five cents for those under fifty-nine inches. The twenty-eight-foot-tall book was emblazoned with the following greeting:

> *Here is the Land of Once Upon a Time....Step through the pages of this big Story Book...and visit the people and places every child knows...and Loves. Here dreams are real...and so are your Story Book Friends.*

A small two-dimensional clown sign greeted all visitors who stepped though the giant book with the following message:

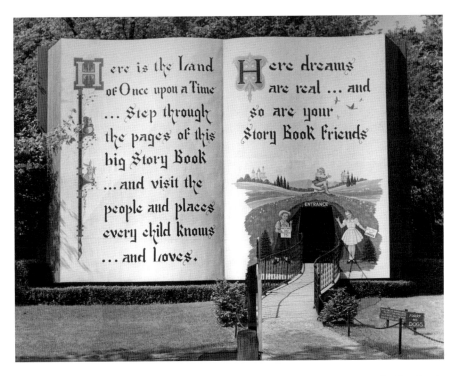

The children painted on either side of Story Book Forest's entrance represent Art Jennings's son and daughter. Art Jr.'s sign reminds folks that anyone over fifty-nine inches in height paid seventy-five cents in admission, while those under fifty-nine inches only paid thirty-five cents. *Courtesy of the Idlewild and SoakZone Archives.*

Welcome to Story Book Forest. Here Childhood is Eternal and Imagination is King.

From there, children and adults followed a winding gravel path through the forest past the various nursery rhyme and fairy tale scenes. Jennings designed the buildings on a smaller scale so that children could easily enter, while adults had to bend down to enter the doorways of the giant shoe and Peter's pumpkin.

Mixed among the sculpted figures and animals at Story Book Forest was a cast of live characters that interacted with guests, literally bringing the fairy tales and nursery rhymes to life. The most beloved character was the Old Woman Who Lived in a Shoe, first portrayed in 1956 by June Lotz of Rector, whose husband, Jack Lotz, cared for the barnyard animals as Farmer Brown. Mary Dean Snyder, whose husband, Vivian, managed the nearby Darlington railroad station, succeeded Lotz in the role.[194] The most famous

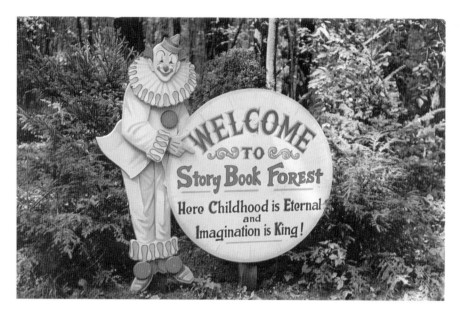

A smiling clown has greeted visitors to Story Book Forest for more than sixty years. *Courtesy of the Idlewild and SoakZone Archives.*

Jack Lotz portrayed Farmer Brown, who cared for Story Book Forest's barnyard animals. *From the Fantastic Fotographica Collection, courtesy of Harry Frye.*

June Lotz was the original Old Woman Who Lived in a Shoe, a role she played for at least a dozen years. *From the Fantastic Fotographica Collection, courtesy of Harry Frye.*

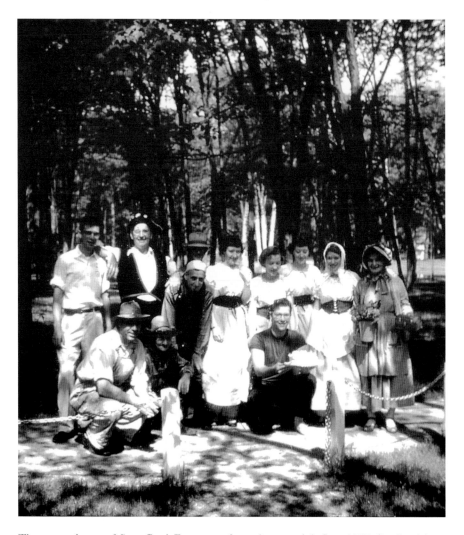

The cast and crew of Story Book Forest pose for a photograph in June 1957. *Standing, left to right*: Dick Mimna, Joseph O'Hara, Elmer Strawcutter, Louis Will, Dorothy Weimer, Carol Johnston, Dolores Weimer, Marilyn Wallbaum and June Lotz. *Front row, left to right*: Tony DiMinno, Jack Lotz and Richard Kislan. *Courtesy of Art Jennings Jr.*

of the little old ladies was Snyder's daughter, Nellie Gindlesperger, who filled the shoes (shoe, rather) of the Old Woman for about twenty-five years after taking over the part from her mother. Theresa Rohaly assumed the role for almost a decade after Gindlesperger retired following the 1997 season. Today, the Old Woman is often portrayed by Eleanor Clark, the park's longest-tenured seasonal employee (since 1968), who has spent almost a half

century working at Idlewild, the last fifteen years as the primary caretaker of the giant shoe.

Other actors greeted guests as they wandered through the forest in the guises of Little Bo Peep and Snow White. Captain Candy, originally portrayed by Joseph O'Hara, welcomed youngsters aboard the Good Ship Lollipop to sign the ship's log and rewarded them with chocolate coins wrapped in gold paper he kept chilled in a cooler hidden in the cabin area. Over the years, more than a dozen human characters "lived" in Story Book Forest, including Snow White, Goldilocks and Little Miss Muffet.

The Enchanted Castle

One character that enjoyed engaging with guests was King Arthur, better known as the Golden Knight, a talking suit of armor that allegedly trapped the ghost of the mythical king. The Golden Knight resided in the Enchanted Castle—the crown jewel of Story Book Forest and the most complicated of all the original scenes to build.

The concrete palace, with white perlite walls, strategically sat near Route 30 to catch motorists' eyes as they passed the more than thirty-foot-tall attraction. The castle also contained a two-way magic mirror that, when illuminated, revealed a grotesque head, along with a covered well that represented the dungeon. A tape recorder placed inside the well blared moans and groans reputedly produced by KDKA radio legend and humorist Rege Cordic and Bob Trow of *Mister Rogers' Neighborhood* fame.

The focal point of the Enchanted Castle was its protector, the Golden Knight, who was tucked into a corner of the castle on a pedestal, framed by a red velvet curtain. The armor was authentic—with articulated fingers and chainmail—and allegedly used as a prop at the medieval-themed Ivanhoe Restaurant in Chicago.[195] Gold paint covered its original steel finish. The actor supplying the knight's voice was concealed about thirty feet above the alcove, in one of the castle's turrets accessible by a hidden ladder from where he could watch the procession of visitors and speak to them through a microphone. Down below, a hidden speaker and microphone allowed a two-way interaction with guests. Dave Robb, a Derry Township boy who gave voice to King Arthur from 1966 to 1968, still remembered the talking knight's monologue after more than forty years:

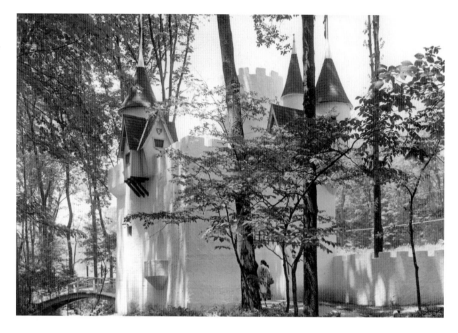

Above: Story Book Forest's original Enchanted Castle was home to King Arthur, also known as the Golden Knight, a talking suit of armor. *Courtesy of the Idlewild and SoakZone Archives.*

Opposite: King Arthur "talked" to guests visiting the Enchanted Castle in Story Book Forest, thanks to a hidden speaker system. An actor concealed in the turret above provided his voice. *Courtesy of the Idlewild and SoakZone Archives.*

> *Welcome to my Enchanted Castle. I have been standing in this suit of armor for over 1,400 years. Why don't you walk across the courtyard and look in the magic mirror to see my mother-in-law, the Wicked Witch.*

King Arthur's voice was supposed to remain hidden in order to maintain the illusion of a talking suit of armor, but that was not always the case, according to Robb:

> *If the girls were cute and would bring you lunch from their family picnic, you might show them where you're at. No shortage of dates for King Arthur.…I jokingly say when I was in the castle the girls would come through and I would tell them, "Bring me some fried chicken and I'll tell you where I'm at." They would go all the way back to Idlewild Park and get fried chicken and potatoes and all that kind of stuff and come back with covered plates and come in. And the castle had a spire at the top and it had a fixed wooden*

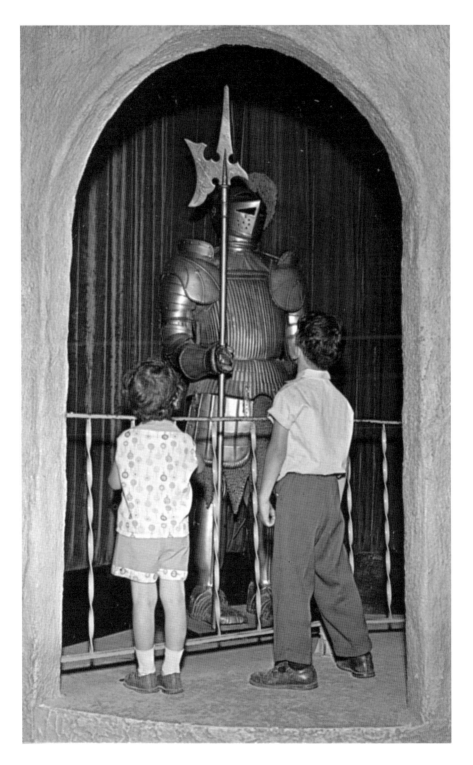

ladder to get in there so you'd go through the dungeon door and you'd put a hook on it and there was a string on the hook—a piece of twine—that went all the way to the top—probably about 25 or 30 feet—so you'd climb up in the castle and you wedged your way in there where you'd sit with your standing microphone and you'd put on a headset. So if you wanted to let somebody in, you'd reach over and you'd pull the hook, pull the string and it would unhook the door and they would come in and re-hook it and they would come up the ladder. A lot of girls found their way into the top of that!

Carol Oravetz corroborated the errant knight's penchant for flirting:

During my school picnic days [in the early 1970s], *my circle of friends would plot our flirtation weeks in advance. And spend much time chatting to the suit of armor, quieting down whenever anyone else came through.... The suit told a wee fib about being stuck there for 1,400 years because he actually unstuck himself once, coming down to visit with us on a more personal level. My friend being the lucky object of this knight in shining armor.*

Typically, the Golden Knight greeted visitors to the castle and held friendly conversations with them. But on busy days, especially when the line stretched all the way back up the sidewalk and you needed to keep the crowd moving through Story Book Forest, actors had to keep chats to a minimum to keep the foot traffic moving. However, during one busy day, Robb, who was playing the Golden Knight, kept the conversation going once he recognized his famous visitors: members of the Pittsburgh Steelers football team who were taking a break from summer training camp at Saint Vincent College in nearby Latrobe:

That was a lot of fun, you know, when you're talking to one of the Steelers and you say, "Why don't you walk across the courtyard and see my mother-in-law the wicked witch in the magic mirror," and he turns around and he has a yellow shirt with a black football helmet on. And you say, "Hey what's that thing on the front of your shirt?" And he says, "I'm a Steeler." "Oh really, what did you steal?" And he said, "I'm a Pittsburgh Steeler." "What's that? I don't know what you're talking about." We just got into a big discussion about it and all his buddies were lining up and getting behind him and pushing and all gathering around. One guy I think it was Cannonball Butler because it seems like I remember a guy saying,

"My name's Butler." "Well, Butler who?" "Jim Butler—they call me cannonball." "I never heard of you, sorry." They just all started laughing because you're kind of up in a 30-foot tower and they can't get to you!

After verbally jousting with the team, Robb saw his boss Jay Schrader walking up to the castle. "He came over and he said, 'Come over to my office.' I thought, 'Oh geez, I'm in trouble.'" Expecting to be fired, Robb headed over to Schrader's office, bent over to enter the small doorway and came face to face with a half dozen Steelers who wanted to meet King Arthur.

Turning the Page

Jennings created several more scenes for Story Book Forest during his tenure as manager of Story Book Forest, including a new automobile entrance for the 1957 season. A castle-themed gateway with mismatched turrets loomed over the new eastbound lanes of Route 30. A smaller three-man crew took on this new round of construction: Jennings; Elmer Strawcutter, who went on to become night watchman; and Andy Peterson, who became a proficient carpenter.

The team also built for that season a crawl-through Tin Can plus the Old Mill refreshment stand complete with a spinning gristmill wheel and a live character named the Jolly Miller. A Little Boy Blue figure slept on top of a haystack in Farmer Brown's barnyard. A flurry of activity went on for the 1958 season. New additions included Henny Penny (later Hickety Pickety); Baa-Baa Black Sheep; a live Little Miss Muffet with giant celastic spider; the Old Dutch Windmill on the pond's island, which was groomed by resident goats; and the Three Men in a Tub, whose barrel floated in the lake. The Butcher, the Baker and the Candlestick Maker figures were modeled after Art Jennings, Ed Schaughency and Rege Cordic, respectively. A larger souvenir stand dubbed Old Mother Hubbard's Cupboard was built for 1959, doubling as Story Book Forest's exit. Jennings also designed a few nearby units leading up to Mother Hubbard's: several stacked alphabet blocks and a grinning, articulated Jack-in-the-Box with rotating head and moving arms.

The stone Wishing Well sat toward the beginning of the winding path through Story Book Forest and collected both wishes and pennies alike— the park donated the coins to charity every year, starting with the junior

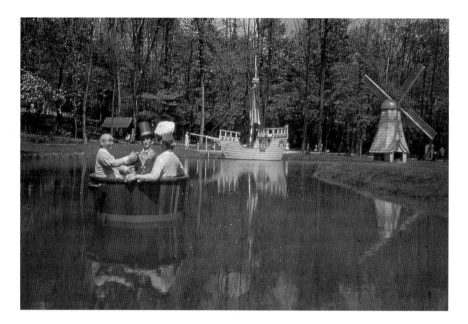

Story Book Forest's small lake featured the Three Men in a Tub, the Good Ship Lollipop and the Old Dutch Windmill. Goats and other livestock grazed on the lake's island at one time. *Courtesy of the Idlewild and SoakZone Archives.*

Art Jennings designed an animated Jack-in-the-Box for Story Book Forest's 1959 season. *Courtesy of the Idlewild and SoakZone Archives.*

and senior bands of the Ligonier Valley Joint School System, which used the donation to purchase band uniforms. Children's Hospital of Pittsburgh was one frequent recipient of the loose change that gradually added up over the season to a sizeable amount. Within the first five years, the Wishing Well had collected more than $3,400 for charity; by 1970, the figure had risen to more than $14,000 and nearly $30,000 by 1978. Today, coins collected from both the well and the stone fountain in Idlewild Park's midway benefit various local charities, including WTAE-TV's Project Bundle-Up winter clothing drive.

The partnership between the engineering clown and the amusement park entrepreneur burned bright but brief. The Frog Prince—a crowned amphibian perched on top of a giant pink toadstool overlooking the lake—was the last scene that Jennings designed for Story Book Forest in 1960, although he had ideas brewing for a moonscape across the creek at Idlewild and a western town between the neighboring parks. He loved stretching his artistic muscles planning and designing the scenes in Story Book Forest but did not enjoy the business side of running a park, especially after C.C. Macdonald died in late 1957, following the attraction's second season.

The Frog Prince overlooks Huck Finn's Wharf and the Three Men in a Tub floating in the lake at Story Book Forest. The Old Mill peeks through the trees in the background. *Courtesy of the Idlewild and SoakZone Archives.*

Jennings resigned as Story Book Forest manager in September 1960 and returned to his roots, hitting the road as a traveling performer with National School Assembly. He would not return to see his creation for forty years.

Jennings left his capable successor, William "Jay" Schrader, an incredibly colorful palette of characters and scenery to build on when the park hired him as Story Book Forest's new manager in 1961. New characters populated the forest throughout the rest of the decade, including Mistress Mary and her garden, filled with faux flowers that would never need watering from her sprinkling can–shaped house. The Little Red School House, with its bright yellow pencil supports, contained an instructive teacher, portrayed in 1969 by Donna Kowatch, who was a real-life student teacher in Ligonier Valley's school district. Visitors to Little Red Riding Hood's grandmother's house saw a furry, nightgowned visitor sleeping in the tiny spindle bed inside—a piece from Grace Macdonald's antique collection. All three units were commissioned for the 1962 season.

Story Book Forest manager Jay Schrader (*left*) and artist Tony DiMinno (*right*) touch up Mitzie Mouse and friend in the workshop. *Courtesy of the Idlewild and SoakZone Archives.*

A teacher welcomes students to the Little Red School House at Story Book Forest, pictured in this souvenir postcard. *Courtesy of the Idlewild and SoakZone Archives.*

A self-taught draftsman, Jay Schrader brought new creativity to Story Book Forest with his fairy tale scenes but also a savvy business sense. Tall, thin and always dressed in a dark suit that made him look more like an undertaker than a children's park manager, Schrader impressed a serious work ethic on his employees, according to Dave Robb:

> *I loved him to death, I really did. I think he taught me a work ethic that's lasted a lifetime. He made the kids do what they were supposed to do. You had to go in role. If you were going to be Little Red Riding Hood, you'd better act like Little Red Riding Hood. If you're going to hand them cookies out, you'd better smile and greet the kids as they come along.*

Schrader engaged local workers to build the new Story Book Forest scenes, like Gene Ambrose of Ambrose Brothers Construction, which helped with Idlewild's Rollo Coaster. The Crooked House (1963), which perfectly suited the Crooked Man and his equally Crooked Cat and Dog, presented a design challenge, with its purposely off-kilter walls. It replaced the Baa-Baa Black Sheep unit. A sword in the stone—King Arthur's Excalibur—naturally appeared adjacent to the Enchanted Castle in 1964, along with a new Elf Village with a working fountain. The 1965 season brought Snow White and

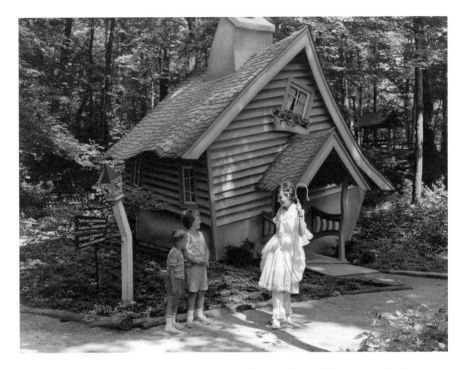

Little Bo Peep greets a few visitors to Story Book Forest's Crooked House, an off-kilter architectural challenge. *Courtesy of the Idlewild and SoakZone Archives.*

the Seven Dwarfs, followed by Mitzie Mouse and her Swiss Cheese House in 1966. A new Goldilocks and the Three Bears house replaced the original log house in 1967. Three Jacks followed suit: Jack-Be-Nimble (1967), the clumsy Jack and Jill (1968) and a second Jack and the Beanstalk (1969), with a celastic vine that replaced the original live tree. By the end of the decade, the number of attractions in the forest had about doubled, thanks in part to its young visitors' suggestions.

All the Story Book Forest units were carefully repaired and repainted between seasons to keep the forest looking fresh and new every year, which typically lasted from early May through early fall, although staff was careful to keep everything consistent so guests would not notice any touch-ups. "There was no deterioration allowed on that—none. And I think Dick Macdonald was good about that because he would walk through that place at least once a week every week or two. If he saw anything he would bring it to Schrader's attention and it would be immediately fixed," said Robb.

Local television and radio personalities visited Story Book Forest for promotional appearances, such as Dick Macdonald's good friend Paul

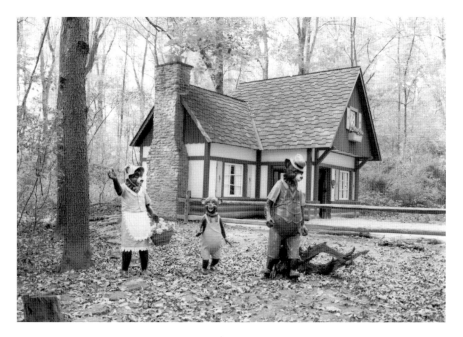

A new Three Bears house, a Jay Schrader creation, replaced the original log cabin in 1967. *Courtesy of the Idlewild and SoakZone Archives.*

Shannon, the Pittsburgh radio king who hosted the popular children's show *Six O'Clock Adventure Time* on WTAE-TV. Other Story Book Forest visitors included Miss Patti of *Romper Room* and Josie Carey, host of public television station WQED's award-winning kids show *The Children's Corner*. Puppeteer Hank Stohl of WTAE's *Popeye n' Knish* show stopped by the seventy-first annual Ligonier Valley Reunion on August 20, 1964, to sign autographs at Story Book Forest and on the Idlewild Park stage, one of his frequent visits to the parks. It is unknown if he brought along his long-nosed mop-haired friend, Knish.

Part of Story Book Forest's success was terrific promotion locally and beyond Western Pennsylvania. Public relations director Miles "Herky" Buell of Laughlintown, who joined the team in 1959 and stayed on through the 1970s, was instrumental in driving business to both Story Book Forest and Idlewild. In addition to his on-site duties as Idlewild picnic representative, Buell, a former reporter for the *Ligonier Echo* and the *Johnstown Tribune-Democrat*, roamed the East Coast over the winter, promoting the neighboring parks, particularly in Ohio, Maryland, West Virginia and Michigan. Armed

WTAE-TV's Hank Stohl, actor and puppeteer of Rodney and Knish fame, signs autographs during one of his appearances at Idlewild Park and Story Book Forest in the early 1960s. *Courtesy of the Idlewild and SoakZone Archives.*

with colorful brochures and coloring books designed by Tony DiMinno, Buell visited travel offices in advance of the upcoming season, hoping to drum up business from vacationers. By the end of the 1960s, more than 1 million people had visited Story Book Forest—half of whom had traveled from out of state.

The Historic Village

Taking a step toward Art Jennings's idea for a pioneer land, in the fall of 1966 Story Book Forest Inc.'s board of directors firmed up plans to add a general store and craft shop at the eastern end of the attraction. The store was the first stage of a three- to five-year development plan for a future themed area called the Historic Village—a snapshot of a typical Main Street in nineteenth-century America. The Historic Village Store opened

for the 1968 season and offered "old fashioned gifts and merchandise," from cast-iron figures to hand-painted towels and teddy bears. Visitors could snap amusing souvenir photos of friends and family locked in a stockade. The building also did double duty as a much-needed storage facility. Although the Historic Village Store was part of Story Book Forest, no admission was required to visit.

The Historic Village expanded in stages over the next decade. Jay Schrader designed a barn-shaped snack bar and patio called the Feed Box for the 1972 season. By the fall of 1975, Story Book Forest's board had moved forward with plans to expand the Historic Village area for America's 1976 bicentennial. Schrader worked with Jack Macdonald's son, Scott Macdonald, on designs for five additional shops at the Historic Village built by contractor Harry Wilkins: the Village Jail and Sheriff's Office, the Blacksmith Shop, AD Boone's Print Shop (newspaper/lawyer's office), a Woodcraft Shop manned by a resident woodcarver and the Copper Penny Saloon.

The blacksmith shop and jail were two of the buildings that made up the Historic Village, built at the eastern end of Story Book Forest. *Courtesy of the Idlewild and SoakZone Archives.*

While the overall goal was to continue building additional units in the area over the next several years, the Livery Photo Studio, where costumed souvenir guest photos were taken, would be the last one added in 1978 to complete the Historic Village. The throwback town was a modern re-creation of the past, but some authentic details were incorporated into its design. The dual sheriff's office/jail consisted of old bricks brought in from Lancaster County, while the two cell doors, with century-old locks, originally confined criminals in an old jail in the nearby town of Bolivar. The print shop contained a hand press used to print legal documents, and a giant eighty-five-year-old saw blade decorated the woodshop. A high-wheeled bicycle originally owned by the Dutton Circus hung at the front of the Historic Village Store, where inside folks could see an authentic brass-finish manual cash register, wooden butter churn and Burnside potbelly stove. Outside the general store sat an antique horse-drawn carriage with upholstered seats. Fiddler Homer Greenawalt and a player-piano treated patrons enjoying snacks and soft drinks in the saloon to live music. Wood plank sidewalks, hitching posts and watering troughs also enhanced the new themed area that promised guests "A Visit to Yesteryear!"

A Best Seller

For more than sixty years, people from all fifty states and more than twenty foreign countries have visited the forty-plus scenes throughout Story Book Forest since it first opened in 1956. The attraction grew throughout the 1970s with the additions of a Talking Tree (1972) and Old King Cole (1970), who sat on his throne entertained by his fiddlers three. Huck Finn's Wharf, an homage to Mark Twain's beloved literary character, was added to the lake in 1979. By the end of the decade, Story Book Forest had entered a new chapter. Jay Schrader continued as manager through the 1976 season, after which he took a medical leave and subsequently retired, before his passing. Tony DiMinno also retired, returning briefly to train Story Book Forest's new artist and eventual manager, Ed Ostroski, in the art of caring for the classic characters who lived in Story Book Forest when the latter was hired in 1977.

Story Book Forest's growth slowed throughout the 1980s and 1990s. Some of the older scenes, such as the Frog Prince and Jack and the Beanstalk, were removed and replaced by new stories. Other planned units

were scrapped, including Rapunzel, Cinderella and a Boneyard Shelter. A second Alice in Wonderland unit with a live character and full-sized playing cards debuted in 1980 for a short run, followed by live Raggedy Ann and Andy characters and their toy box in 1985. Hansel and Gretel's cottage became Geppetto's Workshop. The Little Engine that Could and Aladdin's Magic Carpet were two later additions. A giant celastic goose that topped Kennywood's Kiddieland bathrooms moved to Story Book Forest in 1984 for a few seasons,[196] and the park often had a live character referred to as Mother Goose who collected tickets and handed out nursery rhyme pamphlets. However, a permanent Mother Goose character wasn't fully developed until 1994. After more than twenty years in the role, Beverly Leonatti continues to greet visitors to the Forest inside the giant storybook, with Bertrum, her stuffed goose sidekick.

In 1984, the park relocated the storybook entrance and reversed the direction of Story Book Forest's walking path. After forty years, the aging Enchanted Castle was removed in 1997 to accommodate a new entrance for Idlewild. Despite the heartbreaking loss of the castle for many of the attraction's fans, who would have to wait almost twenty years for its royal return, Story Book Forest has not lost its appeal to those who step through the pages of the giant book every year.

THE SECOND MACDONALD ERA

Family Fun in the Beautiful Laurel Highlands
—Ligonier Echo *(1976)*

By the late 1950s, the Macdonald family managed a pair of popular Ligonier Valley attractions—the historic Idlewild Park and the brand-new Story Book Forest. Idlewild had survived the Great Depression, World War II and the Ligonier Valley Rail Road abandonment, and Story Book Forest was an immediate success with children and families.

After a sixty-two-year career in the amusement park industry, C.C. Macdonald passed away in November 1957 while on a hunting trip in Texas. Those who knew him not only applauded his management skills but also remembered his generosity and kindness,[197] as well as that of his wife, Grace, who died in October 1964. The couple left Idlewild Park and Story Book Forest in the capable hands of their two sons. The change in leadership due to the deaths of the elder Macdonalds also meant that some new faces joined the company boards, including Juanita Barkley, a longtime park office employee, and Charles Scott ("Scotty") Macdonald, Jack Macdonald's son.

The second generation of Macdonalds assumed more active roles at the two neighboring parks. Elder son Jack was already working at Idlewild; in 1942, he became general manager and then president in 1957. His brother Dick, a U.S. Air Force veteran, entered the business after World War II as assistant general manager, later operating Story Book Forest. For more than twenty-five years, the Macdonald brothers ran Idlewild and Story

Book Forest as independent ventures, separated by a fence in between. One park had paid parking (Idlewild), while the other had free parking (Story Book Forest). One sold Coca-Cola products, while the other sold Pepsi. Nevertheless, the two parks were marketed together: "Supplementing scenic splendor, neighbors in presenting refined relaxation."

Ligonier Links

A few years after the addition of Story Book Forest, the Macdonalds decided to expand the family business by opening a public golf course across from Idlewild Park. For decades, the wooded acreage on the north side of Route 30 sat vacant. Part of the original Darlington estate, the land was once a thruway for the Ligonier Fire Clay & Brick Company's narrow-gauge railroad that branched from the Ligonier Valley line to reach a fire clay mine north of the park.[198] Any remaining roadbed was obliterated when ground broke on the first half of the new golf course in the fall of 1962.

On May 30, 1963, the first nine holes of Timberlink Golf Course opened along the westbound lanes of Route 30 directly across from Idlewild Park. Like Story Book Forest, this venture would be completely separate from Idlewild but still owned by the Macdonald family. Jack, Dick, Grace and Scott Macdonald initially formed the board of directors for Timberlink Inc., a new corporation set up on July 18, 1962. Scott was tapped to manage the new golf course. The Idlewild Management Company sold Timberlink Inc. just over 121 acres of property on the northern side of Route 30 for $20,000,[199] as well as loaned funds to construct the golf course, clubhouse and maintenance building.

The name Timberlink was an oxymoron for Ligonier's new golf course, covered with oaks, elms and maples—the antithesis of a sparse links-style course. Pittsburgh-based engineer X.G. Hassenplug placed the holes among the tall trees and added various touches such as footbridges, stonework, water fountains and post and rail fencing. The plan also included a maintenance building and a clubhouse where inside was a pro shop offering professional golf instruction plus a snack bar.

Timberlink's second nine holes, added in early fall 1964, were ready for public play at the start of the 1965 season. Now complete, the eighteen-hole par-fifty-five executive short course totaled 2,375 yards and appealed to both beginner and expert golfers, with a variety of regulation tees and greens

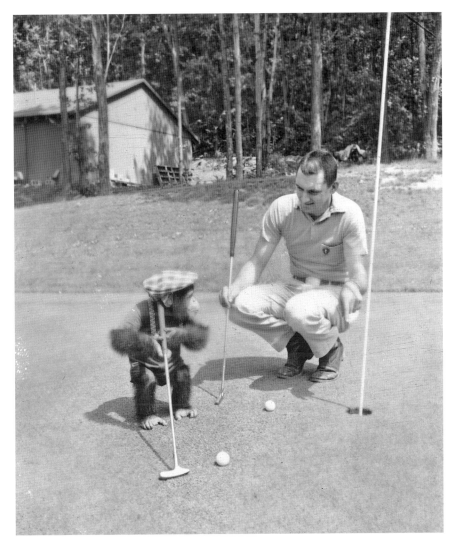

Golf champ Harry Wilkins monkeys around at Timberlink Golf Course with Dusty, one of the Antonucci chimpanzees that appeared at Idlewild Park in June 1964. *Courtesy of the Idlewild and SoakZone Archives.*

ranging from 75 to 225 yards. Timberlink's course was easily playable within a short amount of time.

A decade after Timberlink first opened, the Macdonalds converted the golf course's combination pro shop/snack bar into the self-service Timberlink Steak-Out Restaurant. The Steak-Out opened on April 14, 1973, offering customers "a completely new experience in family dining" where they

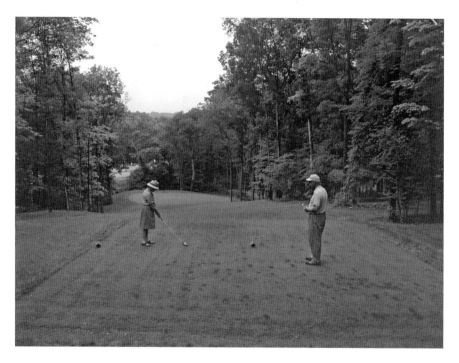

Reverend and Mrs. H.J. Fisher of Monroeville play a round at Timberlink, located across from Idlewild on the northern side of Route 30, seen in the background. *Courtesy of the Idlewild and SoakZone Archives.*

broiled their own steaks and kabobs and enjoyed an adult beverage, as the venue served alcohol. Initially, the Steak-Out only served beef, but later Cornish game hen appeared on the menu cooked by a new rotisserie chicken oven. Scott Macdonald claimed that his father's travels in Hawaii influenced Steak-Out's concept, as similar restaurants with outdoor grills were popular there. It took some clever engineering to install an indoor gas grill without an exhaust problem, but once complete, the seasonal restaurant became another Macdonald family success, offering patrons a unique dining and social experience.

Ligonier Highland Games

In addition to his responsibilities as owner and president of Idlewild Park, Jack Macdonald immersed himself in the local community, co-founding the Ligonier Valley Chamber of Commerce in 1946, among other endeavors.

Inspired by the rich Scottish heritage in not only his family but also across the Ligonier Valley and Western Pennsylvania overall, in 1959 Macdonald established the Clan Donald Highland Games with Carnegie Institute of Technology bagpipe director Lewis Davidson and Pittsburgh businessman Reginald Macdonald of Kingsburgh. The three men conceived this annual event as a gathering of Scottish clans that traced their ancestry to branches of Highland Clann Domhnaill, the oldest and most famous clan in the country.

Although not a park-sponsored event, the Highland Games have been held rain or shine on the athletic field at Idlewild Park since the inaugural games on September 13, 1959. After its first three seasons, in 1962 the organizers rechristened the event as the Ligonier Highland Games. Originally held the first weekend after Labor Day, the one-day event features heavy athletic competitions like tug-of-war and tossing the sheaf, where competitors use a pitchfork to launch a sixteen-pound bale of hay over a bar. The caber toss became the Highland Games' most popular sport, where competitors attempt to flip logs the size of telephone poles end over end.

The Ligonier Highland Games now kick off the fourth Saturday in September, after Idlewild Park's regular season ends. The weekend begins with a dinner on Friday night, followed by the main events at the park on Saturday and a pipe band service on the Diamond bandstand in Ligonier on Sunday. A beautiful massed bagpipe parade featuring dozens of visiting Scottish clans from the United States and Canada closes game day on Saturday evening.

The Ligonier Highland Games also include dancing contests as well as solo and mass drumming and bagpipe competitions that broadcast music across the park all day, much to Idlewild Superintendent Bill Luther's chagrin, who reportedly shouted, "God save me from those pipes!" at the first Games. Vendors cook traditional Scottish delicacies such as haggis at colorful tents around the sporting field. Other merchants offer authentic Scottish kilts, kitchenware and specialty goods. The Games are also the only day during the year when beer is served at one dedicated area in Idlewild. Acknowledging the role that the Scottish Highlanders played in the Ligonier Valley during the Forbes Campaign and the French and Indian War, living history demonstrations feature the 1763 Royal American Regiment of Fort Pitt, whose reenactors perform fife, drum and musket drills. Pups are equally welcome to the Highland Games, with sheepdog demonstrations and Scottish terriers, collies and other native canine breeds exhibited in the main area of Idlewild Park.

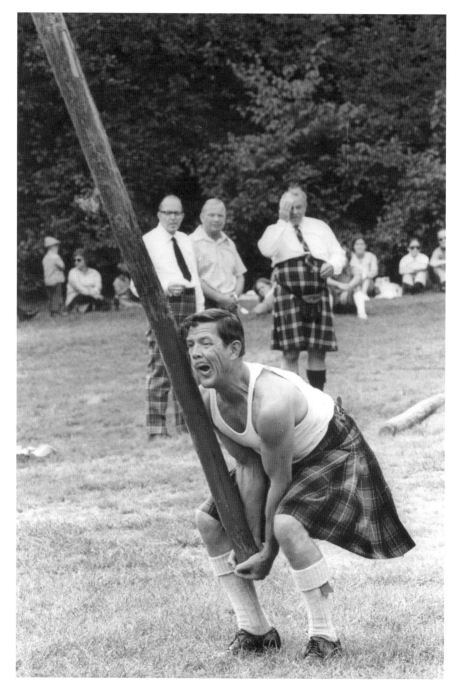

The caber toss is one of the most popular events at the Ligonier Highland Games, as seen here in the early 1960s. *Courtesy of the Idlewild and SoakZone Archives.*

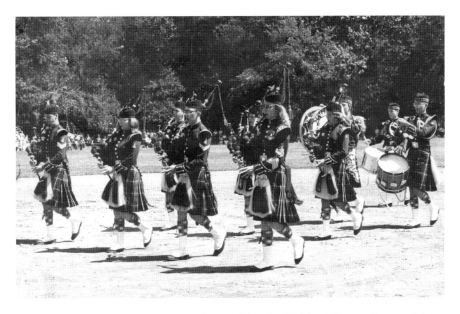

A massed bagpipe parade closes out each year's Ligonier Highland Games. *Courtesy of the Idlewild and SoakZone Archives.*

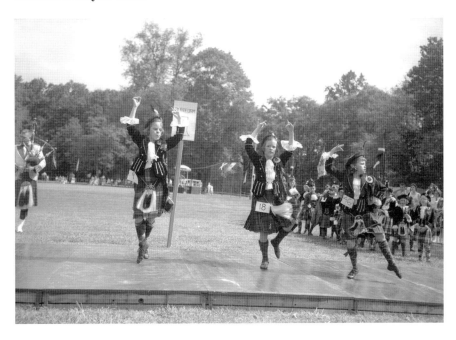

Girls perform the Highland Fling during a dance competition at the annual Ligonier Highland Games at Idlewild Park, circa early 1960s. *From the Fantastic Fotographica Collection, courtesy of Harry Frye.*

Celebrating sixty years in 2018, the Ligonier Highland Games continue to share sports, arts, cuisine and other aspects of Scottish history and culture with the local community; the event also serves as a fundraising program for the Clan Donald Educational and Charitable Trust. The nonprofit organization is overseen by an executive director and a large group of volunteers. The late David Peet served as the Highland Games' longtime executive director for more than four decades. According to current executive director Richard Wonderly, the Ligonier Highland Games are the third-oldest Scottish games in the United States and continue to attract an average of forty clans from across the United States and Scotland, mostly because the forested Idlewild Park faithfully replicates the experience of authentic Scottish games across the Atlantic Ocean.

Loyalhanna Limited and Frontier Safariland

The year 1965 was a momentous one for Idlewild Park with the launch of two major attractions. The Idlewild Management Company negotiated an agreement with Crown Metal Products of Wyano, Pennsylvania, to install a second miniature railroad on the eastern side of the park—this one powered by a true coal-fed steam locomotive. Crown Metal assumed all costs of installation, operation and insurance, whereas Idlewild received 25 percent of the gross receipts plus the first option to purchase the entire ride—including locomotive, tender, cars, track and bridges—which the board eventually voted to do in September 1974.

The twenty-four-inch-gauge "Loyalhanna Limited" originally pulled five canopied steel coaches along the north bank of the creek, roughly following the former roadbed of the Ligonier Valley Rail Road. The train, displaying the "Little Toot" moniker on its engine, transported passengers to and from the neighboring amusement parks, between stops located near the Skooter and Whip in Idlewild and at Story Book Forest.

In 1966, two trestles installed over the Loyalhanna Creek allowed the Loyalhanna Limited to cross to the south side, wind through a forest glade and return to the main park. The train now brought folks past Idlewild's new zoo that had opened the previous year, Frontier Safariland. Replacing the rustic Shadowlands, the zoo was built on an island within what remained of old Lake Woodland[200] and featured a collection of North American wild animals and a domestic petting yard.

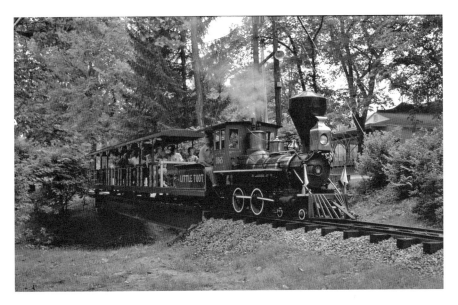

A 1965 addition, the steam-powered Loyalhanna Limited transports its passengers between stops located near Story Book Forest and across the creek. *Courtesy of the Idlewild and SoakZone Archives.*

Friendly deer enjoy treats from guests visiting the petting zoo at Frontier Zoo, shown here in 1975. *From the Thomas Baldridge Collection, courtesy of the Latrobe Area Historical Society.*

A young girl visits the sea lions at Frontier Safariland on May 24, 1965. The new zoo, featuring exotic and domestic animals, opened the previous day on the south side of the Loyalhanna Creek. *Courtesy of the Idlewild and SoakZone Archives.*

With special guest Don Riggs, host of KDKA-TV's *Safariland*, on hand for the grand reveal, Frontier Safariland opened to the public on May 23, 1965. Len Kiser managed the new attraction, which featured three major sections: a large pool containing California sea lions; a walk-through aviary housing flamingoes, macaws, storks, peafowl, swans and other birds; and a deer park featuring whitetail and ornamental deer. The zoo's other animals included a monkey house, a snake house, bear cubs, a llama, a mountain lion, a bobcat, an ocelot, a porcupine, an armadillo, a coyote, foxes and raccoons. For a small fee, guests could feed the sea lions and young deer. The zoo area also included a Mule Train that employed four mules and a wagon.

The zoo was renamed Safariland Zoo in 1967 and then Frontier Zoo by 1970. Private owner William Holmberg, of Ligonier Township, took over operations in 1968, adding other species such as camels, Scottish sheep, South American llamas and Sicilian (miniature) donkeys. During

the offseason, the barnyard animals lodged at local farms, while the exotics spent the winters at the park in a heated concrete building not far from the zoo's entrance.

'60s and '70s Idlewild

Economic shifts after World War II brought attention to an empowered demographic in America: teenagers. Music, movies, fashion and other culture specifically engaged teens, who now had more independence and economic power. The rock-and-roll explosion of the 1950s highlighted the growing generation gap between kids and their parents. Rock-and-roll and pop music were extremely important to teens, who heard their own lives reflected in the music that combined their lyrical hopes and rebellious desires.

By the early 1960s, Idlewild acknowledged that cultural shift and increased its marketing to teenagers by hosting record hops at the park. Popular local disc jockeys—including Clark Race, Jim Williams and Bob Tracy from Pittsburgh's KDKA Radio and Stan Wall from Greensburg's WHJB—broadcast live from Idlewild during event days and group picnics. Sometimes the hosts promoted the guest appearance of a well-known singer or group, including the Essex, an R&B group known for their 1963 chart-topper "Easier Said than Done." The Essex performed during the Derry Community and School Picnic in 1966 decked out in full dress uniforms, as all their members were enlisted U.S. Marines.

Folks stomped their feet to music by Jack Purcell's Jongleurs every Wednesday and Saturday night from 8:00 p.m. to 11:00 p.m. starting in 1961 at the park's Hemlock Grove dance hall located behind the Auditorium. New for 1960, the pavilion was a gift from the Mellon family, originally built at their Rolling Rock Farms homestead, Huntland Downs, for Richard King Mellon's daughters' coming out parties in the late 1950s.[201] The tall trees clustered around the area inspired the pavilion's name. One notable pop star who performed at the Hemlock Grove was Bobby Vinton, who appeared during West Penn Power's company picnic on July 29, 1961. At that time, the Canonsburg, Pennsylvania native was poised to climb the national charts with his smash hit "Blue Velvet."

With its new appeal to teenagers, Idlewild Park remained inclusive to all generations. Musical entertainment encompassed a wide variety

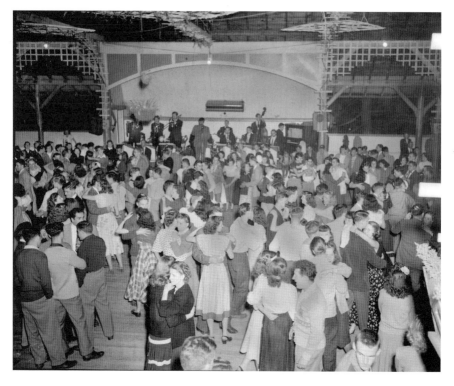

A live band plays for a large crowd dancing in Idlewild's Auditorium in the early 1940s.
From the Fantastic Fotographica Collection, courtesy of Harry Frye.

of genres: rock-and-roll, pop, country-western, bluegrass and spiritual. Gospel harmonies from vocal groups like the Blue Ridge Quartet and the Sunshine Boys echoed across the park. Country music artists like Westmoreland County's champion fiddler Harry "Tink" Queer continued to be popular at Idlewild. Queer led several incarnations of his country-western orchestra at square dances during alumni and merchants picnics from the 1940s through the 1960s. Labor Day 1964 marked the inaugural date for a Country Music Spectacular that closed Idlewild's operating season. Grand Ole Opry stars like Minnie Pearl, Hank Snow and Grandpa Jones typically headlined the annual concert, with regional country acts like Doc Williams and his Border Riders and Cowboy Phil of WHJB joining in for the grand finale on the Idlewild stage. Minnie Pearl (real name Sarah Ophelia Colley Connor), who later joined the popular *Hee-Haw* variety show, brought her comedic hillbilly character to Idlewild for the park's Labor Day Spectacular in 1965, 1967 and 1977.

How-deeee! Country comedian Minnie Pearl was "jes' so proud to be here" when she appeared for Idlewild Park's Labor Day Country Music Spectacular. Dick Macdonald (*left*) and Bill Luther (*right*) pose with the Grand Ole Opry and *Hee-Haw* star at the stage door. *Courtesy of Richard Z. and Ann Macdonald.*

In 1959, the park continued scheduling free acts on Sundays, which included stage shows of radio and TV personalities plus other performers and guest speakers. Maria von Trapp, whose family was immortalized in *The Sound of Music*, was the featured speaker during Dependence Day for the Christian Family on Sunday, July 3, 1977. Musical entertainment often headlined the park's special event days, such as the Polka Spectacular, which featured multiple polka bands on stage before a free dance, and Italian Day, which featured a strolling accordionist. "America's Polka King" and Grammy Award–winning musician Frankie Yankovic appeared on stage during the park's Slovenian Day in 1978. For the younger crowd, a children's theater called the Barnyard Playhouse was added in 1971 that featured a Punch and Judy–style show starring live animal actors. The playhouse replaced the Hemlock Grove.

Idlewild's long-running Old Fashioned Day kicked off on August 23, 1961, featuring an "old-fashioned" fashion show, barbershop quartet and antique

auto show. All ride admissions were reduced to two tickets. Eventually, the single day would expand into a weeklong event at the park, with throwback games like watermelon seed spitting and catfish derby, vintage stage shows with Charleston dancers and mimes and quick-draw artists. The climax was always the antique car parade that drove through the center of the park—a tradition that continues as a stand-alone event today.

In addition to entertainment, Idlewild also added new rides and attractions from the late 1950s through 1970s. The Little Show Boat, a twenty-four-foot-long fiberglass replica of a Mississippi showboat, replaced the aging motor launch in the late 1950s.[202] The Alan Hawes Manufacturing & Display Company boat toured up to thirty passengers around Lake Bouquet, propelled by a working paddlewheel. The eighteen-hole Goofy Golf miniature golf course opened at the park in the spring of 1959, erected between the Rockets and bridge on the former site of a picnic pavilion.

The Idlewild Management Company continued to purchase rides from popular amusement park ride manufacturers, including an Allan Herschell

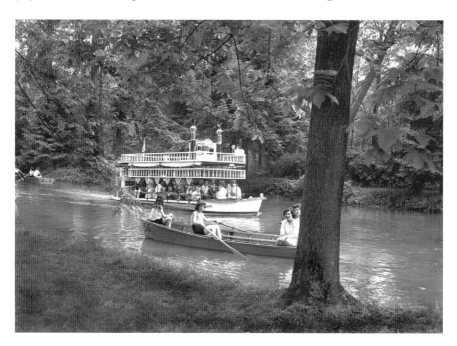

Picnickers enjoyed cruising around Lake Bouquet in the Little Show Boat or floating in one of the rowboats, as seen here in this late 1950s photograph. *From the Fantastic Fotographica Collection, courtesy of Harry Frye.*

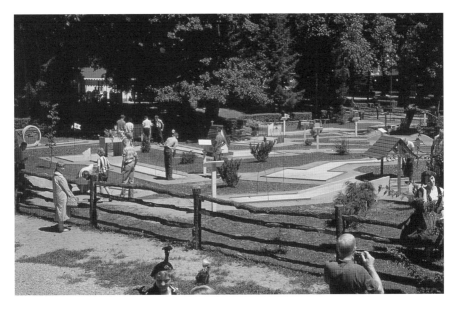

An eighteen-hole miniature golf course called Goofy Golf was added at the park in 1959. *Courtesy of the Idlewild and SoakZone Archives.*

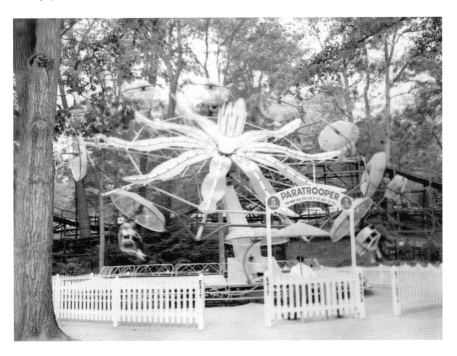

Added in 1964, the Paratrooper originally sat near the Rollo Coaster before moving to its current location near the Skooter. *Courtesy of the Idlewild and SoakZone Archives.*

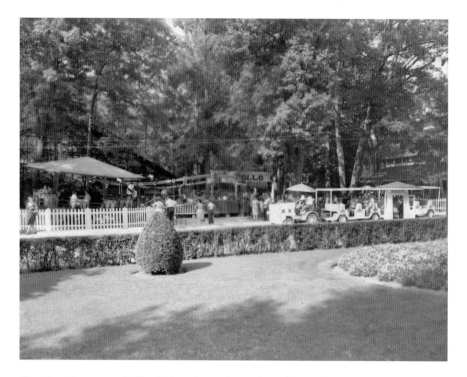

The West Plaza area of Idlewild has changed over the years. In this early 1960s photograph, the area featured the Tilt-a-Whirl and the Jitterbug. A sightseeing tram that shuttled folks across the park also appears in this view. *Courtesy of the Idlewild and SoakZone Archives.*

Helicopter ride in 1962 that sported eight painted metal cars each with an up-down control that passengers used to create a custom flight. A forty-five-foot-diameter Frank Hrubetz & Company Paratrooper, a parachute-themed ride that spins suspended cars at an angle, followed in 1964. Both rides were installed in the west plaza area near the Rollo Coaster, requiring the park to relocate its Sellner Manufacturing Company 1957 model Tilt-a-Whirl along the creek next to the Rockets.

While traditional rowboats were still available in Lake Bouquet, pontoons called Water Skeeters floated in Lake St. Clair beginning in 1967. A Hrubetz Round-Up, also called the Cloud 9, was added in 1968. The twenty-nine-foot-diameter steel wheel used centrifugal force to keep up to thirty passengers pressed against its sides for more than two minutes as it spun at a seventy-degree angle. The Trabant, a fluctuating spinning disc ride, spent 1972 through 1983 at two locations in the park, appearing its first year near the restaurant before moving to the future Spider location

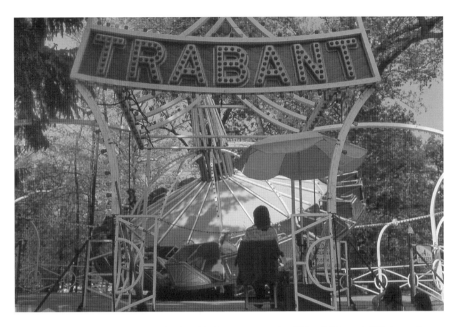

Reminiscent of a satellite, the spinning Trabant operated at Idlewild from 1972 through 1983. *Courtesy of the Idlewild and SoakZone Archives.*

below the Auditorium. The Chance Manufacturing creation's German name translates to "satellite."

Idlewild continued its relationship with the Philadelphia Toboggan Company by purchasing a Crazy Dazy teacup-style ride for the 1973 season. Unfortunately, the popular ride was on backorder for more than a year before the park finally received its Crazy Dazy ride in early 1974. Briefly called the Mad Scrambler, Idlewild's Eli Bridge Company twelve-car Scrambler (1977) was aptly named because the ride's movement resembles a kitchen blender; the ride was initially installed on the west side of the carousel before relocating to the east side many years later, in 1998.[203]

The year 1978 marked Idlewild's 100th anniversary. Over the previous century, the park had evolved from a placid picnic ground into a popular amusement park buzzing with rides, games and entertainment. To celebrate its centennial, the park scheduled special event days throughout the season and invited several music guests, including Stella Parton, a successful country music singer-songwriter like her sister Dolly. Following Top 20 country chart success earlier that year, Parton took the stage on July 23, 1978, singing her biggest hit, "I Want to Hold You in My Dreams Tonight." She recalled her experience performing at Idlewild:

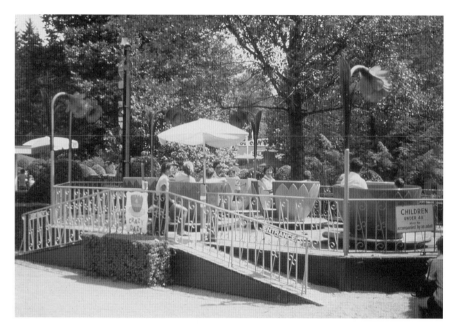

A flower-themed teacup ride called the Crazy Dazy, Idlewild's third Philadelphia Toboggan Company ride, debuted in 1974. *Courtesy of the Idlewild and SoakZone Archives.*

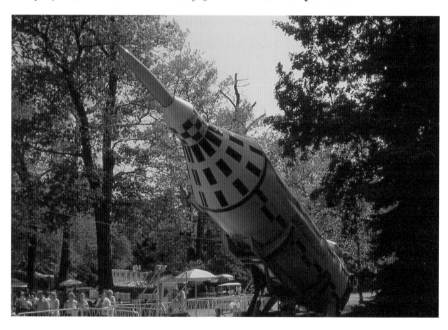

The Astro-Liner simulator ride marked Idlewild Park's centennial year in 1978. *Courtesy of the Idlewild and SoakZone Archives.*

Stella Parton performed on the park's outdoor stage on July 23, 1978, as part of Idlewild's centennial year. *Courtesy of Ron Newcomer.*

My memories of working Idlewild were awesome! The weather was beautiful and the Pennsylvania audiences were always so kind and generous to me....I cherish the memories and the friendships I forged with many of the people from that area.

Idlewild also installed Rail Rodeo, an impressive model railroad display, and launched the Astro-Liner, considered the first simulator ride created for the amusement park industry, for the 1978 season. Forty passengers aboard the Wisdom Rides spaceship watched a projected space adventure from a sixty-degree angle as the ride's operator manipulated a joystick to tilt the ship back and forth as the film progressed. Located near the Skooter, the Astro-Liner was a high-maintenance ride prone to breakdowns, but the space-age attraction was nevertheless a unique addition to the historic park.

A High Caliber

Idlewild Park was not just the product of good business practices and savvy promotion. It also succeeded because management attracted an extremely high caliber of people to work for it, according to Dick Macdonald. Full-time staff working behind the scenes to maintain the rides and grounds included Ken and Bob Parker, Charlie Deemer and longtime park superintendent William Peoples Luther, who worked (and lived) at Idlewild for about forty years as one of the park's longest tenured employees.

Bill Luther began his Idlewild career in the late 1930s as ride superintendent, replacing Walt Anderson as general superintendent when the latter left Idlewild in 1957. After spending summers at the park and the offseason at home, Luther eventually moved his family—wife Edith and children Sandy and Bill—to the park around 1950, where they lived in a cottage between Idlewild and Story Book Forest that had its own farm and garden.

Growing up on a farm in West Fairfield, Pennsylvania, Luther cultivated a love of agriculture that translated to his job. As park superintendent, Luther was responsible for both the rides and the grounds at Idlewild, but the latter gave him an exceptional source of pride. Many Idlewild guests remember colorful posies bursting from flowerboxes beneath the second-story windows of the park buildings. Those arrangements were all Luther's doing, inspired by the landscaping he saw at other parks during his travels for the Macdonalds. Luther took his job seriously, as Dick Macdonald remembered:

> Bill Luther was one of the finest people we ever knew....Bill used to say, "You fellas are killing me," because he kept all the flowers nice and everything. Hand-watered. I said, "Bill, why don't you put artificial flowers?" He said, "Are you asking me to lower my standards?"

Luther's loyalty to Idlewild Park rivaled his dedication to his family, according to daughter Sandy Luther Smetanka, who pointed out one such incident during a 1954 flood to illustrate his tenacity. The park had recently received a shipment of lumber to rebuild the Whip floor, which washed away in the rushing water. Luther jumped in a rowboat and began paddling across the park to rescue the load, despite not knowing how to swim. The superintendent's long career at the park lasted until 1984, when he retired before his passing in 1986.

The Luther family's year-round tenancy at Idlewild Park was a mixed bag for young Sandy and Bill. An amusement park childhood came with

obligations to give free ride tickets to classmates and dates when the school picnic rolled around and the expectation that you would eventually work at the park too. Yet it also had unique perks, like bicycling around the grounds when the park closed on Mondays and becoming intimate friends with many of the free acts that performed each summer. As the two girls were close in age, Smetanka became bosom friends with Maddalena Zacchini, who shot across the Idlewild midway twice a day when her famous human cannonball family appeared at the park during the mid-1960s. When Pinky Madison brought his elephants to the park for a summer engagement, he often brought Dolly and Minnie to the Luther house for rides. During one visit, one of the elephants trampled on the grass seed that Luther had so carefully planted.

In addition to Idlewild's core group of full-time year-round employees the park hired—and still hires—hundreds of seasonal employees to operate Idlewild throughout the summer, mostly young people from the surrounding communities, including Ligonier, Latrobe, Derry and Greensburg.[204] Teachers were also a common hire, filling up their summers between school years by working at Idlewild and Story Book Forest. Employees operated the attractions, sold ride and refreshment tickets, worked on the grounds crew, staffed the arcade and portrayed various storybook characters, among other responsibilities. Workdays were long and hot, but memories made were strong and enduring, like those of Idlewild alumni Ralph Zitterbart and Carol Oravetz.

Before graduating from Latrobe High School in 1959, Zitterbart spent the summers of 1957 and 1958 working in Kiddie Land, primarily operating the Miniature Ferris Wheel. Zitterbart grew up in Edgewater Terrace in Latrobe—literally in Mister Rogers's neighborhood, as Fred Rogers's family lived next door. Every day during those two summers, Zitterbart stood at the end of what is now Fred Rogers Drive where it meets Route 30 and stuck his thumb out for a ride. His hunter green work shirt with the "Idlewild" emblem on the sleeve alerted drivers to his destination.

The work ethic at Idlewild was high. Employees usually arrived at the park around 11:00 a.m. and often worked until 11:00 p.m. Nearly sixty years after Zitterbart left Idlewild's employ, he'd still keep every pay stub from those two summers; his weekly pay of $34.05 broke down to about $0.60 per hour. Slower days afforded some innocent mischief for teenage boys like Zitterbart and his coworkers, including hand car races where they would jump the cars off the track as they whizzed around the bends. Working at the park also gave Zitterbart an opportunity to meet high school girls throughout the day. He would often allow them to ride the Miniature Ferris Wheel, intermittently squeezing the hand brake so that the wheel would start rocking and the girls

would start screaming. Kiddie Land usually closed around 9:00 p.m., but the rest of the park was open later, so Zitterbart often met his new friends after his shift ended to ride a few of the adult rides, including the Caterpillar: "We made it a point to take the girls on the Caterpillar....We were gentlemen and let them get in first. Things got comfortable."

On slower days, Zitterbart would take over the Skooter, which afforded him another opportunity to please the girls. A ride on the Skooter typically lasted about three minutes, but if business were slow, he extended the ride to five, six or even seven minutes. Ride supervisor Bob Parker eventually caught on to his shenanigans, as the public address office was located above the adjacent stage, within earshot of the noisy Skooter cars, and he scolded the teen for running the ride too long.

As adults, Zitterbart and his wife, Edra Mae, brought their three children to Idlewild at least once a year for Latrobe Steel union picnics, which attracted seven to eight hundred employees and family members. Now he occasionally brings his granddaughter to the park when his son's family is in town. What always impressed him about Idlewild was its inviting, relaxing atmosphere: "What makes Idlewild Park unique is the fact that it does have a country, family setting where you just get away from the big rides. You could turn your kids loose."

Carol Oravetz spent the summer of 1975 working at Idlewild Park. It was the nineteen-year-old's first job after high school:

I spent the sunshine-graced summer of '75 as operator of the helicopters. In those days, the ladies wore candy cane striped pinafores. Located in a very central spot, I could observe activities at the Trabant, the Paratrooper, the Rollo Coaster and the ever popular merry-go-round. I can still hear sing-along with Mitch [Miller] over the PA. Every morning began with, "Happy Days Are Here Again," immediately followed by "Hello. Hello. Hello. What a Wonderful Word, Hello..." The music would end. A brief pause, an expectant moment, and that old merry-go-round Wurlitzer organ would open up with "Stars and Stripes Forever." Life could continue, for all was in order at Idlewild Park.

I could go on and on about that summer. Funny how it did not seem so at the time, but it was actually one of the best summers of my life. So many memories. So many life lessons. A less common experience would be the night I got stranded in the park after closing. It was one of those late nights where many of the staff had already left. At the final note of the national anthem, those that were left made our trek to the office, toting our ticket boxes and chatting away as friends

do. Our small group was the last to make it to the wooded parking area near the office where we parted, each to his own vehicle. Leisurely, I organized my belongings and buckled up. But when I turned the key to start my car, all I heard was "Click. Click. Click." Yikes! Dead battery! And all I saw were taillights leaving the parking area. Desperately, I ran after them yelling—no, make that screaming—for someone to stop! I ran to the office. But it was dark and locked up tight. Knowing that the gates would be closed and locked long before I could get there on foot, I was left to explore my mid-'70s low-tech options. There was a phone booth on the midway, but I had no coins. So I decided to walk to the maintenance shed at the far end of the park by Story Book Forest in hopes of finding someone…anyone.

That journey through a deserted park stands as the most surreal experience of my life. Dark but for a few street lights, I passed through what had recently seemed a living, breathing entity, alive with laughter, kinetic with people, savory with the smells of cotton candy and caramel corn. Now, everything was eerie, changed, phantom-like. I paused at the merry-go-round, contemplating the carved horses, frozen in mid-prance and full-gallop. I floated past the center stage and the Skooters, oddly homesick for the smell of hot grease and ozone. Oh joy! There was a light in the distance. How I ran toward that light praying it would not go out before I got there. My short drama came to a relieved conclusion as I found [my supervisor] *Ken Parker finishing up his day. Don't think he was too happy with me, but I was truly happy with him. The reality of a golf cart ride back through the park abruptly broke the enchantment of the prior 15–20 minutes. My battery got the jump it needed, and away I went. Another memory nugget to carry with me forever.*

I only worked there one summer. The Idlewild job was offered the same day I was offered a factory job at Williamshouse. I wanted the money. But my dad encouraged me to render pay a secondary consideration. He felt I should accept a job that had more potential for personal satisfaction. Thanks Dad. You have taught me many things, including wisdom.

Captain Idlewild

The Macdonalds employed different marketing schemes to promote Idlewild Park, from traditional newspaper ads with catchy graphics and tag lines ("You Can't Beat Fun") to sending ambassadors Happy Dayze to local schools and Miles Buell across state lines to promote the park. In the early

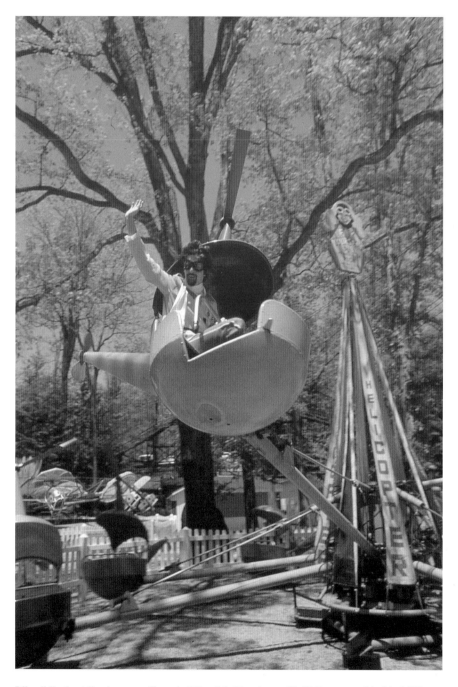

Idlewild's short-lived mascot Captain Idlewild rides the park's Helicopter, added in 1962. *Courtesy of the Idlewild and SoakZone Archives.*

1980s, management worked with a Pittsburgh-based agency to bring in a new but short-lived mascot during the 1980 and 1981 seasons for television promos and personal appearances.

The agency's original idea was to float a hot-air balloon a few times over Idlewild Park during the season. A preliminary sketch included a pilot riding in the balloon, which sparked the idea for a live character who would serve as Idlewild's "Protector of Family Fun." The first rendering was a superhero with a cape, which bombed in favor of a World War I flying ace sporting a leather helmet, goggles and white scarf.

A Mon Valley kid, twenty-one-year-old Alan Fisher portrayed the fictional aviator, Captain Idlewild, for the 1980 season during the summer between his junior and senior years as a music theater major at Pittsburgh's Point Park College (now University). He got the call to audition for the role and decided he would try to land the summer gig. Fisher was initially turned down for the part, with a rather nice rejection letter. "I was a close second because of my familiarity with Idlewild Park," he said, explaining that his family would often visit Idlewild for his dad's company picnics.

However, Fisher got a follow-up call in April from the ad agency, which told him there was a problem with the original actor and asked him if he was still available for the part and able to come the next day for a costume fitting. Skipping class that day, he went to Costumes Unlimited in Pittsburgh, where he was fitted for the Captain's official uniform—a long yellow jacket with two giant pockets, orange pants reminiscent of 1920s movie directors, a white scarf and a hat—a cross between Ronald McDonald and a World War I flying ace. The agency took Fisher to a tackle shop for boots to complete the outfit. "They got me these really fancy riding boots that were a pain in the butt to put on," he remembered; he was forced to make his own bootjack to get them on and off.

Drawing from this theater background, Fisher developed Captain Idlewild's backstory during the long drive from Pittsburgh to Ligonier for this introductory meeting with the Macdonald brothers at Idlewild. In a tale reminiscent of *The Wizard of Oz*, Captain Idlewild's balloon blew off course, landing him in the beautiful area of Ligonier, where he meets the characters of Story Book Forest. Using his magical powers, the Captain built the forest as a place for them to live and Idlewild Park as a place for people to visit. He gave a fifteen-minute presentation to Jack and Dick Macdonald at the Historic Village. He made a good first impression, although the pair could not stand one thing about the captain: his hat. "You've got a nice head of hair—let's use that," they told him.

Fisher had recorded four radio commercials within two days. The next weekend, he was about two hundred feet in the air, riding in the basket of a

tricolored hot air balloon while a camera crew shot a television commercial from multiple angles. Fisher glanced up toward the helicopter filming from above and then down at the camera on the ground when he said his lines. The balloon pilot ducked down in the basket for each shot. Although Captain Idlewild was a frequent face around the park during the summer, his Storybook Balloon only made a few appearances at the park that season. Fisher recalled only one time making a hard landing where the balloon dragged for a few hundred feet. "I remember thinking the Captain is going to die right here!"

Captain Idlewild's official duties included opening and closing the park each day. Every morning, after "The Star-Spangled Banner" played over the loudspeaker, Captain Idlewild's entrance music, the theme from *Superman: The Movie*, introduced the mascot. "I declare today's fun has begun!" he announced. All the ride operators then turned on the rides. At the park, Fisher spent the day entertaining children and visiting group picnics, helping with prize drawings, riding attractions and visiting Story Book Forest. Having worked as a professional magician since he was nine years old, Fisher incorporated magic tricks into a twenty-minute act he took to malls, stores and around the park: Captain Idlewild's Magically Musical Musically Magical Musical Magic Show. He passed out balloons to children and made ride tickets magically appear out of thin air. His least favorite area of the park was Frontier Zoo, mainly because of a misbehaving spider monkey and a spitting camel. He helped promote Story Book Forest's new Alice in Wonderland exhibit, which included a giant walk-through fan of playing cards.

Captain Idlewild never had to fork over ride tickets. His electric yellow jacket made him an easy target for kids riding the Skooter. Rides on the Astro-Liner were always extra bumpy with the Captain as the pilot. One of Fisher's favorite memories is riding the Hand Cars, which harkened back to his days as a youth during his father's company picnics. He became a Skee-Ball expert in the Penny Arcade and selected small prizes from the souvenir stand to give to the smallest kids in the crowd who had not yet scored at one of the game booths.

> *Getting to spend a summer in an amusement park was great. There really was nothing for the character to do except play with the kids. I just had a ball going on the rides with the kids. I was a kid. It was being a kid for a summer and having a ball.*

Fisher only spent one season as Captain Idlewild, accepting a job the next year with Brockett Productions. The park hired another actor for the 1981 season, Captain Idlewild's last. The character was relatively successful but not overly popular. Management decided to move the park in a different direction.

IDLEWOOD

Someone you love is going to love what's new at Idlewild Park
—Idlewild Park (1984)

By the early 1980s, the Macdonald family had operated and then owned Idlewild Park for more than fifty years and transformed the Gilded Age picnic grounds into a modern amusement park. A century before, the Ligonier Valley Rail Road secured a mere forty-foot right-of-way through the Darlingtons' farm; by 1983, Idlewild Park contained "Six Areas of Family Fun" within a roughly 410-acre estate[205] that boosted the Ligonier Valley's tourism and local economy: Idlewild Park, Story Book Forest, Frontier Zoo, Historic Village, Timberlink Golf Course and the Steak-Out Restaurant. The main park itself contained two dozen adult and kiddie rides, two miniature trains, a riverboat, rowboats, live pony rides, a swimming pool, a baseball field, a miniature golf course, various game booths, refreshment stands, a sit-down restaurant and live entertainment, not to mention eleven pavilions and hundreds of picnic tables accommodating more than five hundred visiting groups each season. Both generations of Macdonalds had a successful run as owners of Idlewild Park, according to Sandy Springer Mellon: "I think the Macdonalds were really good stewards. Jack and Dick, they were very good....They had the park and they ran it very well. They ran a tight ship."

As time went on, however, Idlewild Park Inc. (renamed from Idlewild Management Company in December 1977) faced increased operating

costs coupled with a downturn in the economy and park receipts. The board had to be creative with spending yet maintain a high standard of customer service, such as foregoing a planned log flume ride for the park's centennial,[206] relocating rides to create the illusion of new development and arranging a concession agreement for an outside company to manage the Penny Arcade.[207] The Macdonalds also invested in a six-figure advertising program to promote a "total new look" for their three primary facilities: Idlewild, Story Book Forest and Timberlink.

The new decade brought major changes to Idlewild, although in a much different way than originally planned. In early 1981, the Macdonalds brought a multi-year development plan to Ligonier Township's board of supervisors for approval. Created by International Management & Design of Sandusky, Ohio, the proposed $15 million plan involved: twelve to fifteen new rides, including a log flume; a sky train linking Idlewild and Story Book Forest; a whitewater raft ride; an extended train ride; new indoor and outdoor theaters; a ghost house; a water slide to replace the swimming pool; and a complete redesign of the park layout where all parking would be consolidated into one lot. An overnight camping facility proposed on the north side of Route 30 would cover the back nine holes of Timberlink Golf Course. Engineered by Hassenplug and Associates—the same firm that designed Timberlink—the campground would contain forty-four units served by an underground sewage system.

In March 1981, Ligonier Township's board of supervisors approved a "major portion" of the park's request and sent Dick Macdonald a list of conditions including additional screening, tree maintenance, natural landscaping and traffic control. However, the board denied the campground, as that particular use—temporary overnight accommodations—was not permitted in that zoning district within the township at the time. The supervisors also barred any development on the north side of Route 30 unless a pedestrian underpass was erected to allow passage between both sides of the highway. The underground tunnel alone was estimated to cost $500,000.[208]

However, that planned expansion of Idlewild never happened. The Macdonalds did not pursue a zoning ordinance change to permit the campgrounds or tunneling under Route 30, and the project never moved forward. Instead, some less ambitious improvements were made, such as the 1982 addition of the Black Widow Spider, a six-armed Octopus ride made by the Eyerly Aircraft Company.

What did happen was more significant: the park changed hands.

Kennywood Park

After careful consideration, Jack and Dick Macdonald decided to put Idlewild Park up for sale—the business that their family had managed since 1931. Running an amusement park is analogous to running a city, and the two brothers were both getting older while their children had different interests than the amusement park business. It was simply time to end a momentous chapter in Idlewild's history.

The buyer was the Kennywood Park Corporation, a family-run company whose urban park had similar roots to the rural Ligonier park plus a Mellon family connection.[209] Kennywood Park evolved from Kenny's Grove, a nineteenth-century picnic area overlooking the Monongahela River east of Pittsburgh in what is now West Mifflin. The Monongahela Street Railway Company, founded by the Mellon family, leased the grounds from the Kenny family to build a trolley park, which opened in 1899 as Kennywood. In 1906, a partnership between Fred W. Henninger, Andrew S. McSwigan and A.F. Megahan subleased the park from the consolidated Pittsburgh Railways Company, and over the next century, the Henninger and McSwigan families built the business into a successful amusement park venture—the only one surviving in Greater Pittsburgh today.

Idlewild was the first acquisition for Harry "Henny" Henninger Jr., a third-generation Henninger who served as Kennywood's general manager in the early 1980s and later as its chief executive officer. It was also the first addition to Kennywood's future five-park conglomeration.[210] Henninger received a tip from a colleague that Idlewild Park was up for sale, with an Ohio outfit interested in purchasing it. Although he admitted that he knew very little about Idlewild, Henninger immediately recognized its potential for growth, but when he brought his idea to purchase the park to Kennywood president Carl Hughes, he was initially met with opposition. Henninger argued that with some improvements he could generate more attendance and revenue at Idlewild, telling Hughes, "It is a gem in the rough."

Once he got the green light to pursue the acquisition, the next step for Henninger was to convince the Macdonalds that Kennywood was the right buyer for their park, especially considering a competitive deal was already on the table. By purchasing Idlewild, Kennywood could also bar any competitors from entering the Western Pennsylvania market. Henninger worked with Pittsburgh-based dealmaker Grant Peacock to determine a value for Idlewild and broker a deal.

After a difficult few months of negotiations, the Macdonalds eventually accepted Kennywood's offer over the other prospective buyer, the Rossi family—one of the principal shareholders for Cedar Point amusement park in Sandusky, Ohio. Although neither party ever disclosed an official price, Idlewild Park, Story Book Forest, Timberlink Golf Course and the Steak-Out Restaurant were sold for a combined $2,025,000.[211]

While Jack and Dick Macdonald left their family park in capable hands in their retirement, Scott Macdonald, who served as vice-president, stayed on as director of special projects for both Idlewild and Kennywood. The company brought on Keith Hood as Idlewild's new general manager. Hood was also an experienced amusement park manager, coming from Camden Park in Huntingdon, West Virginia, and Ocean View Amusement Park in Ocean City, Maryland, and, before that, starting his career with a summer job at Cedar Point.

Kennywood's purchase of Idlewild was emotionally jarring to the park's employees, its patrons and the Ligonier Valley community. Many worried that the Henninger-McSwigan contingent would swoop in, cut down all the trees and asphalt the entire park, essentially creating a "Kennywood East." However, the new ownership group did not transform Idlewild into a thrill park with bigger and faster rides, recognizing that the rural park's appeal was in how different it was from the urban Kennywood, set among mountains, trees and the Loyalhanna Creek. Hughes told the press that although the company planned to improve Idlewild, it would not change its overall concept.

When Kennywood purchased Idlewild, the latter was 105 years old. At that age, many of its buildings and rides dated to the 1930s or earlier. The park's oldest buildings—the two largest picnic pavilions and the old train station—were built not long after the park was established in the late nineteenth century. Idlewild needed new infrastructure to stay competitive with and distinct from other amusement parks within the tristate area.

Jumpin' Jungle and Hootin' Holler

Harry Henninger's first priority was to fill the "vast wasteland" between Idlewild Park and Story Book Forest, now considered a single entity rather than the separate ventures they had operated as for nearly thirty years. Management initially considered purchasing Oriental-style rickshaws and horse-drawn

Jumpin' Jungle connected Idlewild and Story Book Forest when Kennywood combined the two adjacent parks in 1983. *Courtesy of the Idlewild and SoakZone Archives.*

wagons to carry folks between the two areas. Instead Henninger decided to relocate a Soft Play area intended for Kennywood's kiddieland to Idlewild's empty space. Designed by Pittsburgh-based landscape architect Tom Borrellis, the "Jumpin' Jungle" playground opened for the 1983 season. Both children and adults enjoyed multiple physical activities in the new themed area built around a three-story treehouse accessed by a giant net climb. A swinging suspension bridge connected the treehouse to a Tarzan swing and body slide. Jumpin' Jungle also featured a giant ball pit filled with 150,000 colorful plastic balls (now called Bubbling Springs), a Moon Walk bouncy house and a pulley-operated raft ride (now called Alligator Swamp). The park expanded Jumpin' Jungle in later years, adding Bigfoot's Mudslide in 2008, where parents and children alike can slide down one of three ninety-foot-long mat chutes.

For the 1984 season, the park added a second themed area to completely bridge the quarter-mile gap. Henninger commissioned Borrellis and GWSM Inc., along with architectural firm J.R. Minnick & Associates, to design a turn-of-the-century western mining town using the existing Historic Village as the foundation, adding elements inspired by other western theme parks like Silver Dollar City in Branson, Missouri. Originally dubbed "Wilde

Hanna's City," presumably a nod to the nearby Loyalhanna Creek, the new attraction debuted as "Hootin' Holler."

The entire Historic Village was relocated to the eastern end of Idlewild at a former maintenance site next to Jumpin' Jungle. It was no small feat to move these buildings approximately two thousand feet, especially the Historic Village Store, plus build a new maintenance and warehouse area and install a new park sewer system and wastewater treatment plant. An additional challenge was scooting the Skooter ride about twenty feet south to facilitate pedestrian traffic; the grounds crew cut the building in half and reassembled it in its new spot. Idlewild Park seemed to be completely under construction during the winter of 1983–84 while the work crew spent nine months building Hootin' Holler, only finishing two days before the park opened for the season.

Additional buildings, landscaping and other features fleshed out "The Rootin' Tootin' Shootinest Town Around," including a man-made stream, a water tower and a gazebo for live shows. Hootin' Holler retained the tradespeople of the Historic Village, offered vintage photograph sessions at the Livery Stable and featured a shooting gallery at the Casino. The Loyalhanna Limited miniature steam train fit seamlessly into the design of the Wild West town, with a depot located at Hootin' Holler.

The central attraction was Confusion Hill, a walk-through tilted house filled with illusions where the resident hayseed tells the history of the "explosive" feud involving fictional villain Filthy McNasty and moonshiner Zack the Muleskinner that inadvertently knocked the building off its foundation. Keith Hood remembered the process to create Confusion Hill in a 2004 employee newsletter:

> *The tilted house was first built high on stilts on a level plane. Then one corner support was removed and, with the help of a huge crane, the opposite corner was raised so the whole house tilted across the diagonal. All this work just to make water flow uphill!*

Kennywood revived the free act concept in 1983, only instead of engaging traveling troupes for weeks at a time, live western shows featuring resident actors were staged throughout the day at the Historic Village. Those shows likewise moved to Hootin' Holler. The park tapped outside entertainment companies and consultants to provide the talent and create the shows, including Paul and Michelle Osborne, who scripted and designed Hootin' Holler's comedy acts. An old maintenance building was converted into

The General Store was one building from the original Historic Village used to create Hootin' Holler, a turn-of-the-century Wild West Town that opened in 1984. *Courtesy of the Idlewild and SoakZone Archives.*

Hootin' Holler's Wild Horse Saloon was the site of live entertainment featuring gun-slinging heroes and villains. *Courtesy of the Idlewild and SoakZone Archives.*

Right: The Confusion Hill tilted house remains a popular fixture in Hootin' Holler, where the floor leans and water flows uphill. *Author's photo.*

Below: A stone building formerly used as the men's bathroom became Hootin' Holler's Potato Patch restaurant for several years. *Courtesy of the Idlewild and SoakZone Archives.*

Kennywood revamped Idlewild's daily live entertainment after purchasing the park in 1983. Here, a gunslinger showdown takes place in the Historic Village, soon to be relocated as Hootin' Holler. *Courtesy of the Idlewild and SoakZone Archives.*

the Wild Horse Saloon, which housed an hourly vaudeville act called the Wild Horse Revue featuring dance hall girls and animatronic characters. The Osbornes created a variety of street entertainment: Doc Abbot's Snake Oil Show, a magic act and a high noon gunfight between the town's sheriff and deputy and a pair of villains. The park solicited high school students interested in musical theater to join the cast for not only the Wild West showdowns but also for the variety of live shows staged around the park in the succeeding seasons through today, from rock-and-roll medleys to Dixieland jazz numbers and salutes to Hollywood and Broadway.

Although its parent company was cognizant of maintaining Idlewild's unique aesthetic, Hootin' Holler was home to one iconic Kennywood product: Potato Patch French fries. The salty, fresh-cut Idaho potato fries later became a staple of the Mineshaft Kitchen, a food complex added to Hootin' Holler in 1994 to replace the Wild Horse Saloon, but the original Potato Patch building at Idlewild had a much more interesting backstory. A certain structure with a stone façade became the Potato Patch in 1986; since the Macdonalds added the building to the park in the 1931, it had served as the men's bathroom!

The "Old Timer"

Hootin' Holler also featured artisans who created and sold their handmade wares—a potter, wood carver, basket weaver and quilter. However, the "mayor" of the new themed area was the "Old Timer," portrayed by Steve Tomasic of Smithton, Pennsylvania. The ragged, white-bearded, bespectacled prospector could be found telling yarns at the General Store and educating visitors on Wild West culture—how to shoe horses, fashion tools and repair wagons. Tomasic's real-life wife, Eunice, portrayed the Old Timer's fictional spouse and enjoyed quilting and greeting guests from a comfortable rocking chair on the General Store porch.

The Tomasics were good friends with Carl and Ann Hughes, and Steve's connection to Kennywood dated back to the 1950s—the park was searching for a Conestoga wagon to use in its Fall Fantasy parade and heard of a local "Buffalo Bill" that could fill the order. Tomasic was a diesel mechanic by trade, but in the 1960s, he began feeding his passion for collecting antiques and historical reenactments. After Kennywood acquired Idlewild, Hughes asked the Tomasics' daughter, Stephanie, if her parents might consider portraying characters at the new park. Steve and Eunice first appeared in the Historic Village in 1983 before relocating to Hootin' Holler the following year.

Steve Tomasic embodied the Old Timer character, often walking around the park barefoot, sporting a flannel shirt and suspenders holding up his well-worn jeans and scouting for burrs to place in his beard. An old jug he carried around likely contained some of his own handcrafted moonshine. Steve was somewhat of a historian, given his penchant for antiques; he brought many items from his vast collection to decorate Hootin' Holler, from an old whiskey distiller to a stagecoach. The Old Timer enjoyed talking to guests and often bellied up at picnic tables to join a family luncheon.

"He was always in bare feet, even at home," which displeased Carl Hughes, who finally told him he needed to wear shoes, recalled Stephanie Tomasic. The Old Timer found a compromise. One afternoon, as Hughes was walking through the park, he passed Steve reclining in an old hickory rocker and resting his cowboy boots up on a stump. Hughes stopped in his tracks, stood with his arms folded, on his toes, and ran his hand through his hair, as he typically did when he was angry. Tomasic had cut out the soles of those boots.

The Tomasics' engagement at Hootin' Holler lasted until Steve died in January 1994. Eunice passed away in 1998. Daughter Stephanie said

Always barefoot, Hootin' Holler's Old Timer swapped yarns at the General Store, joined picnickers for lunch and enjoyed the antiques that he displayed around the park. *Courtesy of the Idlewild and SoakZone Archives.*

their decade-long career in Hootin' Holler was extremely significant to the couple, keeping them active every summer.

> *For ten years, that park was my parents' life. It meant the world to them....*
> *Those ten years at the park were probably the most meaningful of their lives.*

A Water Wonderland

Idlewild's swimming pool had cooled off thousands of locals and tourists for more than fifty years when Kennywood purchased the park. By 1983, the original sand beach was long gone—one half replaced by grass in 1955 and the rest in 1958—because it required such high maintenance. The swimming pool remained the centerpiece of Lake Bouquet and continued to attract business, but by 1984, attendance had dwindled to about twelve thousand visitors per year. Management eyed a way to boost those low numbers.

Rafter's Run, a "dry" water slide involving rafts, seen here in July 1988, its inaugural season. *Courtesy of the Idlewild and SoakZone Archives.*

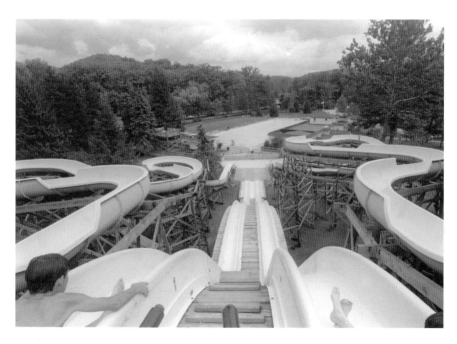

Idlewild's first water slides, added to the island area in 1985, began what grew into today's sprawling SoakZone water complex. *Courtesy of the Idlewild and SoakZone Archives.*

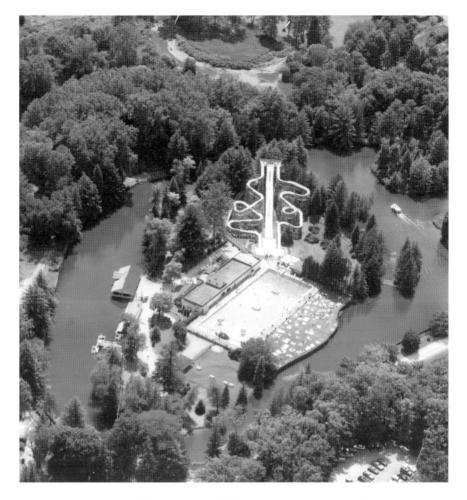

An undated aerial view of the developing H2Ohhh Zone on the central island in Lake Bouquet. *Courtesy of the Idlewild and SoakZone Archives.*

The Macdonalds considered adding a water slide to Idlewild as early as 1980, but it was not until a few years later that the idea took shape. A six-acre "Water Wonderland" was plotted out on the island area for the 1985 season. Ultimately named the H2Ohhh Zone, the resulting water park included four new water slides that dumped riders into a small pool—a pair of two-hundred-foot speed slides and another pair of four-hundred-foot curving flumes called the Serpentine Slides. The bathhouse was also completely refurbished and the swimming pool sandblasted, repainted and equipped with new filters and electric system.

Idlewild continued to develop the new water park area throughout the 1980s and 1990s. Two shotgun slides with a six-foot free fall into the main pool's deep end filled out the area in 1986, primed for more adventurous swimmers. A portion of Lake Bouquet was filled in to create a foundation for Rafter's Run, which opened in 1988 as a "dry" tube slide that folks who forgot their bathing suits could enjoy. Rafter's Run is a quick ride from about fifty feet up—two-person rafts snake through a pair of four-hundred-foot-long enclosed tubes, ending with a splashdown in the pool below. In 1992, a small-fry play area called Little Squirts was added to the H2Ohhh Zone that included a children's wading pool and spray features. Unfortunately, the island's historical iron bridge, almost a century old, was removed to accommodate the new attraction.

The H2Ohhh Zone was the one addition at Idlewild that made the biggest impact on attendance and revenue after Kennywood took over the park. Pool attendance jumped to 125,000 for the 1985 season, and monster traffic often gridlocked Route 30 as people came pouring into the park, excited to try the park's new water slides.

Fees and Gates

Although automobile traffic outside Idlewild worsened, foot traffic inside the park improved after the additions of the H2Ohhh Zone, Jumpin' Jungle and Hootin' Holler because the new areas better spread guests throughout the park. Management then addressed the long lines of cars stretching down Route 30 each morning by building a new main entrance for 1986. Various routes were considered, even along Darlington Hill Road (now Idlewild Hill Road) at the west end of the park, but the best option was to place the entrance a quarter mile east of the current stone entrance/exit with a two-hundred-foot deceleration lane that fanned out into multiple ticket booths. Guests followed a new access road that skirted Story Book Forest to parking lots that were better utilized to hold about 15 percent more cars.

To make the new entrance work, the Enchanted Castle was converted from a walk-through attraction to a drive-through tunnel. The park's former stone entrance gate became its dedicated exit. The brave Golden Knight that greeted guests to the Enchanted Castle for thirty years moved to a new Guinevere scene in Story Book Forest, where he guarded the

"It's the tradition of the picnic that's so unique," said Kathy Sichula, Idlewild and SoakZone's longtime group sales director. Picnickers in this 1950s photo take advantage of Idlewild's shady bowers and picnic tables for their feasts, as they have done since the late nineteenth century and continue to do today. *Courtesy of the Idlewild and SoakZone Archives.*

damsel from a threatening dragon—a former prop from Kennywood's Le Cachot dark ride. Unfortunately, King Arthur eventually succumbed to the elements.

Kennywood also instituted a new price structure for Idlewild. Until the 1980s, admission to Idlewild was free, but patrons had to pay a nominal parking fee and purchase ride tickets and refreshment tickets. Historically, "pay one price" admission days where you could ride unlimited were intermittently scheduled, often for group outings, even in the 1970s, but not consistently. Story Book Forest, Frontier Zoo and Jumpin' Jungle retained separate admissions, while seasonal swimming pool passes could likewise be purchased. In 1984, Idlewild eliminated parking fees and offered two pricing tiers: a general admission and an all-inclusive admission that covered all rides and themed areas, except Story Book Forest. By 1989, the park had completely moved to a one-price admission covering all areas, eventually phasing out general admission. The park's unique entrance prompted this decision; customers now purchased tickets while driving through the admission booths instead of parking first. This move also

eliminated the need for individual ride tickets and the time and work it took to collect and process them.

Idlewild's increased attendance was also a result of the park's group picnic business—especially company employee picnics—which remained incredibly important for the park's economy, especially as "rain insurance" to make up for the leaner days. To handle the orders and create special programs for Idlewild's large number of groups, Kennywood put a strong group sales team into place, continued to promote community, school and corporate picnics and advertised special event days at Idlewild, including the popular Italian Heritage Day.

Restoring the Carousel

Once Idlewild and Story Book Forest merged into one entity, the latter's resident artists, Ed Ostroski and Rosemary Overly, became responsible for the upkeep of both areas. Overly was hired in 1979, after Ostroski was promoted to Story Book Forest manager. A third staff artist, Dale Johnson, joined the team to help build Hootin' Holler. The three seamlessly repaired character figures, hand-lettered directional signs, painted rides and created murals for all the midway games. Their artistry was on display every day for thousands of visitors to view.

Management later entrusted these artists with a complete full-scale restoration of the historic Philadelphia Toboggan Company carousel, which had resided at Idlewild for more than a half century by the time Kennywood took over the park. The trio headed the intense two-year project, beginning once the park closed for the season in 1984. For the first round of restoration, which focused on the horses and chariots, the team brought in a small group of seasonal workers to help remove paint and hand-sand the poles to reveal the original brass. The artists discovered bows, ribbons and other striking details lost over time and under many layers of paint as they stripped each steed using heat guns. Ostroski, Overly and Johnson split the repainting work between the three of them, with Rosemary also tackling the two chariots. It took each artist a full forty-hour week to complete a single horse, as they patiently and painstakingly applied the multiple layers of primer and paint. The process was not without its challenges. The team first used chemicals to remove the paint only to find the mixture dissolved the boiled rabbit skin glue that held the wooden horses together.

At the time, PTC no. 83 had what Ostroski described as a very bland color scheme, heavy on muted Japanese colors, a lot of tan and black, and no white horses. It needed brightening. When creating a new color palate for the carousel, Ostroski said the team consulted industry catalogues, inspired by the Philadelphia Toboggan Company carousel on California's Santa Monica Pier, with its bright colors reminiscent of a birthday cake. The artists employed Medieval and Oriental themes that would work well with the horses' stances and expressions, using colors that were authentic to PTC. Each horse received two coats of primer, two coats of oil-based paint and two coats of varnish, plus artistic airbrushing to bring each one to life. Each horse was personalized with a name on the bottom of one of its hooves. Overly's favorite was Dolly, the black lead horse sporting a plume.

It took the team several months to complete the first phase of the project and restore all forty-eight horses, two chariots and the rounding board, finishing up around Valentine's Day 1985. Over the next winter, the team tackled the carousel's center, overhead bays, beams, platform, mechanics and the two organ façades. The murals were the only part of the carousel left mostly unrestored to retain their value and authenticity.[212]

The carousel needed additional repair work several years later; around New Year's Day 1990, several teens pilfered two stationary horses for a young man wanting to impress his girlfriend's mother, who collected antiques. The police caught the thieves trying to steal another pair, tracked down the criminal mastermind and returned the two stolen horses to the park. Although both horses were unfortunately damaged in the theft, one even decapitated, they were able to be restored.

Recognizing PTC no. 83 as an example of a past era of artistry, in 1987 the Westmoreland County Historical Society designated the carousel a county historic landmark. The attraction is Philadelphia Toboggan Coasters Inc.'s longest-running carousel in a permanent location.[213] This machine has stood in the same spot since it was moved to Idlewild in 1931 and remains today the focal point of the midway.

Mister Rogers' Neighborhood of Make-Believe

One imaginative addition that Kennywood made to Idlewild Park came in 1989, when park officials decided to replace the longtime zoo on the south

side of the creek with a new major attraction. However, true to Idlewild's philosophy, it was not a monster theme ride. Instead, it was a ride designed to instill good feelings and self-worth in its young patrons.

Idlewild and Kennywood collaborated with Family Communications Inc. (now the Fred Rogers Company) to create a new themed area based on the popular PBS children's show, *Mister Rogers' Neighborhood*. Show creator and host Fred Rogers was a Latrobe native and had often visited Idlewild Park as a young boy with his parents and sister for community and school picnics.

Rogers remembered riding the train from Latrobe to Idlewild, enjoying root beer and cotton candy at the park and pulling a card from Esmerelda, the mechanical fortune teller of the Penny Arcade. These fond memories remained with him years later when Idlewild and Kennywood officials approached him in 1988 with the idea of re-creating the television neighborhood through which children and their families could travel via trolley. With its peaceful environment and casual pace, Idlewild seemed to be the perfect place for a life-size version of Fred Rogers's fictional world. Children could ride an exact duplicate of the red trolley through the Neighborhood of Make-Believe and spend a beautiful day in Idlewild Park seeing characters from their favorite television show in person.

Keith Hood, Harry Henninger and Carl Hughes met Fred Rogers for lunch to discuss the potential partnership. After only a half hour of discussion, the parties had a handshake deal in place to create Mister Rogers' Neighborhood of Make-Believe. Rogers told Latrobe writer E. Kay Myers of the meeting in a May 1994 letter: "The people who own Idlewild (and Kennywood) asked if I would like to help create such an experience for young people and their families. I think that Idlewild is the most naturally beautiful amusement park in the world."

The $1 million ride was more than a year in the making. Family Communications, Kennywood and Idlewild commissioned Dallas-based J.R. Minnick & Associates to develop a 1,600-foot-long narrow-gauge trolley ride on the south side of the Loyalhanna Creek. The site was an ideal spot for the ride, as it was "quiet and secluded, without distractions" and had plenty of room to expand.[214]

The team also worked with two animation firms—Creegan Company in Steubenville, Ohio, and Sally Animation in Jacksonville, Florida—to bring each of the eight neighborhood scenes to life. Idlewild artists Ed Ostroski and Rosemary Overly stepped in to plan and paint the various sets. Don Thomas, who re-created the squishy-tongue whale entrance for Kennywood's Noah's Ark ride in 2016, helped to build King Friday XIII's

castle. The ride's soundtrack came from musical director Johnny Costa, who composed the score for the television show.

Maintaining an "integrity of content" was a guiding principle throughout the planning and designing of Mister Rogers' Neighborhood of Make-Believe. Each unit along the five- to ten-minute ride was intended to be a replica of the major characters and sets on the television show—just on a larger scale. Fred Rogers was intensely involved as a creative consultant every step of the way, writing the script and providing the voices for each animatronic neighbor. In fact, Rogers vetoed Bob Minnick's preliminary concept where King Friday XIII engaged all of the Neighborhood characters to form a band and instead came up with a different storyline.[215]

After boarding Trolley in the "real world," guests traveled through a tunnel and entered the Neighborhood of Make-Believe where they first met King Friday XIII and accepted his request to invite all the neighborhood characters to a "hug-and-song" party at the castle. Trolley then made its way through the fictional world, stopping at each character's home so riders could chant, "Come along, come along, to the castle hug-and-song":

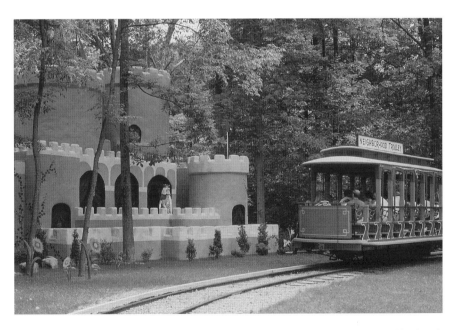

Seen here in 1992, a life-size trolley takes passengers through Mister Rogers' Neighborhood of Make-Believe to invite each of the show's characters to a "hug-and-song" party at King Friday XIII's castle. *Courtesy of the Idlewild and SoakZone Archives.*

Cornflake S. Pecially at his Rock-It Factory, X the Owl and Henrietta Pussycat in their tree, Lady Elaine Fairchilde at the Museum-Go-Round, Dr. Bill, Elsie Jean and Ana Platypus in their mound, Daniel Striped Tiger at his clock and Ana and Prince Tuesday at the castle playground. Once Trolley brought the guests to the castle, they reunited with all the characters in the courtyard, joined by King Friday and Queen Sara Saturday, all ready for the Hug-and-Song Party. Guests hugged the person next to them while singing along to Fred Rogers's composition, "It's Such a Good Feeling."

The main element of the attraction was the trolley, which transported up to forty guests through the Neighborhood of Make-Believe. The ride employed two bright-red trolleys that appeared identical to the television show's Trolley, although they were not specifically commissioned for the Neighborhood. Gales Creek Enterprises of Oregon Ltd., based in Forest Grove, Oregon, built the cherry, oak and brass streetcars in November 1987 for the Indianapolis Zoo. However, as the machines were too heavy for horses to pull, the park could not use them, and they were subsequently fitted with new motors and sold to Idlewild.

Mister Rogers' Neighborhood of Make-Believe opened on June 10, 1989.[216] Idlewild's collaboration with Family Communications on the unique trolley ride kicked off a long relationship between the park, WQED and the Mister Rogers characters, who appeared at the park for WQED Days celebrations throughout the 1990s. At the time of its build, Mister Rogers' Neighborhood of Make-Believe was Idlewild Park's largest single investment and the only commercial application of Fred Rogers's television creation of its kind at an amusement park. The attraction was a testament to how much the Latrobe native loved the region where he grew up and how much he trusted Idlewild to convey his vision, said Keith Hood: "[Fred Rogers] had to trust us enough to safeguard it and cherish it and not tarnish it. A lot of people worked really hard to gain his trust."

Raccoon Lagoon and the Wild Mouse

Kiddie Land was a prime victim of the rising waters of the Loyalhanna Creek, whose proximity to the park made Idlewild extremely susceptible to flooding throughout its history.[217] When Hurricane Agnes ravaged the park in 1972, Kiddie Land rides suffered the most damage—rising floodwaters

swept cars off their tracks and uprooted the rails from the ground.[218] Although Jack Macdonald invented a system to raise and lower the motors on the miniature rides to keep them dry, it was ultimately a losing battle. For this reason, and to open up more space in the main park, the entire Kiddie Land area—then consisting of nine rides[219]—was relocated to the south side of the Loyalhanna Creek for the 1990 season to join the pony track, which moved across in the 1970s.[220]

The new kiddie area called Raccoon Lagoon also featured new refreshment buildings, a gift shop and a stage for the park's new mascot, Ricky the Raccoon. Raccoon Lagoon complemented Mister Rogers' Neighborhood of Make-Believe, and the combined attractions created a larger dedicated space for Idlewild's younger guests. The kiddie rides were now spread out among a winding gravel path bordered by trees and benches. Renamed Pollywog Regatta, the Miniature Boats now floated within a large man-made pond punctuated by a spewing fountain. The bright-red World War I biplanes on the Red Baron (1987)—the converted Helicopter ride—stood out against the surrounding greenery.[221] Idlewild's other classic kiddie

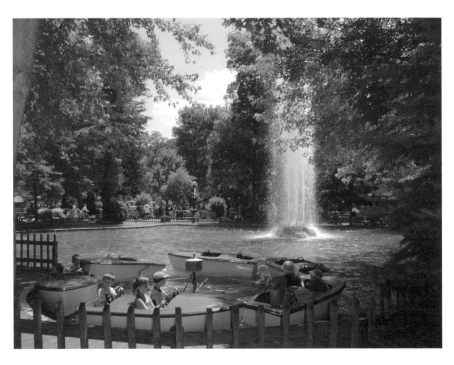

Now called the Pollywog Regatta, the Miniature Boats are the centerpiece of Raccoon Lagoon, a new kiddieland area created in 1990 on the south side of the Loyalhanna Creek. *Author's photo.*

World War I–themed planes replaced the Helicopters to create the Red Baron kiddie ride, new for 1987. *Courtesy of the Idlewild and SoakZone Archives.*

rides also received new names: Scampers (Miniature Cars), Rainbow Wheel (Miniature Ferris Wheel) and Little Rascals (Kiddie Hand Cars).

Additional rides fleshed out the area, including a trio in 1990: a Caterpillar Train from Zamperla, which only spent a few seasons in Raccoon Lagoon; Zamperla miniature bumper cars named Cattail Derby that were transferred from Kennywood; and adult Hand Cars built from kiddie Hand Cars that also operated at Idlewild's sister park. Dino Soars (1992) was a prehistoric refashion of Kennywood's kiddie flying saucers. Ricky's Racers (1998), a turnpike ride with 1950s sports cars that looped around the tall trees, came from the defunct Old Indiana Fun Park in Indianapolis. Before that, the Arrowflite Freeway auto ride operated at two Ohio parks: Euclid Beach Park in Cleveland and Shady Lake Park in Streetsboro.[222] Tea Party, a Zamperla miniature teacup ride that also accommodates adults, replaced the Flivvers in 2009 after spinning at Ohio's Geauga Lake.

The north shore of the Loyalhanna Creek was soon filled by the addition of the Wild Mouse, the park's second roller coaster, which opened for the record-breaking 1993 season. The ride was the only Wild Mouse–style coaster that manufacturer Vekoma ever created, specifically for Wiener

An antique car ride called the Flivvers, originally added in 1968, was relocated to the new Raccoon Lagoon with a Lincoln Highway theme. *Courtesy of the Idlewild and SoakZone Archives.*

Kennywood's former kiddie Hand Cars were used to create an adult version added to the new Raccoon Lagoon area in 1990. Dino Soars and the Raccoon Theater stage appear in the background. *Author's photo.*

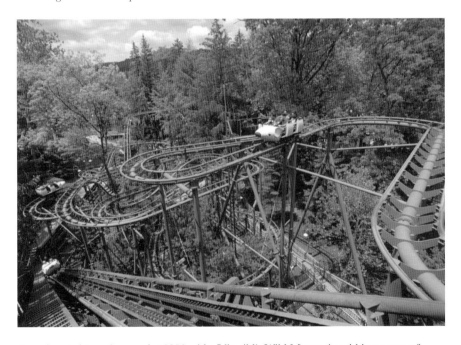

A modern twist on the popular 1950s ride, Idlewild's Wild Mouse sits within a grove of hemlock, spruce and Douglas fir trees. *Courtesy of the Idlewild and SoakZone Archives.*

Prater in Vienna, Austria, in 1985. After two years, the steel track coaster was moved to Alton Towers, an amusement park in England, where it operated for about four years until Harry Henninger purchased it hoping for an opportunity to set the mouse-shaped cars loose in Kennywood. Relocating Kiddie Land across the creek gave him the chance to bring the Wild Mouse to Idlewild instead.

A throwback to the popular 1950s ride, Idlewild's steel mouse consists of nineteen jarring switchbacks and hairpin turns and seven sudden dips—with the largest drop at forty feet. One unique aspect of the coaster is the fifty-degree slanted lift hill at the beginning; while at Prater, the original ride had a spinning barrel that enclosed the tilted hill to disorient riders. The park strategically built the Wild Mouse among existing hemlock trees along the creek, planting more trees around the structure. In fact, the ride's location was shifted slightly because of one particular tree that leaned too close to the track.[223]

Further Changes

The visions that Harry Henninger, Carl Hughes and Keith Hood had for Idlewild Park were many and varied. Some ventures, like ordering twenty-five thousand Old Timer dolls that just did not sell, bombed. Others, like building a waterpark, were hugely successful. Smaller changes like switching out rides and reorganizing the park also served to keep things fresh for Idlewild's patrons.

Certainly, one benefit of owning multiple amusement parks was now having the ability to transfer rides between locations, and thus several Kennywood rides eventually found a new home at Idlewild. After forty years without a Ferris wheel, Idlewild welcomed an Eli Bridge Company Ferris wheel that was originally one of a pair of no. 16 BIG ELI wheels installed at Kennywood in 1959. The "new" Ferris wheel debuted in 1984 roughly where Idlewild's first wheel was located, east of the bridge along the creek, but it was soon relocated to the foot of the hill below the Auditorium. The Super Round-Up (1986) replaced its smaller predecessor that had been removed after the 1983 season. Kennywood's Balloon Race, another Zamperla ride, featuring eight hot-air balloon gondolas, also floated to Idlewild Park in 1995. Kennywood's Sellner Tilt-a-Whirl replaced Idlewild's first model in 1989,[224] while modern fiberglass bumper cars replaced the 1940s Lusse Brothers cars that bounced

riders like pinballs around the Skooter building as it became increasingly difficult to find vintage parts to repair the older ones. The "new" cars were yet another Kennywood harvest.

Idlewild's midway evolved as new rides replaced older rides that were retired. The Astro-Liner and Trabant were removed after the 1983 season,[225] and the Crazy Dazy followed suit after the 1985 season. In 1998, Idlewild relocated the Paratrooper ride to its current location near the Skooter to make room for a new mystery ride inherited from Kennywood after a single season as the Tri-Star. Created by Huss of Germany, the unnamed three-armed ride spun twenty-one gondolas as it lifted them into the air. Idlewild received more than 8,600 suggestions when it held a contest to name the ride, temporarily called What Izzat? Fred George Jr., an elementary school student from Johnstown, submitted the winning name: Trinado.

Improvements not only included new rides and attractions but also new infrastructure. Hood's Bridge—a new pedestrian bridge near the entrance to the H2Ohhh Zone—spanned the Loyalhanna Creek in 1993. The Hillside Theatre, a new forty-four- by twenty-two-foot stage added in 1995 near the foot of the hill, replaced the original half moon–shaped stage that featured Grand Ole Opry stars in decades past. The new, bigger

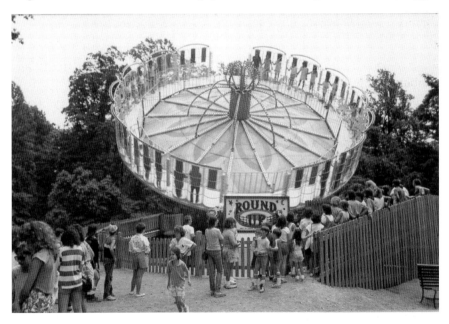

The Round-Up used centrifugal force to keep passengers pressed against the sides of a tilted spinning wheel. Idlewild introduced a Super Round-Up from Kennywood in 1986, seen here. *Courtesy of the Latrobe Area Historical Society.*

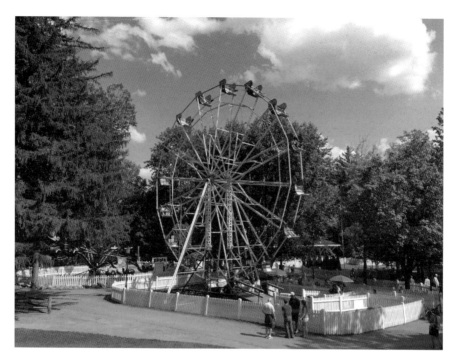

Idlewild lacked an adult Ferris wheel for about forty years until its current Eli Bridge Company version was added in 1984. The Spider appears at left. *Author's photo.*

stage connected with the new Sandwich Factory, which replaced the 1930s hamburger stand.

The park continued to develop Hootin' Holler, building a mystery house called Dizzy Lizzy's Four Quarters Saloon in 1999 between Confusion Hill and Big Zack's food stand. Dizzy Lizzy's was another modern take on an early twentieth-century ride, the Haunted Swing. Riders sat on a stationary bench while the surrounding room rotated around them, giving the illusion that the riders were actually turning upside down, falling from the living room of a western-style home into a creepy subterranean cavern. Harry Henninger challenged Idlewild's then-manager Jerome Gibas to replicate a similar attraction at Lancaster's Dutch Wonderland for a fraction of the cost. Using Idlewild personnel and engineering, the park built the "quadrasphere" ride in-house.

Created by Wisdom Industries, the tornado-themed Howler tore into Hootin' Holler for the 2004 season, featuring eight four-seat cars suspended from a rotating brushed aluminum funnel. The design allows riders to control how tame or wild they want their experience to be by turning a center wheel

Kennywood's Balloon Race was relocated to Idlewild for the 1995 season. *Author's photo.*

to spin each Howler car. Although the Macdonalds at one time envisioned adding a whitewater log flume ride to Idlewild to celebrate its centennial, it was not until 2005 that Paul Bunyan's Loggin' Toboggan opened in Hootin' Holler. Guests floated in log-shaped boats down a winding trough before splashing down from a three-story tower. The 1980s Arrow Dynamics ride was another Old Indiana Fun Park auction purchase.

When planning any new development at Idlewild, officials carefully considered how to build around or replace the park's treasured trees. They contracted Lukcic Log Homes to create seven new picnic and catering pavilions along Idlewild Run near Hootin' Holler in 1999. The company harvested a slew of old spruce growth from the north side of Route 30, removed the bark, hand-sanded the trees and used them to create the log cabin–style shelters and lampposts. Sand volleyball and basketball courts supplemented the new recreational area, which was bordered by post-and-rail fencing. More than three hundred spruces replaced about fifty trees lost in the project. These were only a few of the new picnic pavilions added to the park in the succeeding years.

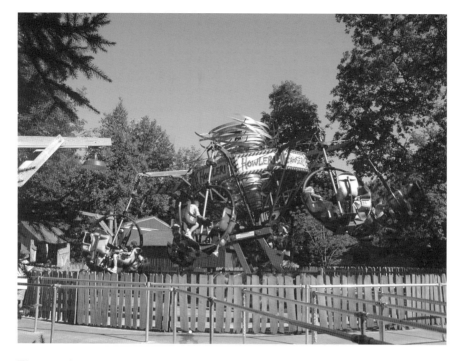

The tornado-themed Howler, added in 2004, fit into the Wild West theme of Hootin' Holler. *Author's photo.*

One more adult ride came to Idlewild during Kennywood's ownership: the Flying Aces, a Premier Rides Inc. device reminiscent of the classic 1939 Bisch-Rocco flying scooter. The ride debuted in 2007 near the Rollo Coaster in place of the Trinado, which ended its run at the park the previous season. The Flying Aces featured ten cable-suspended World War I–themed planes. Like the Howler, the Flying Aces allows riders to customize their two-minute ride by adjusting each plane's vertical wing to change its flight path and altitude.

After more than a decade as Idlewild's general manager, Keith Hood was recruited to reopen the shuttered Lake Compounce in Connecticut, another Kennywood acquisition. Jerome Gibas, a member of Idlewild's family since 1985, took over as general manager in 1996—another record-breaking season in terms of attendance. The park brought back the popular Royal Hanneford Circus, which first performed at Idlewild in 1987. Considered the oldest circus in the world, the seven-generation circus family once toured with the Ringling Brothers and Barnum & Bailey shows. Under an authentic big top tent set up on the south side of the Loyalhanna Creek, the renowned troupe entertained crowds with its high-wire and ring stunts, equestrian

tricks and animal acts featuring elephants, chimps and big cats. The popular act, coupled with outstanding weather, made for a successful summer and convinced management to bring the circus back for the 1997 season and for two more visits in 2010 and 2011

Among Kennywood's successful changes at Idlewild were some difficult decisions. Prior to adding Mister Rogers' Neighborhood of Make-Believe, Kennywood had closed Frontier Zoo in 1985, reintroducing the park-operated New Zoo Review in 1986 that featured Prairie Dog Pete's Place (an underground prairie dog city); Professor Marvel's Itsy, Bitsy, Teeny Tiny Flea Circus; and a domestic petting zoo. The revamped zoo only operated for a few seasons before closing for good once Raccoon Lagoon opened in 1990. Idlewild also added the Far Side in 1991, an athletic area for high school students next to the ball field that featured mud volleyball, water balloon battles, a rock-climbing wall and a 150-foot zip line over the Loyalhanna Creek. Renamed Extreme Elements, the area operated only for several years before it was discontinued.

After twenty-five years of service, the difficulty in maintaining a steam-powered ride led the park to retire the Loyalhanna Limited's original engine in 1991 and sell it to Remlinger Farms, a fun park in Carnation, Washington, where it still chugs today. A Chance Manufacturing company gasoline engine replaced the steam locomotive—a C.P. Huntington Train no. 243 modeled after an 1863 locomotive used to build the Transcontinental Railroad and custom painted to match the red passenger cars retained from the original engine. In 1992, the park purchased the green-colored no. 192, an additional secondhand C.P. Huntington engine and coordinating cars from a Canadian amusement park company. Both trains continue to carry passengers across the creek.

Operating under the moniker "Lakeside Railroad," the Idlewild Express made its last run on Labor Day 1997, after almost sixty years of toting passengers around Lake Bouquet. The ride was removed partly because of the amount of mud that buried the tracks after a rainstorm but mostly to accommodate plans to expand the H2Ohhh Zone. The park expected to re-lay the line and reopen the ride after a few years, but that plan never came to fruition. Once Idlewild's first miniature railroad closed after the season, the tracks were removed and both locomotives sold to a collector.

In order to relieve the crushing crowds, another necessary yet unfortunate change was the removal of the Enchanted Castle, which had charmed Story Book Forest visitors for forty years. The park needed to widen the single-lane access road to the parking lots to handle increasing automobile

traffic to Idlewild, but it was physically impossible to fit two lanes beneath the drive-through castle. Although the park planned to relocate the castle to another spot in the forest, when the maintenance crew started to dismantle it in March 1997, all hope crumbled with its walls. After four decades braving the elements, the Enchanted Castle had deteriorated too much to be salvaged.

After a long run on the midway, in 2003, the Skee-Ball lanes and other vintage coin-operated machines and video games, including Esmerelda the fortune teller, were removed from the Penny Arcade and the building was converted to the Rising Waters squirt gun race game.

The park also said goodbye to both the Timberlink Golf Course and its accompanying restaurant, Steak-Out. Timberlink had struggled for years, even during the Macdonalds' tenure. Initially, the golf course did a great business, but by 1979, the board of directors was seriously reconsidering the feasibility of continuing the venture. Revenues were down 17 percent for that season, while expenses increased. The board was not sure whether to blame poor pro shop management or a combination of economic factors, a gas shortage and bad weather.

Changes were stirring at Timberlink a year later. The Macdonalds' proposed $15 million expansion of Idlewild Park, projected to begin in 1981, included a five-star campground built on the golf course's back nine holes. Although this project never happened, Timberlink was used for a logging operation in the final Macdonald years. Ultimately, management could not build up Timberlink's pro shop business enough to alleviate the financial concerns, so in September 1981, the board voted to lease the golf course to an outside party on a seasonal basis.

Timberlink operated as a lease for more than thirty years, but intermittent closures plagued the golf course throughout Kennywood's ownership. It closed for good in June 2013 after its then-manager, Eugene Livingston, retired. It was a beautiful property, yet ultimately it was too difficult to justify investing any capital into the course when the same funds could be invested at Idlewild for a better return. Although it had good food and a clever concept, the Steak-Out proved to be too much of a niche market with a difficult location, as it was only accessible from the westbound lanes of Route 30. It was briefly re-themed as Lil' Luke's Burgers N' Steaks in 1989 before also shutting its doors. Today, the greens on the northern side of the highway have regressed to a more natural state, awaiting a new development idea.

SoakZone

Idlewild continued to expand its water park into the new millennium, leading it to phase out its more traditional water activities. For more than a century, guests enjoyed boating on its two main lakes, in either self-propelled rowboats or cruise vessels. In 1983, paddleboats replaced the Water Skeeter pontoons and moved from Lake St. Clair to Lake Bouquet, joining the rowboats and Little Show Boat. Eventually, all boats were retired—the riverboat's last season was 1987, before part of the lake was filled in to build Rafter's Run; the rowboats were afterward removed; and the paddleboats followed suit in 2005.

Idlewild doubled the size of the H2Ohhh Zone in 2000 with the addition of Dr. Hydro's Soak Zone, a new complex consisting of six new water slides, including four open headfirst slides (Hydro Racers) and two enclosed tube slides (Pipeline Plunge). The area also contained multiple Hydro Soaker water guns, more beach space with a volleyball court, a renovated

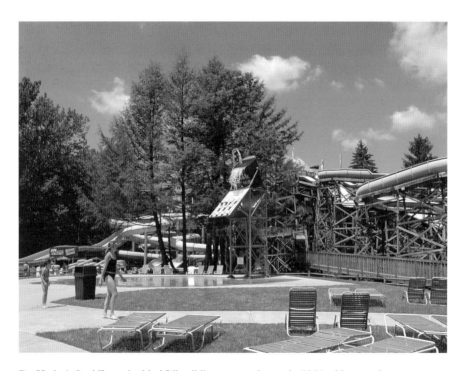

Dr. Hydro's SoakZone doubled Idlewild's water park area in 2000 with several new water slides and a giant tipping bucket of water. *Author's photo.*

bathhouse, a new souvenir shop and a giant tipping bucket timed to dump three hundred gallons of water on folks waiting in the splash zone below once the bucket completely filled. More of Lake Bouquet between the island and the isolated Rafter's Run was filled in to tie the two areas together. This dramatic expansion led to the rebranding of Idlewild's entire water park area in 2001 with a concise new name: SoakZone. The biggest expansion since Raccoon Lagoon at the time, SoakZone solidified Idlewild's water park concept and significantly improved access to the island area. It also boosted the park's teenage audience.

The 2006 season brought a more than $1 million water attraction called Captain Kidd's Adventure Galley, which increased SoakZone by more than 20 percent. AquaPlay created the pirate-themed multi-level play area that includes six water slides, tunnels, net climbs, bridges, dozens of water sprays and an even larger tipping bucket at a whopping five hundred gallons.

A Family Focus

By the time Kennywood purchased Idlewild, the latter had consistently embraced kid-friendly elements for more than fifty years, starting with the addition of its first kiddie ride in 1931. The park's mixture of adult rides, a dedicated Kiddie Land and the nostalgic Story Book Forest allowed both children and adults to enjoy a day outdoors together at Idlewild. Kennywood marketed its new acquisition to families with young children. That focus was a "central element to Idlewild's future," according to Keith Hood: "I think, to me, it was special because we wanted to be the best kids' park we could be. We took a lot of pride in providing service to families with young kids."

Promoting Idlewild as a children's park made sense, especially considering elements like Story Book Forest and Kiddie Land were not very appealing to teenagers. In fact, management seriously considered eliminating Story Book Forest altogether until feedback from parents who enjoyed bringing new generations to see the nursery rhyme characters of their childhood convinced them otherwise.

Idlewild's rural environment was a natural draw for families and crucial to protect. The park made a concerted effort to catalogue its tree population following a big storm in the 1980s that felled many trees throughout the grounds. Each tree is now marked with a numbered iron pin that corresponds to an inventory list. Throughout Idlewild's history, its ownership has tried to

maintain a balance between preserving the forests that define its aesthetic, clearing space for development and promoting healthy tree growth. It was not always as simple as building around the existing trees; some trees were removed because of their poor health or to accommodate a new ride or building—even before Kennywood's ownership. Nonetheless, Idlewild continued to plant new trees around the grounds, often mixing unique species such as callery pears, zelkovas and Chinese elms with typical Northeast hardwoods like maples, oaks and ashes, said Jerome Gibas: "We spent as much money putting trees in as we did taking them out and trimming them because the beauty of the area was important."

The results did not go unnoticed. In 1987, the *Amusement Park Guide Book* named Idlewild Park "The Most Beautiful Park in the United States," which was not the first time the park received that designation.[226]

It was a bittersweet change when in 2002 more defined asphalt pathways replaced most of Idlewild's gravel walkways, followed in 2005 by the complete paving of the main section of the park, now called Olde Idlewild. No longer would your sneakers crunch with every step on the finely ground stones, but it was a necessary adjustment to make the park more accessible to patrons in wheelchairs and strollers. The park replicated the gravel look by brushing concrete dust on top of the black asphalt. A new landmark was added to the center of the Olde Idlewild refreshment stand area during the first round of paving: a stone fountain surrounded by plenty of umbrella-covered seating.

The new millennium also brought changes to Idlewild's operating season. Traditionally, the park opened from mid-May through early September, usually closing around Labor Day. In 2002, Idlewild began extending its season, launching a one-time Fall of the Leaf festival after the Ligonier Highland Games. The three-weekend event was originally conceived as a music festival with food booths and beer. The park experimented with more September weekend events, first with an Oktoberfest for a few years, before settling into the family-friendly Fall of the Leaf weekends scheduled between Labor Day and the Ligonier Highland Games.

Inspired by the success of Kennywood's Phantom Fright Nights, in 2006 Idlewild created its own Halloween-themed program called HALLOWBOO! to expand the operating season into October weekends, a tradition that has continued for more than a decade. Cornstalks, pumpkins and other autumnal flair decorate many of the park's rides, attractions and food booths. Children and their parents are welcome to visit the park dressed in costume, trick-or-treat in Story Book Forest, admire the changing colors

of the leaves, maneuver a hay bale maze and enjoy a few more turns on the Ferris wheel or carousel. Confusion Hill is transformed into a spooky illusion house. The water tower stream oozes neon green slime, while the midway fountain spews an equally vibrant color of water. As the Haunted Hollow Train Ride, the Loyalhanna Limited takes its passengers through an eerie graveyard of monsters, skeletons and fog. No scene is overly frightening to children.

Although its sister parks open on a limited basis for the winter holidays, Idlewild Park only opened during Christmas for one year, when it hosted Overly's Country Christmas in 1992, a six-week-long holiday light display that for more than thirty-five years raised money to support pediatric care at Pittsburgh's Children's Hospital and Greensburg's Westmoreland Regional Hospital. When the display eventually outgrew founder Harry Overly's seven-acre Armbrust home, Idlewild Park stepped up as an alternate site that could handle the traffic that the annual display attracted. Most of the 600,000 lights for the drive-through display were primarily installed throughout the Story Book Forest scenes, along with structures from the original display, including a manger and country village. The park served as a transitional location for the holiday lights before they were moved permanently to the Westmoreland Fairgrounds in 1993. While there are no plans to reopen Idlewild during the winter, the park continues to collaborate with the Indiana County Christmas Tree Growers Association and the county tourism bureau to host an annual Christmas in July event.

IDLEWILD'S LEGACY

Because you love to see them smile!
—Idlewild and SoakZone (2015)

In the twenty-five years after Kennywood acquired Idlewild, the company created individually themed areas, struck up a partnership with beloved children's icon Fred Rogers and developed a popular water park component—all of which attracted large crowds needed for the park to survive within a competitive industry. Yet after more than a century as amusement park owner-operators, in December 2007 the Henninger-McSwigan families announced the sale of the entire five-park Kennywood Entertainment enterprise, including Idlewild and SoakZone. The buyer was Parques Reunidos (Festival Fun Parks), a European corporation based in Spain whose American subsidiary, Palace Entertainment, operated multiple theme parks, water parks and family entertainment centers throughout the United States. The sale was completed in June 2008.[227]

As the Macdonalds did with Idlewild, the Henningers and McSwigans built the modern Kennywood Park over many decades, once again making it difficult for fans to imagine a new owner and the potential changes it might bring to these two historic parks. Palace Entertainment kept the local management team in place, including General Manager Brandon Leonatti, and had no plans to bring monster rides to Idlewild that would disrupt an aesthetic that had defined it since the nineteenth century.

Making New Waves

Idlewild still had room to grow. Palace Entertainment decided to upgrade the popular SoakZone area, which is often crowded during hot summer days. The company's first major decision after acquiring Idlewild was to replace the park's almost eighty-year-old swimming pool with a modern wave pool. The Wowabunga Family Wave Pool, which opened for the 2011 season, re-created the feeling of a day spent seaside without the taxing maintenance of the sand beach of yesteryear. Although small fries must wear life jackets, folks of all ages can enjoy the pool, which has a gradual zero- to six-foot depth and alternates between ten minutes of calm water and seven minutes of white-capped waves. To date, the multimillion-dollar project is the largest single capital improvement in Idlewild's history.

SoakZone was further expanded with the Float Away Bay lazy river. Such an attraction has been on the drawing board since park management and engineers were developing Raccoon Lagoon, but it took about fifteen years for the lazy river to materialize as the missing piece of the water park puzzle. After more than a year of development, the six-hundred-foot-long Float Away Bay opened for summer 2013, allowing patrons to slowly drift in inner

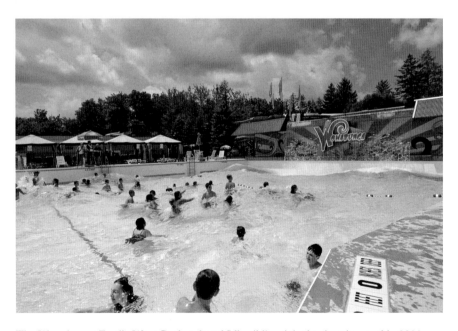

The Wowabunga Family Wave Pool replaced Idlewild's original swimming pool in 2011. *Courtesy of the Idlewild and SoakZone Archives.*

tubes around SoakZone or relax in lounge chairs and cabanas within an adjacent six-thousand-square-foot beach area. The new pool and lazy river complemented SoakZone's existing water slides and kiddie play area.

Daniel Tiger and the New Enchanted Castle

Palace Entertainment also tackled two of the park's other themed areas, beginning with Mister Rogers' Neighborhood of Make-Believe. With the late Fred Rogers's show off the air since 2001 and a new two-dimensional show starring Daniel Striped Tiger's son, millennial children were unfamiliar with the soft-spoken, cardigan-wearing educator whom previous generations had known and loved since the 1960s. Park management was concerned whether it could maintain the attraction after Rogers passed away.

Once again turning to the Fred Rogers Company, Idlewild decided to revamp the popular trolley ride to reflect the changing times rather than completely alter the ride's concept or remove it all together. After a one-season closure, the attraction reopened in 2015 as Daniel Tiger's Neighborhood, based on the current animated show. Although the original animatronic neighbors were replaced by 2-D replicas of the next generation of characters, the ride retains the central element of a pleasant trolley ride throughout the neighborhood. A life-size Daniel Tiger also greets visiting children and performs a daily show on the Raccoon Lagoon stage, "Daniel Tiger's Grr-ific Day." New generations of kids are excited to ride the big red trolley and visit with their friend Daniel.

The following season, Palace turned its attention to the historic Story Book Forest. When the original Enchanted Castle was demolished in 1997, park officials at the time did not make any promises but theorized that someday the castle could return. Many patrons keenly felt the loss of one of the Forest's most beloved attractions. It took almost twenty years to fulfill their wish for the castle to return, but it did, as part of Story Book Forest's sixtieth-anniversary celebration in 2016.

Idlewild commissioned Monster City Studios in Fresno, California, to create a new faux stone turreted Enchanted Castle. Measuring approximately fifty by forty-five feet, the towering castle is located in front of Old Mother Hubbard's Cupboard gift shop and visible from much of Story Book Forest. The design and fabrication company built the $500,000 structure at its workshop, transported the pieces and assembled the castle on site during the

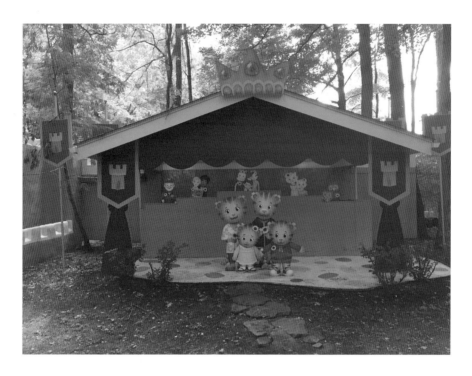

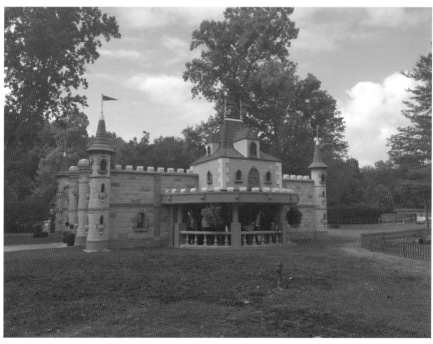

Above: Princess Lily, portrayed here by Lexi Wohlfort, welcomes visitors to Story Book Forest's new Enchanted Castle. *Author's photo.*

Opposite, top: Idlewild's popular trolley ride reopened in 2015 as Daniel Tiger's Neighborhood. *Author's photo.*

Opposite, bottom: Idlewild celebrated Story Book Forest's sixtieth anniversary in 2016 by building a new Enchanted Castle to replace the original one demolished nearly twenty years before. *Author's photo.*

spring of 2016, later adding stonework, paving and landscaping. One of the interior walls features a village scene that blends in with the adjacent gift shop.

The walk-through palace is home to Princess Lily, a new live character in Story Book Forest. The author of this book helped develop Princess Lily's backstory, which links the past to the present, as she is a descendant of King Arthur, the Golden Knight of the original castle. Duke the Dragon, a mascot who also appears at three Palace Entertainment sister parks, also makes daily appearances at the new castle. The inner courtyard contains a new interactive "Sword in the Stone" exhibit that replaced the now retired original Excalibur scene. A talking Duke the Dragon fountain cheers those who successfully dislodge the sword and playfully squirts water from his pedestal.

History Continues

At the time of this publication, Idlewild and SoakZone has operated as a recreational park in Western Pennsylvania in three succeeding centuries. Although much has changed over 140 years and four owners, Idlewild's strong roots as a nineteenth-century railroad park remain intact. The compact train depot where folks once debarked excursion trains from Pittsburgh is now a committee room. The building sits along the former rail bed of the Ligonier Valley Rail Road as one of the few surviving vestiges of the line, along with the Darlington station at the east end of the park. In 2006, Kennywood donated the Darlington station to the nonprofit Ligonier Valley Rail Road Association, which restored and converted it into a museum.[228] Visitors can no longer buy a sandwich or bottle of pop at the station, but they can learn about the history of the short line railroad that created Idlewild at the Ligonier Valley Rail Road Museum.[229]

The Macdonald family added several rides, games and concession stands to Idlewild that are still used today: the two-story replacement railroad station is now the Odds & Ends souvenir shop. Once known as the Dairy-Go-Round, the ice cream stand still serves soft-serve cones, milkshakes and banana splits. Cars bump around in the Skooter building, a Cat Rack game resides in the former shooting gallery and everybody still wins at the Fishing Pond. Although the old hamburger stand was demolished in 2003, the Sandwich Factory standing in its place sports the same style as its older siblings, painted bright white and accented by scalloped fascia.

Idlewild is recognized for its long history and its classic rides. The park hosted a summer-long 125th anniversary celebration in 2002, where former employees reunited, buried a time capsule to be unearthed in 2050 and enjoyed vintage photographs of the park displayed at a temporary museum housed in the original depot. In 2012, the Pennsylvania Historical and Museum Commission honored Idlewild Park with a historical marker acknowledging its heritage as Pennsylvania's oldest amusement park and its ties to the Ligonier Valley Rail Road. The cast aluminum marker stands at the park's exit, a beacon to passing motorists.

In 1990, American Coaster Enthusiasts (ACE) named Rollo Coaster an ACE Coaster Classic, a testament to the ride's long history of providing major thrills within a relatively small footprint. Features of the coaster's three-car trains qualified it for this distinction: traditional lap bars, the freedom to slide back and forth in the seat of your choice and unobscured views as the trains speed along the wooden track. Although Rollo Coaster lost this title

after the park retired its two original trains in 2016, a new ten-passenger train commissioned from original manufacturer Philadelphia Toboggan Coasters Inc. ensured that the historic junior coaster would continue to thrill riders.[230] The 2018 season marks Rollo Coaster's eightieth birthday, placing it among three octogenarian rides at Idlewild (along with the Skooter and carousel), plus a handful of original baby boomer–era kiddie rides and one of the country's few surviving walk-through storybook parks.

Although the park is no longer family-run, Palace Entertainment continues to promote Idlewild as a family-friendly destination in Pennsylvania's scenic Laurel Highlands, offering a variety of rides for children and adults, hosting kid-centric programs such as Outdoor Classroom Days and running a charitable ticket program to bring disabled and disadvantaged youth to the park for a day of fun. As of the 2018 season, Idlewild and SoakZone offers seven themed areas—Olde Idlewild, SoakZone, Raccoon Lagoon, Daniel Tiger's Neighborhood, Hootin' Holler, Jumpin' Jungle and Story Book Forest—that encompass a mixture of adult and kiddie rides, plus other adventures, games, daily live entertainment and plenty of refreshment stands.

Twenty-two picnic pavilions are available for large family reunions, community and school gatherings and company picnics, while tables and benches sprinkled around the park give parents and grandparents plenty of choices for a family gathering spot. The Auditorium, once the site of big bands, orchestras and flying feet, now hosts large group picnics as Pavilion D-2. The nearby dining hall serves in the same capacity as Pavilion E-1. Both buildings are more than a century old. Local unions like the District 10 Steelworkers and the International Brotherhood of Electrical Workers no. 5 now make up the largest groups hosted at the park. The Westmoreland County Farmers picnic stands as one of Idlewild's longest-running picnics and reached its centennial in 2018. The Ligonier Valley School and Community Picnic continues as an annual chamber of commerce event.

Many folks who came to Idlewild Park as children for company and community picnics return as adults to share a ride on the carousel or a strawberry-filled Cyclone ice cream cone with their kids. The park also continues to spark romance for couples who met as employees, married on the Good Ship Lollipop, hosted their wedding reception in the Auditorium surrounded by fall foliage or ended their ceremony on the SoakZone island with a kiss *and* a splash from the giant tipping bucket.

For almost a century and a half, Idlewild Park has welcomed patrons of all ages—today several hundred thousands of people each season. Idlewild stands as the Ligonier Valley's longest-running business, surviving

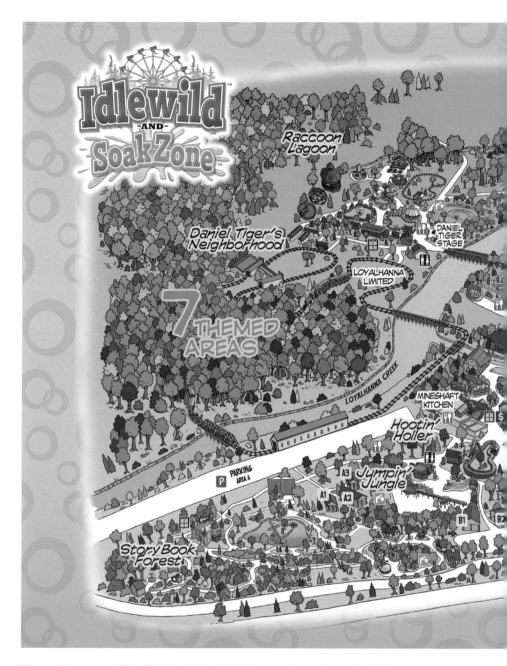

Twenty-first-century Idlewild offers kids and adults seven themed areas, including a water park, daily live entertainment, games, refreshments and picnic pavilions galore. *Courtesy of the Idlewild and SoakZone Archives.*

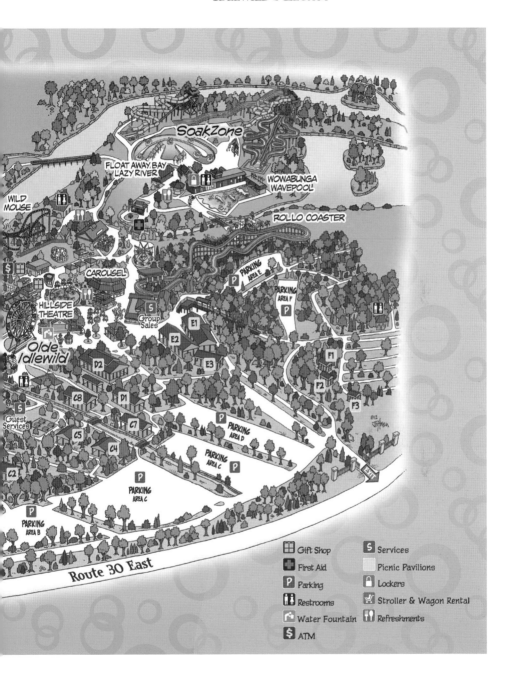

SoakZone

FLOAT AWAY BAY
LAZY RIVER

WOWABUNGA
WAVEPOOL

WILD
MOUSE

ROLLO COASTER

CAROUSEL

PARKING
AREA E

PARKING
AREA F

HILLSIDE
THEATRE

Group
Sales

E1

Olde
Idlewild

E2

E3

F1

D2

F2

F3

C8

D1

C7

Guest
Services

C5

C4

PARKING
AREA D

C2

PARKING
AREA C

PARKING
AREA C

EXIT

PARKING
AREA B

Route 30 East

Gift Shop Services

First Aid Picnic Pavilions

Parking Lockers

Restrooms Stroller & Wagon Rental

Water Fountain Refreshments

ATM

the lean years of the Great Depression, closure during World War II and the folding of the once successful railroad that brought city dwellers to the banks of the Loyalhanna Creek. Idlewild carved its own leisurely niche within an industry filled with thrill parks, ranking as the oldest operating amusement park in Pennsylvania, the third oldest in the United States and one of only two surviving railroad parks in the country.[231] For eight consecutive years, Idlewild and SoakZone received *Amusement Park Today*'s annual Golden Ticket award for the Best Children's Park—the highest award for that category in the amusement park industry.

> *To tell of all the charms and beauties of this delightful mountain park would be impossible. Here nature has gathered together everything that could in any way contribute to the physical welfare or the esthetic desires of pleasure seekers, and to these have been added all the improvements necessary to place the park in the first rank among the picnic resorts of Western Pennsylvania. Here, as nowhere else, is it possible for pleasure seekers to enjoy to the utmost a day's outing. Easily accessible to Pittsburg and all Western Pennsylvania towns, this mountain park is, perhaps, more truly in the heart of the mountains than any other resort in the state, for here are shut out from the mind all signs of the turmoil of every day life.[232]*

NOTES

Introduction

1. Idlewild's season count traditionally includes years when the park closed during World War II. The park's 140th *season* was 2017 but its 140th *anniversary* is 2018.

Part I

2. The Stoystown & Greensburg Turnpike was one of the early nineteenth-century toll roads that comprised the Philadelphia-Pittsburgh Turnpike. The correct spelling of the road—Stoystown & Greensburgh—predates the United States Board of Geographic Names' 1891 decision to drop the final *h* from names ending in "burgh." The author has used the modern spelling in this text to avoid confusion.

3. The Ligonier Valley Rail Road was a hands-on venture for the Mellon boys and the only one in which father and all four sons participated together. Initially, Thomas Jr. ran the company as general manager/superintendent and president while Andrew was the financier, a role that suited the future U.S. secretary of the treasury. As a supplies and construction expert, James handled the logistics of building and maintaining the line and was auditor and passenger agent. Richard served as a jack-of-all-trades—a sometimes conductor, promoter, freight agent, ticket salesman and Idlewild manager.

Judge Mellon kept equally involved as solicitor for the company's board of directors. Youngest son George was not involved with the company. Stutzman, *Images of Rail*.

4. The Ligonier Valley Rail Road paid workers wages 10 percent above those offered by the Pennsylvania Railroad. In addition, "At the beginning of each workday, young Thomas Mellon would drive his buggy, loaded with an iced-down keg of beer, to where his workers were laying track, and tell them that once they reached the keg, which he would unload somewhere down the roadbed, they could drink it. This incentive always worked." Stutzman, *Images of Rail*.

5. According to James Mellon in *The Judge* (2011), Richard Beatty Mellon was a guiding influence behind the conception of Idlewild Park: "In 1878, he persuaded his father to lease four hundred acres on Loyalhanna Creek from the Darlington family. It was there that Richard built Idlewild Park as a site for religious camp meetings and as a weekend picnic ground for Pittsburghers." Although unconfirmed, it's plausible that R.B. Mellon could have originated the picnic grounds idea, as he seems to have been the most enthusiastic of the four Mellon boys involved in the railroad venture and had a deep appreciation for nature, the outdoors and the Ligonier Valley, eventually developing the extensive Rolling Rock estate in Ligonier. He is also cited as an early manager of the Idlewild picnic grounds.

6. As described in Myers, *Ligonier Valley Rail Road and Its Communities*.

7. The Stoystown & Greensburg Turnpike was the only developed access to Ligonier contemporary to the Ligonier Valley Rail Road, as the old Forbes Road over the ridge had become more of a local route.

8. Mary and William Darlington were both passionate about history, particularly that of Western Pennsylvania, and not only amassed an incredible collection of letters, books, manuscripts and artwork but also wrote their own historical works. Some of the papers William collected included those crucial to the lineage of Mary's Ligonier Township property that became Idlewild Park.

9. Right-of-Way, dated September 21, 1872, recorded November 26, 1885, Westmoreland County Deed Book, vol. 137, page 380.

10. William Darlington was one of the pallbearers at Thomas Mellon's funeral in 1908. It's plausible that a close friendship may have played into the agreement for leasing the land for Idlewild Park.

11. William Darlington's misspelling; it should be "Bayard's Run."

12. The whereabouts of the original letters between Judge Thomas Mellon and William Darlington are unknown, and the only recorded facsimiles

of Darlington's responses appear in Myers, *Ligonier Valley Rail Road and Its Communities*, and the 1978 Idlewild Centennial publication.

13. *Greensburg (PA) Evening Press*, August 17, 1883.

14. Mary Darlington received the "Muchmore" tract, the "Rich Hollow" tract (containing 250 acres) and the "Elk Lick" tract (containing 50 acres in Donegal Township). Rich Hollow and Elk Lick were subsequently sold. Coincidentally, future Idlewild owner Dick Macdonald owned a residence on a part of the original Rich Hollow tract.

15. Last Will and Testament of General James O'Hara, September 15, 1819; Mary Carson O'Hara's Will, November 15, 1832, Darlington Family Papers.

16. Mary Darlington paid $7,333 in exchange for rights to the three Westmoreland County tracts in 1850. Various deeds between Harmar and Elizabeth Febiger Denny, James O'Hara, Elizabeth Denny O'Hara, Mary Carson O'Hara Darlington and William Darlington related to the transfer of the future Idlewild property to Mary Darlington are contained in the Darlington Family Papers, including land surveys and abstract of title, 1803–79; James O'Hara, Indenture, April 5, 1949; William Darlington, Deed, July 19, 1850; and Mary O'Hara and Mary Darlington, Indenture, November 25, 1850.

17. Mary Darlington also paid $235.95 to the Commonwealth of Pennsylvania for the patent to the 275-acre, 78-perch Muchmore tract on March 21, 1866, which gave her official ownership of the land. Mary Darlington, Deed, March 21, 1866, Darlington Family Papers.

18. The Treaty of Fort Stanwix (1768) created a new boundary line between Six Nations (Iroquois) Indian lands and British colonial settlements after an intense period of Indian and colonist conflict following the French and Indian War (1754–63); the New Purchase was part of that treaty and encompassed lands in Pennsylvania under settled claims between Native Americans and William Penn's family.

19. Westmoreland County was created from Bedford County in 1773.

20. New Purchase application no. 2663, Records of the Land Office, New Purchase Register, Pennsylvania State Archives; Shedrick Muchmore, Survey, November 1770, Darlington Autograph Files.

21. Alternate spellings of Shadrach include "Shedrick," "Shadrack" and "Shadrick."

22. Delegates from twelve of the United States' thirteen original colonies initially comprised the Continental Congress (1774) as the overall governing body during the American Revolution. The pre-Constitution Articles

of Confederation (1781) then created the single-house Confederation Congress (1781–89), which was followed by the Congress of the United States (1789), essentially the two-chamber legislature as we know it today. Arthur St. Clair was elected president of the Confederation Congress in 1787, the highest contemporary office in the country.

23. The Northwest Ordinance (1787) established the Northwest Territory, an incorporated territory spanning part or all of what would eventually become the states of Ohio, Indiana, Illinois, Michigan, Wisconsin and Minnesota.

24. All documents and testimony related to case no. 131 that might explain the reason behind Arthur St. Clair's favorable verdict in the ejectment case are missing from the case file at the Westmoreland County Courthouse. They were missing as far back as 1846, when the case was submitted as evidence in a separate ejectment case with the Westmoreland County Court of Common Pleas. The Board of Property meeting minutes at the Pennsylvania State Archives do not have any background on this case either. Perhaps Shadrach Muchmore's 1775 death or St. Clair's status played a role in the county ruling in St. Clair's favor.

25. Article on Ejectment from court, February 1846, Darlington Family Papers.

26. Judgment for James O'Hara, December 29, 1809, Darlington Family Papers.

27. The suit also mentions a second defendant by the name of Kennedy, perhaps a second tenant. Article on Ejectment from court, February 1846, Darlington Family Papers.

28. George W. Harris, *Pennsylvania State Reports*, vol. 20, Containing Reports of Cases Adjudged by the Supreme Court of Pennsylvania, vol. 8 (Philadelphia, PA: T.K. and P.G. Collins, 1854).

29. The 1787–88 "Remarks" are an almost eleven-page series of fifty-five-year-old George Washington's comments and notations on a proposed biography of himself where he details his experiences during the French and Indian War, including the friendly fire incident near Fort Ligonier. The "Remarks" are part of the George Washington Gallery at the Fort Ligonier Museum (www.fortligonier.org).

30. Boucher, *Old and New Westmoreland*, vol. 1.

31. To complicate matters, other sources list the Idlewild station build date as 1888: a 1917 Interstate Commerce Commission Bureau of Valuation engineering report and Myers, *Ligonier Valley Rail Road and Its Communities.*

32. According to Ligonier Valley Rail Road historian Jim Aldridge.

33. The measurements of the railroad depot at Idlewild are according to the Interstate Commerce Commission Bureau of Valuation Report dated May 28, 1918, describing the building dimensions, as well as the author's own measurements. Although various publications have claimed that Robert Ripley deemed the Idlewild station as the record-holder, *Ripley's Believe It or Not!* has no record of the Idlewild station.

34. Stutzman, *Images of Rail.*

35. An article describing a Masonic picnic at Idlewild in the August 13, 1879 issue of the *Latrobe Advance* specifically names R.B. Mellon as the "manager of the picnic grounds." He is given as a contact for Idlewild on published Ligonier Valley Rail Road timetables.

36. Myers, *Ligonier Valley Rail Road and Its Communities.*

37. Deed, Mary Darlington, May 8, 1890, Darlington Family Papers. This deed assigning A.W. Brandon of Danville rights to the white oak and rock oak timber on the Darlington estate reserved "out of said timber the grove containing four or more acres laying between the Railroad and Creek and now in occupancy of Thomas Mellon as picnic grounds at the station and known as Idlewild which is not included in this sale but to remain as it is."

38. Myers, *Ligonier Valley Rail Road and Its Communities.*

39. One end of the Loyalhanna Creek bridge was knocked loose in 1881 but was subsequently repaired. A heavy rain caused flooding that washed out the footbridge in August 1888. The bridge was further replaced in 1890, prior to the widespread improvements the next year. Yet another new bridge was built to replace one that washed away in a March 1912 flood.

40. Myers, *Ligonier Valley Rail Road and Its Communities*; *The Annual Report of the Secretary of Internal Affairs of the Commonwealth of Pennsylvania*, Part IV, *Railroad, Canal, Navigation and Telegraph Companies for the Year 1878.*

41. *Latrobe Advance*, July 8, 1885.

42. Probably in 1880, as Ligonier Valley Rail Road timetables in 1879 do not include Idlewild.

43. *Pittsburgh Post-Gazette*, July 20, 1880.

44. From the *Greensburg (PA) Evening Press*, August 22, 1884: "Never in the history of the Idlewild picnic grounds has that popular resort been so well patronized as the present season and it might be well to state that much of its continued success is due mainly to the exertions of George Senft, superintendent of the Ligonier Valley Rail Road."

45. From the *Latrobe Advance*, May 15, 1889: "The fame of the unequalled (in this part of the state, at least), natural beauty of these parks, has spread far and wide, and the low rates offered by the railroads has made the forming

of dates greater than ever before. Excursions from Manchester and South Side, Pittsburg to this point, have been unknown, heretofore these all went to Allegrippa [Aliquippa Park]."

Part II

46. *Greensburg (PA) Evening Press*, August 22, 1884.

47. *Ligonier Echo*, July 8, 1890.

48. *Pittsburgh Daily Post*, April 2, April 23 and June 27, 1891.

49. Darlington Family Papers.

50. Mary Darlington, Deed, May 8, 1890, Darlington Family Papers; Myers, *Ligonier Valley Rail Road and Its Communities*.

51. Beginning in 1891, the Ligonier Valley Rail Road's rent for Idlewild was $62.50 per quarter, but it increased to $100 in 1901. George Senft to John C. McCombe, Esq., October 6, 1893; Myers, *Ligonier Valley Rail Road and Its Communities*.

52. *Pittsburg Dispatch*, June 14, 1891.

53. *Indiana Democrat*, April 2, 1891. Reachable by passing from Lake St. Clair, we can surmise that this thirty-acre sporting field was created on the future site of the larger Lake Bouquet, although the acreage seems exaggerated.

54. Multiple reports in the *Ligonier Echo* and other newspapers suggest that there was a merry-go-round at Idlewild earlier than 1891, although such a device could be brought in for a specific picnic rather than installed for an entire season. A "'fly horse'—a regular Roman hippodrome on half shell" was available at the Fourth of July picnic in 1889 for those who did not want to dance, according to the July 10, 1889 issue of the *Echo*. Dr. Miller of Latrobe was reported holding fast to the "jolly-come-round" during the Lutheran harvest home picnic on August 8, 1889. An article in the September 4, 1889 issue announced that "none suffering with dyspepsia, or who howl when their fingers are pinched, or are given to drinking habits so that they cannot ride safely on the merry-go-round will be invited" to a Blairsville picnic at Idlewild Park the following week. This could be the same "large flying machine" reported by the *Indiana Progress* and the *Indiana Democrat* coming from Idlewild Park for the Indiana County Agricultural Society's annual fair in October 1889: "This machine has twenty-four artificial horses and a number of carriages on a platform upwards of 40 feet in diameter, is

run by steam and accompanied by music and cost the proprietors we are informed over $3,000 and the price is only five cents a ride." The *Indiana Weekly Messenger* went so far as to name Kunsel & Law as the firm that would be coming to set up the great "Steam Riding Gallery" for the fair and specifically mentioned "wooden horses" on the device. A July 9, 1890 *Echo* article mentions that the "'flying jinny' was doing a powerful business" at the Fourth of July Picnic at Idlewild, and a subsequent story on August 20, 1890, reported that "[s]ome modus operandi" shut down the "original 'merry-go-round' of the summer at Idlewild on Lutheran picnic day," suggesting criminal mischief. "A similar money making institution was set up and operated by a Braddock firm." An April 30, 1931 article in the *Latrobe Bulletin* dates the first merry-go-round at Idlewild, run by horse power, to 1876 (an obvious date error) and states that it was replaced by a steam-powered one (presumably the 1891 Parsons device).

55. Myers, *Ligonier Valley Rail Road and Its Communities*, cites an 1891 lease with Parsons giving the details of his merry-go-round. However, the *Ligonier Echo* reported on May 18, 1892, that "the merry-go-round at Idlewild has been bought out by M.B. Parson [*sic*] who is putting in an entirely new outfit and will have everything first class," suggesting that someone else may have owned the device in 1891 while Parsons managed it. The lease that James Madison Myers's thesis cites has not been found.

56. Letter from George Senft to John H. Galey, Esq., March 18, 1892; letter from George Senft to John [surname illegible], April 4, 1895.

57. *Ligonier Echo*, August 28, 1895.

58. Ibid., October 5, 1892.

59. Ibid., May 18, 1892; February 1, 1893; and February 15, 1893. The National Hotel was located on East Main Street at the current location of the Veterans of Foreign Wars post. The Hotel Loyalhanna was likely the Menoher House, later known as the Commercial Hotel, located at South Market and Loyalhanna Streets. Both establishments were owned at one time by John Freeman Menoher, Parsons's brother-in-law.

60. *Ligonier Echo*, May 20, 1896.

61. George Senft to T.M. Harton, April 5, 1895.

62. Ibid., December 1, 1895.

63. Both Moses Parsons and the T.M. Harton Company probably installed more than one merry-go-round at Idlewild, upgrading or replacing their machines over time. For example, the *Ligonier Echo* reported on November 14, 1894, that Parsons had a merry-go-round shipped from

New York to Ligonier, where it was stored in R.M. Graham's warehouse over the winter in anticipation of the 1895 season. The *Echo* later reported on May 24, 1899, "T.M. Harton, of Pittsburg, is now having his handsome new merry-go-round placed in position on the Idlewild picnic grounds for the summer. This new merry-go-round is of the latest style and date and will be a source of great pleasure and amusement to the young folks." An article in the April 30, 1931 issue of the *Latrobe Bulletin* describing the new Philadelphia Toboggan Company carousel at Idlewild mentions that Charles Dickson managed the previous merry-go-round for thirty-three years, which could corroborate the 1899 date of a new T.M. Harton merry-go-round at the park.

64. The build date for the merry-go-round pavilion is unknown. An article in the *Latrobe Bulletin* on the park's reopening in 1946 indicates a build date of 1906, although this year is unconfirmed: "Mr. Macdonald reported that the merry-go-round building, built 40 years ago, was carefully examined and that not a single decayed spot could be found."

65. As of 1900, the T.M. Harton Company owned and operated only three merry-go-round concessions, according to the *Ligonier Echo*, May 23, 1900. According to Harry Michaelson, those were at Idlewild, Rock Springs and Conneaut Lake Park.

66. For the 1899 season, Chas Dickson was assisted by Harton employee Harry Covode and Idlewild employee R. Russell McKinley, the latter known as a "popular ladies' man of town" who previously worked at a merry-go-round in Asbury Park, New Jersey.

67. The railroad company contracted Al. Jones and a team of laborers for the construction of Lake Bouquet. George Cook was named as superintendent of the project. *Ligonier Echo*, November 13, 1895; January 15, 1896; March 11, 1896; and May 20, 1896.

68. George Senft spells Idlewild's new lake as "Boquet" in his first mention of its name in a letter to the Globe Ticket Company on June 11, 1896. This spelling also appears in turn-of-the-century publications such as Pennsylvania Railroad brochures, the souvenir *Idlewild: A Story of a Mountain Park* plus various newspaper articles. According to the May 20, 1896 issue of the *Greensburg Tribune Herald*, the names of the two neighboring bodies of water were slated to be "the Twin Lakes St. Clair."

69. The Battle of Bushy Run (August 5–6, 1963) was an important British victory during Pontiac's War (1763–66), when Native American tribes rebelled against British colonists in the aftermath of the French and Indian War. Bouquet's troops were in route to relieve Fort Pitt in present-

day Pittsburgh when they encountered the tribes in an open glen one mile east of Bushy Run station in present-day Jeannette.

70. Pennsylvania Railroad Company Idlewild Parks brochure, 1897 season.

71. The author measured Lake Bouquet using the DaftLogic Google Maps area measurement tool as of May 2017. George Senft estimated the new lake's area at eight to ten acres in a letter to Daimler Motor Company on March 13, 1896, although the October 30, 1895 issue of the *Ligonier Echo* described the future lake as covering twenty-three acres from Darlington to Idlewild Park with a depth of six feet.

72. George Senft to Marine Vapor Engine Company, December 28, 1896.

73. Ibid., September 20 and December 8, 1897; George Senft to Edward Purcell Mellon, December 23, 1897.

74. *Ligonier Echo*, October 21, 1891.

75. *Pittsburg Dispatch*, September 6, 1891.

76. George Senft to B.F. Hilt, Esq., September 15, 1892; Ligonier Valley Rail Road Traffic from 1879 to 1952, Inbound Passengers, appendix XV, in Myers, *Ligonier Valley Rail Road and Its Communities*.

77. George Senft to Farmer's Handy Wagon Company, June 6, 1896.

78. *Ligonier Echo*, June 8, 1898.

79. For the 1898 season, Dick Graham and Milt Wilt operated the two naphtha launches, John H. McDowell managed them and Ralph Irwin sold tickets. William Fowler operated the swan boat. William Kimmell managed the rowboats. Gus Bitner had charge of the checkroom. E.R. Shirey served as ticket agent. *Ligonier Echo*, June 8, 1898.

80. The *Ligonier Echo* for August 12, 1891, mentions a picture gallery at Idlewild during the Lutheran picnic. A letter from George Senft to Richard B. Mellon on January 25, 1893, indicates that a man named Mr. Arthur offered his services. "His offer I think very good and I believe the man is alright," Senft told Mellon. "We realized out of the photo last year $1,095.88."

81. The poplars were removed in the fall of 1923, as most of them had died.

82. However, during the first decade of the twentieth century, the Pennsylvania Railroad's special excursions to Idlewild and other resorts dropped off generally, and trips were limited to regular passenger traffic due to heavy freight schedules (which spiked in 1903 and 1905, for example), but more specifically because significant track work in Latrobe prompted the Pennsylvania Railroad to limit large convoys by refusing to issue groups cheap excursion rates. According to railroad historian Jim Aldridge, the Pennsylvania Railroad completely rebuilt the track between

Derry and Greensburg, involving major line relocations and expansions and elevations of the track, and the priority was the Ligonier Valley Rail Road's heavy coal traffic coming out of Ligonier. Any curtailment of special excursions was a matter of practical necessity and did not hurt Idlewild in the end.

83. Pennsylvania Railroad Company Idlewild Parks brochure, 1897 season.

84. *Greensburg (PA) Tribune Herald,* June 10, 1896.

85. Sunday school, public school and community picnics at Idlewild date back to at least 1880. Greensburg schoolchildren picnicked there on June 12, 1880, according to Connellsville's *Weekly Courier,* June 18, 1880. The largest gathering of Sunday school children in Westmoreland County—attracting Lutheran congregations from Latrobe, Derry and Greensburg—occurred on August 17, 1883, according to the *Latrobe Advance*, August 22, 1883.

86. It is unknown if and when "Idlewild Mazurka," a lively Polish folk song in 3/4 time, was ever performed at Idlewild after it was written but before the twenty-first century. On September 10, 2017, the Penn Trafford Community Flute Choir performed an adaptation of the piece during the park's Fall of the Leaf celebration.

87. *Ligonier Echo*, August 21, 1929; *Ligonier American*, August 23, 1929.

88. George Senft to Pennsylvania Railroad assistant superintendent R.S. O'Donnell, July 8, 1897.

89. Joseph and David Nicely were tried and convicted in the 1889 robbery and murder of Jennerstown resident Herman Umberger and subsequently hanged on April 2, 1891.

90. From the *Idlewild Lutheran*, August 6, 1891.

91. Frederick Pershing (1729–1794), a Huguenot immigrant, built a log cabin along Nine Mile Run between the Western Pennsylvania villages of Youngstown and Pleasant Unity in 1768, later establishing the first gristmill west of the Alleghenies. He was allegedly a member of Proctor's Militia and one of the leaders during the Hannastown Resolves in 1775, which was an early colonist challenge to British authority predating the Declaration of Independence.

92. For example, fifteen counties participated in the Westmoreland County Democratic Committee's Roosevelt Day Picnic at Idlewild on August 17, 1933. A ten- or eleven-county Republican picnic and rally was held at the park on August 25, 1938, to launch the 1938 GOP campaign in Pennsylvania and attracted a reported twenty-five to thirty thousand attendees.

93. Thousands of people—white and black—picnicked at Idlewild during the Fourth of July 1890: "Every description of humanity was there; the colored man and the colored woman as well as the good and bad who are found everywhere that the human race assembles." *Ligonier Echo*, July 9, 1890.

94. Myers, *Ligonier Valley Rail Road and Its Communities.*

95. During the early twentieth century in the United States, the Ku Klux Klan revived under the guise of a benevolent, patriotic organization, becoming active in Western Pennsylvania between 1921 and 1928. Local KKK chapters raised funds for charities, were concerned about the state of the country and enjoyed socializing during picnics at local parks like Idlewild. Nonetheless, their racist, anti-union, anti-Jewish, anti-Catholic, anti-immigrant and nativist philosophies led to violent outbreaks and the group's eventual sharp decline by the end of the decade. See Craig, *Ku Klux Klan in Western Pennsylvania*, a comprehensive study of the Klan's message, activities and presence in context of the period and geographic area.

96. The *Latrobe Bulletin* estimated the attendance at the September 13, 1924 Ku Klux Klan picnic at eight to ten thousand people, the *Ligonier Echo* at twelve to twenty-five thousand and the *Indiana Weekly Messenger* at more than twenty-five thousand.

97. The Householders continued a long relationship with Idlewild Park throughout their married life. Robert had a long career working for the Ligonier Valley Rail Road, notably running the weigh station in Latrobe. As the longest-tenured employee at the time of the railroad's closing in 1952, he was recognized during the last run and issued the last ticket from the Idlewild depot. Many years after courting at Idlewild as a young girl, Sarah would often sit on one of the park's iconic green metal benches below the Auditorium, this time watching her granddaughter, Sara Jane, enjoy the park as she did.

98. "A number of Latrobe society people held a moonlight hop last Friday night at Idlewild." *Ligonier Echo*, July 21, 1897.

99. Ruth Love, "Long Ago Picnics at Idlewild Recalled," *Tribune-Review*, February 17, 1980.

100. Letter from George Senft to T.M. Harton, April 5, 1895.

101. An odd refusal, considering the *Indiana Democrat* reported rifle ranges at Idlewild in 1891.

102. Idlewild patrons could, however, ride a Ferris wheel installed in the spring of 1895 on property near the park that was owned by Walter J.

Seger and I.T. Clark and operated until moved to Johnstown in July 1896. *Ligonier Echo*, August 7, 1895; and July 29, 1896; *Pittsburgh Press*, May 12, 1895.

103. Myers, *Ligonier Valley Rail Road and Its Communities*.

104. *Latrobe Bulletin*, June 4, 1920.

105. *Map of Darlington Estate (Idlewild Park-Ligonier Valley Rail Road)*.

106. Mary Carson O'Hara Darlington passed away in June 1915. Her estate was divided equally between her three children: O'Hara, Mary and Edith. The heirs of the Idlewild property in 1923 were: Mary O'Hara Darlington; the Commonwealth Trust Company of Pittsburgh and Francis R. Harbison, as trustees for Samuel A. Ammon (Edith's husband); the Commonwealth Trust Company of Pittsburgh as guardian of Barbara Lane Darlington; the Fidelity Title and Trust Company of Pittsburgh as guardian of Lois Darlington Dowling; and Edith Darlington Ghyssels.

107. Deed, February 26, 1923, recorded March 17, 1923, Westmoreland County Deed Book 743, pages 83–86. The deed description reads as follows: "Beginning at a chestnut stump in line of lands of Baker; thence by lands of same south 21°45' east Twenty-five hundred thirty-six and forty-one hundredths (2536.41) feet to a red oak; thence by line of lands of Overcash, south 4°7' east, Twelve hundred eleven and thirty-two hundredths (1211.32) feet to a point at or near Coal Pit Run; thence by lands of Crescent Pipe Line pump station south 26°17' west, Three hundred twenty-seven and four hundredths (327.04) feet to a point at or near the south bank of the Loyalhanna Creek and in line of lands of Elmer Deeds; thence by lands of same North 72°25' west, One hundred ninety-one and ninety-seven hundredths (191.97) feet to a point; thence by lands of same south 78°15' west, Nine hundred eighty-five and nine hundredths (985.09) feet to a point marked by three blazed trees; thence continuing by lands of Elmer Deeds south 20°15' west, Nine hundred seventy-four and two tenths (974.2) feet to an iron pin; thence by lands of Luther H. Geisy [sic] south 76°14' west, Six hundred forty-nine and fifty-three hundredths (649.53) feet to a white oak; thence by lands of same south 65°29' west, Seven hundred twenty (720) feet to a post; thence by lands of same north 52°5' west, Sixteen hundred thirty-five and eighty hundredths (1635.80) feet to a post; thence by lands of same north 64°10' west, Two hundred four and six tenths (204.6) feet to a maple; thence north 2°57' west, Two hundred fourteen and twenty-two hundredths (214.22) feet to a post; thence north 28°49' west, Three hundred five and sixty-seven hundredths (305.67) feet to a white oak at or near a public

road; thence by lands of A. Johnson north 0°53' west, Five hundred sixty-three and one tenth (563.1) feet to a post; thence by lands of same north 16°59' west, Three hundred six and nine tenths (306.9) feet to post; thence by lands of same north 24°59' west, One hundred forty-one and nine tenths (141.9) feet to a post; thence crossing the Loyalhanna Creek south 82°51', Two hundred forty-one and twenty-nine hundredths (241.29) feet to post; thence by lands of Charles Dumont, in part by lands of Mrs. Scott, and in part by lands of Baker, north 50°42' east passing through a stone monument marking the intersection of the lands herein described and the corner common to lands of Charles Dumont and Mrs. Scott for a distance of Forty-five hundred three and eight hundredths (4503.08) feet to a chestnut stump, the place of beginning. Containing Three hundred twenty-five and forty-six hundredths (325.46) acres more or less."

108. Indenture, February 28, 1923, recorded March 17, 1923, Westmoreland County Deed Book, vol. 738, pages 510–11.

109. The 1891 dining hall was improved with a new concrete foundation and metal railing probably sometime after the Ligonier Valley Rail Road purchased the Idlewild property.

Part III

110. Certificate of Incorporation of the Idlewild Management Company, Pennsylvania Charter Book no. 303, page 189, April 29, 1931; and Allegheny County Charter Book, vol. 63, page 723, April 30, 1931.

111. In the early days of the Ligonier Valley Rail Road, job titles and responsibilities were evolving and tenures overlapped. Those who served as general manager/superintendent of the railroad were Thomas A. Mellon (1877–89), Richard Beatty Mellon (1877–81), George Senft (1881–1914), William Van Kirk Hyland (1913–26) and Joseph P. Gochnour Jr. (1926–52).

112. An Idlewild Management Company ledger book (1931–48) shows a manager's salary of $1,800 under income as of December 31, 1931.

113. The original incorporators and stockholders of the Idlewild Management Company were Thomas E. Shaw, Thomas Ewing Jr. and E.C. McHugh. All three resigned as directors of the company and were replaced by Richard King Mellon, Howard M. Johnson and C.C. Macdonald, respectively, at the May 11, 1931 stockholder meeting. Grace R. Macdonald and Joseph P. Gochnour filled the two vacant seats on the revised five-member board,

which increased to seven members in 1945 and decreased back to five members in 1950. Board members in the succeeding years included R. Stewart Scott, Fred Mellon, E.B. Clarke, E.O. Grubbs, Clinton Keith (Jack) Macdonald, Robert E. Willison, Richard Zane (Dick) Macdonald, Juanita R. Barkley, Charles Scott Macdonald and Stanley R. Nalitz Jr.

114. Minutes from 1943 and 1944 Idlewild Management Company stockholder meetings indicate the Idlewild Company shares in the IMC were divided between the following stockholders: Lucille Mellon Hasbrouck; the A.W. Mellon Educational & Charitable Trust; Sarah Mellon Scaife; the Union Trust Company of Pittsburgh, Trustee; Thomas Mellon; Richard King Mellon; the Estate of Richard Beatty Mellon; William Larimer Mellon; Mary Mellon McClung; William Larimer Mellon Jr.; Edward Purcell Mellon; T.A. Mellon; Edward Purcell Mellon II; the Nollem Corporation; and Mac & Company.

115. *Latrobe Bulletin*, April 23, 1931. Lawrence William Darr, of Loyalhanna Street in Ligonier, was a house carpenter, building contractor and lumber/house dealer who later partnered with Jacob Byers, an owner/operator of a sawmill in the Weavers Mill district just southwest of the community of Rector. An Idlewild Management Company ledger book (1931–48) shows payments to these businessmen for materials supplied to the park in the 1930s. Darr remodeled the Macdonalds' farmhouse in 1933.

116. Per its lease from the Idlewild Company, the Idlewild Management Company agreed to spend no more than $35,000 for general improvements to the grounds.

117. *Greensburg Daily Tribune*, May 27, 1931.

118. According to Jack Macdonald in a November 20, 1991 interview with Jim Futrell; Futrell, *Amusement Parks of Pennsylvania.*

119. The Idlewild Company built the new $3,000 administration building and rented part of it to the Ligonier Valley Rail Road Company for a ticket office and station and part of it to the Idlewild Management Company for its offices and headquarters. IMC Board of Directors Meeting, May 11, 1931.

120. Inbound passengers on the Ligonier Valley Rail Road fell from a high of 361,835 in 1914 to 56,460 in 1930. Myers, *Ligonier Valley Rail Road and Its Communities.*

121. The company had horses for one three-row carousel and some for a second already completed, along with one pole and machinery for both.

122. The Philadelphia Toboggan Company had one new carousel finished by September 1929 and was making the rest of the horses for the second,

presumably no. 83. In December, it had "two that are practically finished." As of December 31, 1929, factory work in process included fifty-eight carousel horses and one body as well as the drop boards, panels, joint covers and rim specifically for no. 83.

123. Philadelphia Toboggan Company carousel no. 83 has sixteen standers in the outer row, fourteen jumpers in the middle row and fourteen jumpers/four standers in the inner row.

124. Using existing Sanborn fire insurance maps from 1921 and 1949, the author determined that Philadelphia Toboggan Company carousel no. 83 was located on the south side of Connecticut Avenue in Atlantic City, New Jersey. The building later housed the Dude Ranch, a Wild West–themed restaurant and nightclub that had a round dance floor—a telling footprint of a former carousel. Sokolic and Ruffolo, *Images of America: Atlantic City Revisited.*

125. Philadelphia Toboggan Company carousel no. 83's first season lasted from April 19 to September 14, 1930. PTC net a $762.21 profit after paying Weber his percentage and absorbing repairs and maintenance costs.

126. William F. Weber's legal troubles may have led to the financial difficulties that resulted in his bankruptcy and the loss of Philadelphia Toboggan Company Carousel no. 83. Weber, the contractor he engaged to build an "amusement place" on the Atlantic City boardwalk to house a carousel (Brazier T. Booye) and Atlantic City's building inspector (John W. Conway) were embroiled in a sweeping vice and corruption investigation of city officials in 1930. The carousel was indirectly involved in the scandal. Conway was indicted but cleared on charges that he extorted money from Weber via Booye to smooth the way for the amusement structure to be built after he failed to issue building permits and neighbors began complaining about a merry-go-round being installed there. Weber, who testified during Conway's trial, was alleged to have altered his testimony and was charged with perjury and conspiracy. *Vineland (NJ) Daily Journal,* May 29 and June 4, 1930; *Asbury Park Press,* June 3, June 4 and July 12, 1930; *Central New Jersey Home News,* June 4, 1930; *Bridgewater (NJ) Courier News,* June 4, November 10 and December 20, 1930.

127. George P. Smith Jr. to Thomas J. Arculeer, Manager of Jefferson Beach Park Inc., January 24, February 7 and February 18, 1931; George P. Smith Jr. to A.M. Godshall (telegram), February 13, 1931.

128. PTC Executive Committee Meeting Minutes, January 26, 1931.

129. PTC assistant secretary A.W. Godshall to Philip Stuhltrager, January 23, 1931.

130. PTC secretary K.S. Gaskill to Henry Maholm, March 20, 1931.

131. PTC Executive Committee Meeting Minutes, March 24, 1931.

132. George P. Smith to H.M. Johnson, April 13, 1931.

133. The "Capehart" outfit was most likely a Capehart Orchestrope, a phonograph that PTC began selling through its Play Equipment subsidiary in 1929.

134. The Wurlitzer Caliola, an air-operated calliope with serial no. 4124, is listed in a Wurlitzer company ledger as being shipped to Pittsburgh on October 25, 1928, so the machine spent time somewhere else before moving to Idlewild Park; an Idlewild Management Company ledger book notes a twenty-five-dollar equipment expense for a calliope in January 1934. The provenance of Wurlitzer no. 103, a more common band organ, is problematic because its serial number is unknown. According to Carousel Organ Association of America member Patrick Nese, the Wurlitzer no. 103 allegedly replaced an original Artizan Factories band organ (why the façade was retained) after the company closed because Wurlitzer music rolls were more readily available; the date of this alleged conversion is unknown. The original Artizan organ is rumored to be owned by a private collector. Amusement park historian Charles Jacques says in his *Carousel News Trader* article, "Linger Awhile at Idlewild: The Home of PTC #83," "According to park staff, the carousel's Wurlitzer band organ originally came from a roller rink in Latrobe, Pennsylvania." It is also unknown whether the presumed original Artizan organ was what C.C. Macdonald purchased when he bought the "carousel, organ and Capehart music outfit" from the Philadelphia Toboggan Company in October 1932.

135. Work on the new swimming pool was reported to start in November 1931, but the Idlewild Management Company Board of Directors did not authorize officers to enter into contracts or borrow money for the construction until its January 11, 1932 meeting.

136. A 1947 entry in the Idlewild Management Company's ledger book notes the original investment for the swimming pool at $73,111.54.

137. "Idlewild was one of only a few parks in the United States which ended the [1932] season showing a profit." *Latrobe Bulletin*, October 14, 1932. C.C. Macdonald told the *Pittsburgh Post-Gazette* in 1934 that only 3 percent of amusement parks made money the preceding year.

138. *Billboard*, September 30, 1933.

139. *Latrobe Bulletin*, July 6, 1931.

140. *Billboard*, September 30, 1933.

141. *Latrobe Bulletin*, May 5, 1933.

142. The Idlewild Management Company purchased the produce stand in 1937.

143. The first tree planted at Idlewild Park during a picnic outing for the southwestern district of the state federation of Women's Clubs was in honor of First Lady Eleanor Roosevelt.

144. Idlewild's historic Whip received replacement fiberglass cars around 1995 and remained active through part of the 2015 season, after which the ride was decommissioned due to technical issues and placed in storage in September 2017.

145. Idlewild histories have traditionally identified only two Whips at the park (1934–37 and 1939–present). However, evidence suggests that the second Whip was not installed until 1941 and may have actually been the park's third. A Whip did not operate in 1938—it was not listed in an Idlewild Management Company ledger book as an operating ride for that year. The IMC board authorized C.C. Macdonald to purchase a new Whip at its November 8, 1937 meeting. The *Ligonier Echo* reported a new Whip at the park (May 12, 1939), corroborated by an Indiana District school pupils' picnic advertisement and ledger book entries noting income for the ride that year. It is unclear whether the park did purchase a brand-new Whip or if it repaired or refurbished the original Whip after a year off. Fast-forward to 1941, when the *Latrobe Bulletin* reported another new Whip that year (May 23, 1941). Amusement park historian Jim Futrell's book *Amusement Parks of Pennsylvania* mentions the Macdonalds' purchase of a new Whip during the 1939 World's Fair, which ran from April through October in both 1939 and 1940. According to Futrell, it is probable that the Macdonalds made their visit in 1940, given the board of directors' approval for Macdonald to again purchase a new Whip at its April 7, 1941 meeting and ledger book entries noting a deposit and equipment payments for a new Whip that year, plus the sale of $403.57 worth of parts (presumably from the prior Whip).

146. *Latrobe Bulletin*, May 16, 1935.

147. Idlewild Management Company ledger book, 1931–48. According to Peter Petz, German rides were incompatible with American electricity, so it is unknown but possible that the Dangler could also have been a maintenance problem for Idlewild.

148. Ibid. Idlewild Park purchased the Dangler for $384 in December 1934.

149. C.C. Macdonald left Queen the bear a widow. The park offered Barney's carcass to the Latrobe and Ligonier Sportsmen's Club for a banquet. Queen was released to a game refuge in Potter County in May 1935.

150. Walter, Bill, Red, Pat and Mike were the names of the monkey quintet that escaped in 1934. Thirteen-year-old Mary McMahon of Darlington captured one of the monkeys. After luring the escapee with raisins, she dropped a sack over its head. Her aunt caught a second monkey. *Ligonier Echo*, June 27, 1934.

151. Idlewild Management Company ledger book, 1931–48.

152. Covered by an orange canopy, the bingo stand was designed after a ship's deck and had tables for four players.

153. C.A. Pressey's Fishing Pond patent involved a tank with moving current of water and buoyant fish-shaped pieces designed to be caught by a hook. Amusement Apparatus, serial no. 441.314, U.S. Patent Office, August 10, 1909.

154. Idlewild Management Company ledger book, 1931–48.

155. Philadelphia Toboggan Company, *Pretzel for Idlewild Park, Ligonier PA— Plan Showing Changes in Track for Installation of Stunts*, November 26, 1941. This plan indicates Idlewild planned to revamp the Rumpus for the 1942 season. The plan showed the original track path, the proposed addition to the building and revised track layout, spaces for fourteen stunts and a space outside the building behind the loading area for Laffing Sal. The park also purchased $160 worth of stunts and animated heads in 1940 and an additional $29 worth of funhouse stunts and parts in 1942.

156. According to William Luca, a dark ride expert behind authoritative website Laff in the Dark (www.laffinthedark.com).

157. Rumors of snakes running rampant at Idlewild Park have persisted for years, usually reports of snakes crawling into the Caterpillar and falling on riders when the canopy opened. Donna Benson, who grew up in Jennerstown, Pennsylvania, remembered her mother and grandmother warning her not to put her hands in the mouths of the carousel horses for fear there might be snakes hiding in them.

158. The Philadelphia Toboggan Company and the Idlewild Management Company entered into the coaster contract on December 8, 1937, and Idlewild put down a $500 deposit.

159. According to the minutes from the September 22, 1937 PTC Board of Directors meeting, Schmeck reported on recent and future business for prospects, mentioning a kiddie coaster as one of the prospects he was

working on. Schmeck received a traveling expense a few weeks before that meeting, according to a PTC Statement of Assets from September 2, 1937.

160. The Rollo Coaster's track has been reported at various lengths, from 900 to 1,600 feet; the measurement given in this book is based on the Idlewild Park 1976 Valuation Report, which states 1,094 linear feet of track.

161. According to the *Latrobe Bulletin*, April 22 and May 20, 1938, and the Greensburg *Daily Tribune*, May 27, 1938. Other than this confirmation from the media, no on-site photographs or documentation have been found confirming the sawmill and wood source for the Rollo Coaster. References to purchased lumber in Idlewild and PTC records add a shroud of mystery: a line item in the Philadelphia Toboggan Company's December 31, 1938 annual financial statement for the sale of $1,357.88 worth of lumber to Idlewild Park with no explanation of its purpose; a line item for lumber related to the coaster in the Idlewild Management Company ledger book dated October 1, 1938, in the amount of $149.27; and a sale of $161.25 worth of lumber related to the coaster to pony track manager Mr. Van Kirk dated June 30, 1938. It is plausible that part of the coaster (the structure) was built from park lumber and the rest (the special length track) was made from lumber shipped to the park—or that PTC provided lumber for another project.

162. The eastbound lanes of Route 30, constructed between July 1955 and October 1956, probably cover the roller coaster sawmill site.

163. Undated Philadelphia Toboggan Company plans for a "Proposed Ligonier Rustic Front," presumably for the coaster station, show a sign with the name "The Woods," suggesting that this was a potential name for Idlewild's new roller coaster.

164. Idlewild's roller coaster name contest ran until June 18, 1938. The winners' names were to be published in the newspapers the following week, but no announcement followed. The first instance of the name "Rollo Coaster" appeared in the *Latrobe Bulletin* in 1941.

165. From the *Latrobe Bulletin*, May 15, 1940: "There are more church groups and community picnics at Idlewild than at any other park in Western Pennsylvania. This is due, not only to the clean operation of the park and its high class moral atmosphere, where intoxicating liquors of all kinds are absolutely forbidden but also to the courteous attendants in all departments."

166. An editorial in the November 19, 1890 issue of the *Ligonier Echo* called for moving an older Westmoreland County Fair to Idlewild, a change

rumored at the time. "Not only is Idlewild the best adaptable location in Westmoreland County, but the best in Western Pennsylvania....We defy any part of Westmoreland County or even do we challenge Western Pennsylvania to show a community to which more interest is being taken in the improvements of livestock or in which better livestock may be found than in Ligonier Valley."

167. The full text of the bill is available at http://explorepahistory.com/odocument.php?docId=1-4-1E7.

168. *Latrobe Bulletin*, June 6, 1936.

169. The totem pole was purchased for $175 from Mrs. William H. Wolfe of Hollidaysburg, Pennsylvania.

170. Despite the war, the Fourth of July 1942 marked the largest crowd at Idlewild in a dozen years, which filled the park until midnight. Heavy traffic lined the Lincoln Highway, and parking lots hit capacity in the afternoon, forcing the park to close its gates for two hours. Folks waited in line for up to two hours to use the swimming pool. *Latrobe Bulletin*, July 6, 1942.

171. C.C. Macdonald partnered with Joe Critchfield to create a fish hatchery where he raised largemouth bass and bluegills in Lake Bouquet, which he then sold. It was not a solid business—more like a hobby for the expert fly-fisherman—but it generated a little extra revenue.

172. This amount might include the total value of the building itself, plus all of the equipment inside. The Idlewild Management Company ledger book totals the fire loss (the Rumpus ride, the new restaurant equipment and Rock Springs Park equipment) at $7,077.17 before depreciation.

173. C.C. Macdonald's letter to Joseph Gochnour on the Rumpus fire gives 12:00 p.m. (noon) instead of 12:00 a.m. (midnight) as the time Fred Clawson punched in for his shift, although he likely meant the latter.

174. Only two of four surviving original Caterpillars in North America are still operating. Idlewild's Caterpillar was at one time repaired using parts of the Caterpillar at Kennywood Park in West Mifflin.

175. *Ligonier Echo*, June 25, 1948, and September 2, 1949.

176. *Ligonier Echo*, May 21, 1948.

177. Although Idlewild's kiddie area is more commonly spelled as one word, "Kiddieland," the author has chosen to spell its proper name as two words, "Kiddie Land," as written on the original clown sign at the park and noted in Idlewild Management Company Board of Directors meeting minutes, and use the single word to refer to children's ride areas in general.

178. Idlewild's first children's amusement could technically be considered a small sailboat that the Ligonier Valley Rail Road purchased for kids to float in the lakes in 1900. *Ligonier Echo*, May 2, 1900.

179. From *Latrobe Bulletin*, "Kiddie Land at Park," June 25, 1941: "Special attention has been paid to and for the little folks amusements in Idlewild. An area has been set aside in the West Plaza where ornate rides have been erected."

180. During this time, C.C. Macdonald also co-owned a dedicated children's park and dude ranch located at 3013 Broadway Street in San Antonio, Texas, called Kiddieland, which he took over in 1945 with Idlewild Management Company board member R. Stewart Scott and managed for about two years. Macdonald has been traditionally, yet mistakenly, credited with originating the kiddieland amusement park concept. The San Antonio Kiddieland was located adjacent to Kiddie Park, which opened in 1925 under owner W.R. Curry as the nation's first children's park. Although he accomplished much during his long amusement park career, unfortunately Macdonald did not create or own the pioneering Kiddie Park. See *San Antonio Light*, "City's Very Young Set Finds Mecca," February 1, 1946; Bill of Sale for Kiddieland Operating Company, R.S. Scott and C.C. Macdonald to Harry E. Pressey, January 9, 1947.

181. Jack Macdonald reported that work was progressing on relocating the Kiddie Land rides during the May 1, 1951 meeting of the Idlewild Management Company Board of Directors. The *Ligonier Echo* reported on May 25, 1951, "Mr. Macdonald also disclosed that an entirely new Kiddieland has been erected below the railroad tracks. Featuring numerous rides for the small fry, it has been separately fenced for safety purposes." Macdonald followed up with a report a year later, at the May 9, 1952 meeting: "Kiddieland has been completely rebuilt, and two new rides, the Bug and Kiddie Ferris Wheel have been installed," which brought the number of known kiddie rides to eight. The May 16, 1952 issue of the *Ligonier Echo* noted changes to the already existing Kiddie Land: "Among the many improvements at the park this year is Kiddiesland which is now all in one location. The Kiddiesland has been renovated throughout making it a completely miniature children's park." Idlewild performance clown Art Jennings, who would create neighboring Story Book Forest a few years later, was instrumental in relocating Kiddie Land, according to his son, Art Jr.: "One of the first changes dad made at the park was to move and consolidate the Kiddie Land on the lower flat. The idea was to

make it easier for the parents to keep an eye on their kids without having to run all over the park."

182. Probably added in the 1950s, at least by the early 1960s, the Jitterbug was initially located in the west plaza and eventually relocated to Kiddie Land. It moved next to the Motorcycles for the 1980 season.

183. According to the July 5, 1923 issue of the *Latrobe Bulletin*, 1,348 automobiles were parked at Idlewild during the Fourth of July Holy Family picnic, more than ever before in the park's history.

184. In 1947, Alex Hutchinson contacted the Idlewild Management Company Board of Directors with news that he planned to petition the state's Public Utility Commission to permit him to extend his common carrier bus line from Ligonier to Greensburg. His line ran between Franklin Borough and Ligonier, with a local extension to Idlewild Park, which would be eliminated, but the extension would allow him to provide direct service from Greensburg to Idlewild Park and back. The board authorized Jack Macdonald to testify in favor of the extension. IMC Board of Directors Meeting, April 14, 1947.

185. Deed, January 26, 1949, recorded April 21, 1949, Westmoreland County Deed Book, vol. 1338, pages 226–27; Mortgage, January 26, 1949, recorded April 21, 1949, Mortgage Book, vol. 736, pages 547–50. The sale of Idlewild Park to the Idlewild Management Company was contingent upon Richard King Mellon's approval, which itself was based on a full appraisal of the park property. At this point, the property also included an 8.44-acre portion of the adjoining Giesey farm on the south side of the creek purchased in 1942 (Indenture, November 7, 1942, Westmoreland County Deed Book, vol. 1,135, pages 465–66). The Idlewild Management Company also purchased the railroad's right-of-way in 1953 and two small parcels in 1955 that predated the park (Indenture, October 19, 1953, recorded August 23, 1979, Westmoreland County Deed Book, vol. 2,332, pages 721–23; Indenture, June 27, 1955, recorded July 8, 1955, Westmoreland County Deed Book, vol. 1,613, pages 315–20).

186. The board transferred 102 shares of Idlewild Management Company stock owned by members of the Mellon family to Jack and Dick Macdonald at the June 19, 1950 stockholders' meeting.

Part IV

187. Art Jennings explained the simple yet powerful idea for Story Book Forest during an interview for a homemade documentary of the park's construction that his son, Art Jennings Jr., put together in the 1980s. The

documentary consists of Jennings Sr.'s 8mm home movies shot during the construction of Story Book Forest.

188. Minutes from the September 14, 1955 Idlewild Management Company Board of Directors meeting note that the board agreed to lend the money to "Enchanted Forest, Inc." but that name was scratched out and "Story Book Forest, Inc." written in. Art Jennings and the Macdonalds may have learned that a similarly themed amusement park called the Enchanted Forest opened in Ellicott City, Maryland, in August 1955.

189. Story Book Forest Inc.'s original board of directors consisted of C.C. Macdonald, Grace R. Macdonald, Clinton Keith (Jack) Macdonald, Richard Zane (Dick) Macdonald and Arthur H. Jennings. Later directors included Virginia M. Hand (C.C. and Grace Macdonald's daughter), Juanita R. Barkley, Charles Scott Macdonald (Jack's son) and Stanley R. Nalitz Jr.

190. Article of Agreement, January 1, 1956, recorded May 18, 1956, Westmoreland County Deed Book, vol. 1,545, pages 320–24; Indenture, May 6, 1958, recorded August 6, 1958, vol. 1,714, pages 246–50.

191. According to Art Jennings Jr., the mule was actually used to dig the spot for the log bridge near the Three Billy Goats Gruff pen.

192. Four rabbit figures replaced the live bunnies for the 1970 season.

193. Despite having a Three Billy Goats Gruff unit, Story Book Forest initially only had the two goats Eenie and Meenie because "there is no Mo [more]." Mo was added later. *Latrobe Bulletin*, June 15, 1956.

194. If each actor's timeline is accurate, the women who played the Old Woman Who Lived in a Shoe overlapped. The March 23, 1967 issue of the *Latrobe Bulletin* noted June Lotz as portraying the Old Woman for the preceding twelve years—since the beginning of Story Book Forest. Nellie Gindlesperger finished a twenty-five-year career when she retired after the 1997 season, so she would have begun in 1973, leaving five years at most in between Lotz and Gindlesperger. It has been widely reported that Gindlesperger's mother, Mary Snyder, portrayed the Old Woman for twelve years prior to Gindlesperger, but if true, that would overlap with either Lotz or Gindlesperger. Snyder died in 1971.

195. According to Art Jennings during his last visit to Story Book Forest in 2000. *Ligonier Echo*, June 22, 2000.

196. The goose was accidentally decapitated by an underpass on Route 30 while it was transported to Idlewild Park. Continual maintenance problems due to its injury led to its removal after only a few seasons.

Part V

197. For example, C.C. Macdonald provided eleven of Idlewild's rowboats to the Ligonier Fire Department to rescue a thousand Johnstown residents stranded after the St. Patrick's Day Flood of 1936. Sandy Luther Smetanka also remembered his generosity among her many memories of growing up at Idlewild. When the park was shuttered for almost three seasons during World War II, Macdonald held the superintendent position open for her father, Bill Luther, to return once the park reopened.

198. Ligonier Valley Rail Road historian Jim Aldridge's unpublished research of the various Ligonier Valley fire clay and brick companies provides an excellent synopsis of the fire clay works that were active near Idlewild Park roughly between 1884 and 1891. The line branched off the Ligonier Valley Rail Road just east of Bayard's Run (Idlewild Run), at the west end of the future location of the picnic train storage siding, and ran about a mile and a half to the mine. The Ligonier Fire Clay & Brick Company entered into two separate lease agreements with William and Mary Darlington in 1884 and 1887 for a right-of-way for the railroad line and the right to use and construct buildings for manufacturing fire brick, roughly where the park's Mineshaft Kitchen is located today. The clay mining operation was relatively short-lived, and no evidence of brick manufacturing works has been found. See William and Mary Darlington, Deed, November 4, 1884, Darlington Family Papers.

199. Indenture, December 24, 1962, recorded December 26, 1962, Westmoreland County Deed Book, vol. 1,850, pages 136–39.

200. Although much overgrown, vestiges of Lake Woodland can be found on the south side of the park today behind Daniel Tiger's Neighborhood.

201. Although the original Hemlock Grove is no longer standing and has been replaced by Pavilion D-1, a concrete walkway (with blocks indicating that posts once stood there) can still be seen leading to the current pavilion. Hemlocks still abound in this section of the park.

202. The Little Show Boat was likely purchased for the 1958 season, as Idlewild Park's archive contains blueprints for the ride's fire system dated August 15, 1957.

203. The delay in receiving the Crazy Dazy ride may have halted the eventual removal of the Rockets until after the 1976 season; that ride was on the maintenance repairs list to be deleted for the 1973 season.

The Rockets lasted through the 1976 season before being replaced by the Scrambler, albeit in a different location.

204. Many Idlewild seasonal employees came from families having multiple generations who worked at Idlewild Park. But perhaps few if none have a history as extensive as St. Vincent College professor John Smetanka's family, whose Idlewild roots run deep on both sides. Dr. Smetanka's maternal grandfather, William Luther, enjoyed a long tenure as Idlewild's trusted superintendent, raising his son and daughter on the grounds, both of whom worked at the park—Sandy as a ticket counter and Bill in landscaping and construction. John's paternal great-grandfather, Stephen Smetanka, a Slovakian immigrant who settled in Latrobe, trimmed hedges, as did his grandfather Michael Smetanka. His father, John Sr., worked at the ice cream stand and as Idlewild's public address announcer, also doing mix room work. John himself worked in landscaping from 1984 to 1987, mowing the lawn three times a week. In 2016, John's daughter, Lindsey, joined the Idlewild team, operating the Trolley in Daniel Tiger's Neighborhood—making her the fifth generation of Smetankas to work at Idlewild Park.

Part VI

205. The developed park is only a portion of that acreage.

206. After nine months of study, the Idlewild Management Company Board of Directors axed the log flume ride, feeling that it would not generate enough income to justify a $350,000 price tag. IMC Board of Directors Meeting, September 20, 1976, and July 18, 1977.

207. The Idlewild Management Company Board of Directors voted to engage Mall Games Inc. as the Penny Arcade concessionaire on a trial basis from 1979 through 1981, moving to Cointronics Inc. for the 1982 season.

208. Letter from Leon T. Smithley, chairman of Ligonier Township Supervisors, to Richard Z. Macdonald, March 10, 1981.

209. Indentures, January 26, 1983, recorded January 27, 1983, Westmoreland County Deed Book, vol. 2,472, pages 86–102.

210. Kennywood Entertainment eventually owned Kennywood Park, Idlewild Park, Sandcastle (Homestead, Pennsylvania), Lake Compounce (Bristol, Connecticut) and Story Land (Glen, New Hampshire).

211. *Greensburg (PA) Tribune-Review*, February 3, 1983.

212. Rosemary Overly remembered restoring two illegible murals at manager Keith Hood's request.

213. The Philadelphia Toboggan Company was renamed Philadelphia Toboggan Coaster in 1991 and then Philadelphia Toboggan Coasters Inc. in 2007.

214. Summary of March 25, 1988 meeting of Family Communications and Idlewild Park Representatives.

215. "Mister Rogers' Neighborhood at Idlewild Park," designed by J.R. Minnick & Associates Inc. (Fred Rogers Center). The original plan also included a neighborhood trolley station, Mister Rogers's house and a tunnel with multi-screen television monitors broadcasting an introductory video where Rogers discussed music.

216. After a successful inaugural year, Mister Rogers' Neighborhood of Make-Believe underwent a few changes for the 1990 season: a new wall, mural and sign at the entrance tunnel; improvements to Corney's factory, making it look more like a workshop with a bench and blueprints; more flowers planted throughout the Neighborhood; and a series of questions posted in the ride's loading area to stimulate conversation among waiting guests.

217. Heavy storms over one weekend in August 1935 forced twenty thousand folks to flee from Idlewild Park. A combination of heavy rain and melting snow caused massive flooding in Western Pennsylvania in March 1912, including Ligonier. Flooding from the Loyalhanna Creek reportedly covered one hundred acres of ground around Idlewild and destroyed the bridge spanning the creek in the park, which was replaced by a new bridge just weeks before the picnic season.

218. Besides the Kiddie Land destruction from Hurricane Agnes, more than one hundred animals in Frontier Zoo drowned in five feet of water, rides were flooded, fish beached on the banks of the Loyalhanna Creek and Story Book Forest was covered by a foot of mud in places. The Loyalhanna Limited train was also damaged—the floodwater knocked the track off the trestle, warped other sections of track and uprooted the station house. *Uniontown (PA) Morning Herald,* July 18, 1972.

219. The existing Kiddie Land rides that were relocated to the new Raccoon Lagoon for the 1990 season were the Miniature Cars, Miniature Ferris Wheel, Doodlebug, Kiddie Hand Cars, Turtle, Miniature Boats, Red Baron, Flivvers and Motorcycles. The following kiddie rides had already been retired before then: Pony Carts, Roto-Whip, Jitterbug, Moon Walk, Miniature Airplanes and Miniature Flying Swans.

220. After a hiatus, the pony track returned to Idlewild in 2000, after which it operated for only a few years before it closed for good.

221. The Idlewild Company board considered replacing the cars on the Helicopter for the 1979 season and listed the purchase of eight Red Baron planes on the park's capital expenditures list for the 1981 season.

222. Werner Weiss, "Midget Autopia Mystery," August 15, 2014, updated June 9, 2017, www.yesterland.com/arrowflite.html.

223. In later years, some of the trees had to be weeded out because leaves falling onto the Wild Mouse track would shut down the coaster.

224. The Kennywood-sourced Tilt-a-Whirl was replaced by a Helm and Sons model in 2016. It did not operate for that season and was relocated to the former location of the Caterpillar ride, where it reopened in August 2017.

225. Astro-Liner fans can still ride an original space simulator at Idlewild's sister park, Dutch Wonderland in Lancaster, Pennsylvania.

226. *Travel* magazine rated Idlewild Park the most beautiful amusement park in the United States and one of the five best amusement parks in America in 1976. *Ligonier Echo*, May 12, 1976.

Part VII

227. As with Idlewild's previous sale, the price Festival Fun Parks paid for the entire Kennywood Entertainment Inc. family of amusements parks was not publicly disclosed. The fair market value for the nine parcels that made up the Idlewild Park property totaled $5,249,741.80, while the 2009 assessed value totaled $1,148,740. Westmoreland County Recorder of Deeds, vol. 009, Instrument no. 200907300030220, July 30, 2009.

228. The Idlewild Management Company voted to purchase the Darlington Station at its September 16, 1953 board of directors meeting.

229. The Ligonier Valley Rail Road Museum is located at 3032 Idlewild Hill Lane, Ligonier, PA, 15658 (phone: 724-238-7819; website: www.lvrra.org).

230. The new Philadelphia Toboggan Coasters Inc. train has primary and secondary restraints, which was a condition for Rollo Coaster to reopen after closing in August 2016 following the only documented rider accident in the ride's history. Instead of three linked two-seater cars holding four people each, the new train seats four people in the lead car and two people in each of the three trailing cars.

231. Lagoon Park in Farmington, Utah, is the only other operating railroad park in the United States. Lagoon began its life in 1886 as Lake Park, a

resort on Utah's Great Salt Lake serving the Denver and Rio Grande Western Railroad. After the lake receded and the park closed, many of the buildings were moved to nearby Farmington, and the resort reopened in 1896 as Lagoon Park, which served the Salt Lake and Ogden Railroad.
232. Irwin, *Historical Ligonier Valley*.

SELECTED BIBLIOGRAPHY

Interviews and Correspondence

Ambrose, Jim, and Julia Ambrose. Phone interview, August 6, 2016.
Bollinger, Corrine Butler. Phone interview, September 28, 2016.
Clark, Eleanor. Personal interview, May 27, 2016.
Croushore, Jeff. Conversations, 2015–17.
Darr, Charles. E-mail correspondence, September 29, 2016.
Deemer, Connie. Phone interview, June 23, 2016.
Domenick, Robert. Phone interview, August 26, 2016.
Fisher, Alan. Phone interview, August 6, 2016.
Frye, Harry. Personal interview, May 14, 2016.
Gibas, Jerome. Phone interview, January 30, 2017.
Giesey, Betty, and Jim Giesey. Personal interview, August 5, 2017.
Henninger, Harry, Jr. Personal interview, July 27, 2016.
Hood, Keith. Personal interview, October 27, 2016.
Jagger, Edith. Phone interview, June 3, 2016.
Jennings, Arthur, Jr. Personal interview, April 23, 2016; November 15, 2016; and January 3, 2017.
Ligonier Valley Rail Road Association (Jim Aldridge, Len Daugherty, Bill McCullough, Bill Potthoff and Bob Stutzman). Conversations and e-mail correspondence, 2015–17.
Lowe, Sara Jane Bitner. Phone interview, May 24, 2016.
Luther, Bill. Personal interview, January 29, 2017.

Macdonald, Dick. Interview by Jim Futrell, transcript, November 22, 1991.

Macdonald, Jack. Interview by Jim Futrell, transcript, November 20, 1991.

Macdonald, Richard Z., and Ann Macdonald. Personal interviews, September 20, 2015; April 30, 2016; and May 29, 2016.

Mellon, James. Phone interview, April 8, 2017.

Mellon, Sandy Springer. Personal interview, June 18, 2016.

Monsour, Hillorie. E-mail correspondence, June 30, 2016.

Oravetz, Carol. Personal interview, September 3, 2015.

Ostroski, Ed. Personal interviews, October 22, 2016; January 13, 2017.

Overly, Rosemary. Personal interview, June 3, 2017.

Parton, Stella. E-mail correspondence, October 15, 2017.

Petz, Peter. E-mail correspondence, December 24–27, 2017.

Ramsey, Jim. Phone interview, October 10, 2016.

Robb, Dave. Phone interview, March 14, 2016.

Shirey, David. Personal interview, October 28, 2016.

Sichula, Kathy. Conversations, 2015–17.

Smetanka, John. Personal interview, May 18, 2016.

Smetanka, Sandy. Personal interview, July 26, 2016.

Smithley, Ina Mae. Personal interview, July 10, 2016.

Snodgrass, Peter. Personal interview, October 28, 2016.

Strayer Jonathan R. E-mail correspondence, July 19, 2016.

Sylvester, Jean Gordon. Personal interview, March 20, 2016.

Zitterbart, Ralph. Personal interview, October 18, 2016.

Company Records

Idlewild Management Company Board of Directors. Meeting Minute Books, vols. 1–3, 1931–82.

Idlewild Management Company. Ledger Book, 1931–48.

Ligonier Valley Rail Road. Letter Press Books, vols. 1–2: Daily Correspondence of George Senft, 1892–98.

Philadelphia Toboggan Company Inc. Board of Directors. Meeting Minutes and Financial Statements, 1929–32, 1937–38, 1940–42.

Philadelphia Toboggan Company Inc. Executive Committee. Meeting Minutes and Reports, 1929–32.

Philadelphia Toboggan Company Inc. General Amusements Operating Company. Financial Statements, 1930–32.

———. Journal, 1930–32.

————. Transledger, 1930–32.

————. Various correspondence on Carousel no. 83, 1931–32.

Story Book Forest Inc. Board of Directors. Meeting Minute Books, vols. 1–2, 1956–82.

Timberlink Inc. Board of Directors. Meeting Minute Book, 1962–82.

Valuation Report for Idlewild Park, Story Book Forest, Timberlink Golf Course and Frontier Zoo. Vols. 1–2, 1976.

Personal Records

Darlington Autograph Files, 1610–914. DAR.1925.07, Darlington Collection, Special Collections Department, University of Pittsburgh. Contains documents owned by William and Mary Darlington that were authored or signed by historical figures. http://digital.library.pitt.edu/islandora/object/pitt%3AUS-PPiU-dar192507/viewer.

Darlington Family Papers, 1753–1921. DAR.1925.01, Darlington Collection, Special Collections Department, University of Pittsburgh. The collection contains personal, legal and financial papers of William and Mary Darlington. http://digital.library.pitt.edu/islandora/object/pitt%3AUS-PPiU-dar192501/viewer.

Maps, Surveys and Land Records

Blockhouse at Idlewild Park. February 16, 1933. Idlewild and SoakZone archives.

Cabin and Gateway for Idlewild Park Entrance. February 22, 1933. Idlewild and SoakZone archives.

Footing and Stonework for Idlewild Park Entrance. February 5, 1933. Idlewild and SoakZone archives.

For Luther Giesey Estate Ligonier Twp. PA. Burgess Ross, surveyor. Undated. Idlewild and SoakZone archives.

Idlewild Park Plot Plan of Entrance. January 23, 1933. Idlewild and SoakZone archives.

Interstate Commerce Commission Bureau of Valuation. *Engineering Reporting Upon Ligonier Valley Rail Road Company Showing Cost of Reproduction New and Cost of Reproduction Less Depreciation*. June 30, 1917. Idlewild and SoakZone archives.

Jennings, Arthur, and William Schrader. Story Book Forest blueprints, various. 1955, 1956, 1961, 1962, 1964, 1966. Idlewild and SoakZone archives.

Kiddie Land Study Idlewild Park. August 21, 1989. Idlewild and SoakZone archives.

Land Survey Idlewild Management Company to Story Book Forest Inc. Gibson-Thomas Engineering Company, Latrobe, Pennsylvania. October 1957. Idlewild and SoakZone archives.

Map Idlewild Park. Burgess Ross, surveyor. November 1939. Idlewild and SoakZone archives.

Map Idlewild Park Ligonier Valley Rail Road. Robert A. Ramsey, engineer, Greensburg, Pennsylvania. June 20, 1938. Idlewild and SoakZone archives.

Map of Darlington Estate (Idlewild Park-Ligonier Valley Rail Road). Farley Gannett, consulting engineer, Harrisburg, Pennsylvania. December 1916. Idlewild and SoakZone archives.

Map of Story Book Forest. In *Story Book Forest Souvenir Brochure.* Wilkinsburg, PA: Wonday Film Service Inc., 1960. Idlewild and SoakZone archives.

Philadelphia Toboggan Company Inc. *Plan and Profile of Coaster at Idlewild Park Ligonier, Penna.* Circa 1938. Idlewild and SoakZone archives.

———. *Proposed Juvenile Coaster Idlewild Park.* October 1937. Idlewild and SoakZone archives.

———. *Rollo Coaster Pavilion Plan and Details.* April 15, 1938. Idlewild and SoakZone archives.

Property Plan for Idlewild Management Company. Gibson-Thomas Engineering, Latrobe, Pennsylvania. March 1956 (revised October 1970, June 1972). Idlewild and SoakZone archives.

Proposed Plot Plan for Safariland Idlewild Park Ligonier, PA. Robert L. Frambach, reg. architect, Johnstown, Pennsylvania. Undated. Idlewild and SoakZone archives.

Survey of Idlewild Park. Gibson-Thomas Engineering, Latrobe, Pennsylvania. 1966. Idlewild and SoakZone archives.

William Darlington, Survey of Darlington Land on Loyalhanna Creek. May 9, 1879. Box 27, Folder 5. Darlington Family Papers, 1753–1921. DAR.1925.01, Darlington Collection, Special Collections Department, University of Pittsburgh.

Court Records

Records of the Land Office, Pennsylvania Historical and Museum Commission. Pennsylvania State Archives. Including Copied Surveys,

1682–1912; New Purchase Register; Patent Indexes, 1684–circa 1957; Patent Books H Series, 1809–present; and Warrant Registers, 1733–1957. Searchable at www.phmc.pa.gov/Archives/Research-Online/Pages/Land-Records-Overview.aspx.

Westmoreland County Prothononary's Office. Ejectment and Miscellaneous Index; Docket Minutes, vols. 2 and 3; Continuance Docket Books 1 and 2.

Westmoreland County Recorder of Deeds. Grantee Index; Grantor Index; Survey Books nos. 1 and 2.

————. www.wcdeeds.us/dts/default.asp.

Newspapers and Periodicals

Altoona Tribune

Beaver County Times

Bedford Gazette

The Billboard

Blairsville Dispatch

Buffalo (NY) Courier Express

Canonsburg (PA) Daily Notes

Connellsville (PA) Daily Courier

Connellsville (PA) Weekly Courier

Focus Magazine

Greensburg Daily Tribune

Greensburg (PA) Evening Press

Greensburg (PA) Tribune Herald

Greensburg (PA) Tribune-Review

Harrisburg Telegraph

Indiana Democrat

Indiana Gazette

Indiana Weekly Messenger

Johnstown Democrat

Johnstown (PA) Tribune-Democrat

Latrobe Advance

Latrobe Bulletin

Laurel Highland Scene

Lehighton (PA) News Record

Ligonier American

Ligonier Echo

McKeesport (PA) Daily News
Monongahela (PA) Daily Republican
Pittsburgh Bulletin
Pittsburgh Daily Post
Pittsburgh Dispatch
Pittsburgh Post-Gazette
Pittsburgh Press
Pittsburgh Sun-Telegraph
Somerset Daily American
Troy (NY) Times Record
Uniontown (PA) Evening Standard
Uniontown (PA) Morning Herald
Westmoreland Traveler

Articles

Futrell, Jim. "The Idlewild Park Story." *National Amusement Park Historical Association News* 14, no. 3 (1992).

————. "The Idlewild Park Story Continues." *National Amusement Park Historical Association News* 15, no. 10 (1993).

Iscrupe, Shirley G. McQuillis. "A Calendar of the Pennsylvania Land Transactions of Arthur St. Clair, 1766–1818." *General Arthur St. Clair 250ᵗʰ Birthday Anniversary Year.* Westmoreland Archaeological Institute and Forbes Road Association Inc., 1986.

McCool, R.L. "Millionaire's Railroad." *Railroad Magazine* (May 1952).

Myers, James M. "The Ligonier Valley Rail Road as It Touched the Life of Latrobe." *Western Pennsylvania Historical Magazine* 38, nos. 1–2 (Spring 1955).

Shetler, Charles. "James O'Hara's Landholdings in Allegheny County." *Western Pennsylvania Historical Magazine*, no. 34 (1951).

Books

Boucher, John Newton. *Old and New Westmoreland.* Vols. 1–4. New York: American Historical Society Inc., 1918.

Butko, Brian. *Luna: Pittsburgh's Original Lost Kennywood.* Pittsburgh, PA: Senator John Heinz History Center, 2017.

Comm, Joseph A. *Images of America: Rock Springs Park*. Charleston, SC: Arcadia Publishing, 2010.

Craig, John. *The Ku Klux Klan in Western Pennsylvania, 1921–1928*. Bethlehem, PA: Lehigh University Press, 2014.

Croushore, Jeffrey S. *Images of America: Idlewild Park*. Charleston, SC: Arcadia Publishing, 2004.

Futrell, Jim. *Amusement Parks of Pennsylvania*. Mechanicsburg, PA: Stackpole Books, 2002.

Hersh, Burton. *The Mellon Family: A Fortune in History*. New York: William Morrow and Company Inc., 1978.

Jenkins, Torrence, Jr. *Herbert P. Schmeck: The Forgotten Legacy*. Oakdale, PA: Knepper Press. 2006.

Ligonier Sesquicentennial Book. N.p., 1908.

Mellon, James. *The Judge*. London: New Haven Press, 2011.

Mellon, Thomas. *Thomas Mellon and His Times*. Edited by Mary Louise Briscoe. Pittsburgh, PA: University of Pittsburgh Press, 1994.

Mellon, William Larimer. *Judge Mellon's Sons*. N.p.: private printing, 1948.

Pershing, Edgar J. *The Pershing Family in America: A Collection of Historical and Genealogical Data, Family Portraits, Traditions, Legends and Military Records*. Philadelphia, PA: George S. Ferguson Company, 1924.

Sokolic, William J., and Robert E. Ruffolo Jr. *Images of America: Atlantic City Revisited*. Charleston, SC: Arcadia Publishing, 2006.

The Stoystown & Greensburgh Turnpike Road Company Minutes, 1815–1826. Laughlintown, PA: Southwest Pennsylvania Genealogical Services, 1976.

Stutzman, Robert D. *Images of Rail: The Ligonier Valley Rail Road*. Charleston, SC: Arcadia Publishing, 2014.

Brochures, Programs and Other Publications

Idlewild: A Story of a Mountain Park. Pittsburgh, PA: Rawsthorne Printing & Engraving Company, 1900.

Idlewild Lutheran 1, no. 1 (August 18, 1891).

Idlewild Park Centennial: Celebrating 100 Years of Outstanding Entertainment. N.p., 1978.

Idlewild Park promotional brochures, various dates.

Idlewild Park souvenir picnic programs, various dates.

Irwin, William G. *Historical Ligonier Valley: A Souvenir*. N.p., 1898.

Myers, James Madison. *The Ligonier Valley Rail Road and Its Communities*. Pittsburgh, PA: University of Pittsburgh, 1955.

Pennsylvania Railroad promotional brochures for Idlewild, 1897, 1898, 1899, 1901, 1902.

Websites

Idlewild and SoakZone. www.idlewild.com.
Laff in the Dark. www.laffinthedark.com.
Ligonier Valley Rail Road Association. www.lvrra.org.

Other Sources

Ancestry.com. United States Censuses, 1870–1940.
Biographical sketches of the Muchmore family. Dictated by Sarah Waugh Roberts to Cora Rodgers Tucker, spring of 1876.
Charles and Betty Jacques Amusement Park Collection, 1873–2014. Collection no. 521, Special Collections Library, Pennsylvania State University, State College, Pennsylvania.
Jennings, Arthur, Sr. Story Book Forest construction film, 1956–58.

INDEX

ABOUT THE AUTHOR

Jennifer Sopko is a writer and historian with a love of Pennsylvania history. A Pittsburgh native who grew up in White Oak Borough, her writing projects focus on Western Pennsylvania history with goals of enlightening readers about forgotten and obscure regional history and reinterpreting connections between familiar stories. Jennifer holds a Bachelor of Arts degree in English from Saint Vincent College in Latrobe, Pennsylvania. Since 2003, she has written about the Ligonier Valley, Westmoreland County and Western Pennsylvania for several regional publications, including the *Latrobe Bulletin*, the *Ligonier Echo*, *Westmoreland History* magazine and *Western Pennsylvania* magazine. Her first book, *Ligonier Valley Vignettes: Tales from the Laurel Highlands*, a series of historical vignettes about Pennsylvania's Ligonier Valley, was published by The History Press in 2013.

Jennifer is also an active community volunteer, serving as co-chair for the Westmoreland County Historical Society's 2015 and 2016 annual fundraisers and regularly helping the Ligonier Valley Library's Pennsylvania

Room, where in 2009 she was guest curator for a historical photo and memorabilia show about Pennsylvania drive-in theaters. Jennifer also enjoys playing flute with the Penn Trafford Community Flute Choir and the Penn Trafford Community Band.